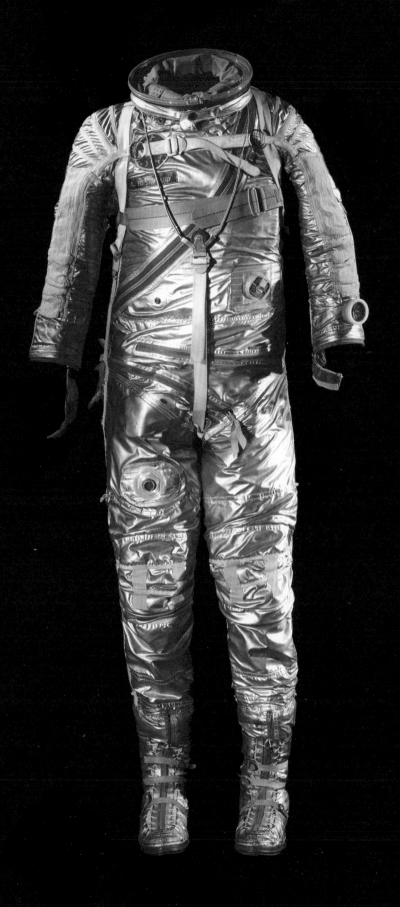

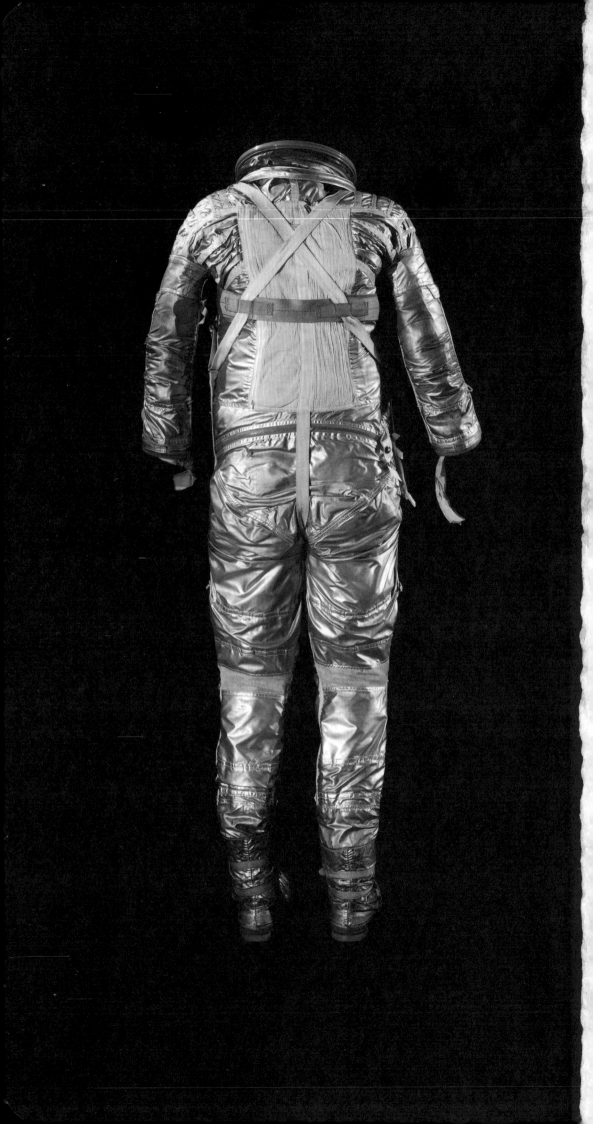

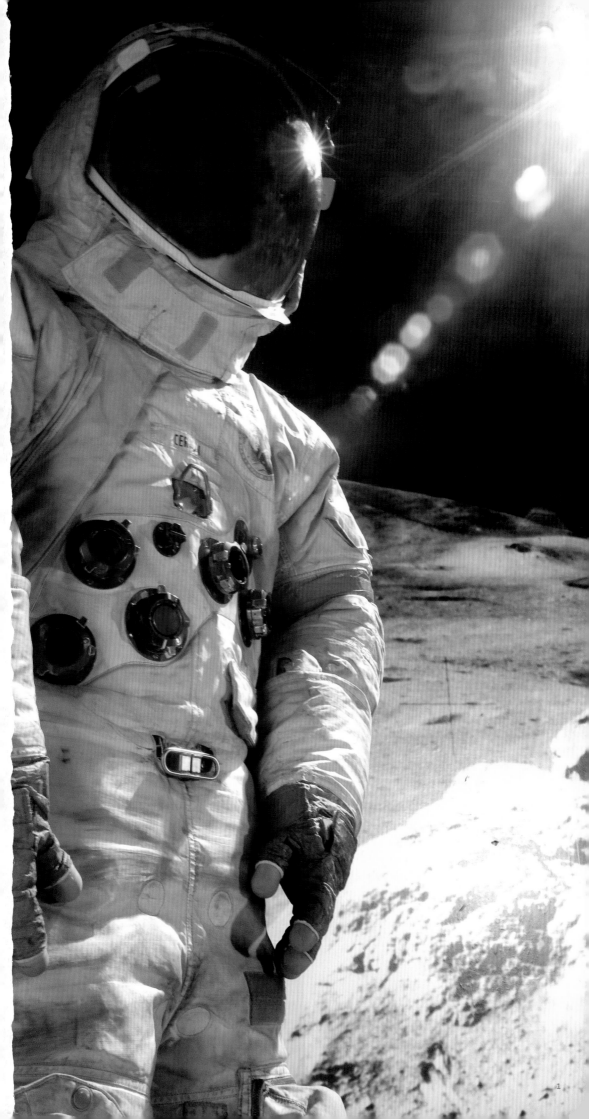

Spacesuits

The Smithsonian National Air and Space Museum Collection

Smithsonian
National Air and Space Museum

pH powerHouse Books Brooklyn, NY

By **Amanda Young**
Photographs by **Mark Avino**

Introduction by **Allan Needell, PhD**
Foreword by **Lt. Gen. Thomas P. Stafford, USAF (Ret.)**

Smithsonian
National Air and Space Museum

pH powerHouse Books Brooklyn, NY

TABLE OF CONTENTS

Almost five decades ago, in May of 1961, Alan Shepard became the first American to leave the bonds of earth, while 45 million people watched on television. Eight years later, on July 20th, 1969, Neil Armstrong and "Buzz" Aldrin walked on the face of the moon. The space age, that had begun with Mercury, evolved during Gemini, and matured during the Apollo program, had fulfilled John Kennedy's goal of placing a man on the moon and returning him safely to the earth.

However, this great adventure had required the almost super-human effort of designing and building new hardware, launch vehicles, and spacecraft—and for the astronauts, who needed specialized garments that would protect them from the perils of traveling, living, and working in the hazardous environment of space, the spacesuit. Development of the space-suit eventually used on the moon turned out to be much more complicated than might be expected. These spacesuits evolved from those used during the high-altitude aeronautical missions of the late 1950s and 60s, and eventually, progressed into those used in zero-gravity, and finally with those worn on the moon. After the missions where these astronauts orbited the earth, flew in deep space to, from, and on the moon, the spacesuits they wore were placed in the custody of the National Air and Space Museum of the Smithsonian Institution. In this special facility, they have been preserved and cared for ever since.

The National Air and Space Museum is the larg-est repository of spacesuits from the United States Space program. The Museum is not only responsible for the care of these objects, but also for determin-ing the optimum conditions under which they can be displayed and stored. The flown suits are officially requested for loan regularly, and can remain on loan at certified facilities for extended periods of time. This collection, numbering approximately 200 suits, includes the artifacts from the years of pressure-suit design and development, early spacesuits, and space-suits from the Mercury, Gemini, and Apollo programs, along with the advanced extra-vehicular suits and those designed for the U.S. Air Force Manned Orbiting Laboratory program. The most historic of these are considered to be the first two spacesuits on the moon, those worn by Neil Armstrong and Buzz Aldrin on Apollo 11, and the last two, worn by Eugene Cernan and Harrison Schmitt on Apollo 17. However, though these suits are considered to be high profile, they are not the only valuable ones in the collection. This book highlights some of the other, lesser known programs, and the spacesuits that were developed for them.

Over the years, spacesuits have sustained a great deal of deterioration. They all suffer from hard-ening and breakage of the rubber interior pressure bladders, ultraviolet and visible light damage, and wear to exterior parts. As spacesuits are heavy, they have suffered from their own weight causing many of them to have "frozen" in a flattened position because of less than ideal storage conditions. The staff of the National Air and Space Museum have worked for years to find the best conditions in which to store and display these icons of the space program, and conse-quently, those wishing to borrow and display these historic artifacts are screened carefully, and have to agree to a stringent set of display guidelines.

This book shows the evolution and rich variety of spacesuits designed for this great adventure. It enables the reader to understand how these iconic objects evolved, and the photography by Mark Avino shows these beautiful suits as they are now, along with images of the time showing them in use.

Lt. Gen. Thomas P. Stafford, USAF (Ret.),
Astronaut
Gemini 6, Pilot
Gemini 9, Commander
Apollo 10, Commander
ASTP, Commander, Apollo

Amanda Young is a museum specialist in spacesuits and Astronaut Equipment for the Smithsonian National Air and Space Museum. She was responsible for the Air and Space portion of American Festival Japan '94, a major exhibit in Tokyo, and co-wrote the collections care booklet *The Preservation, Storage and Display of Spacesuits*. She was also a contributor to *Extreme Textiles: Designing for High Performance* (Princeton Architectural Press, 2005) and *After Sputnik: 50 Years of the Space Age* (Collins, 2007). She continues to conduct research into the causes of spacesuit deterioration.

Mark Avino is the Chief of Photographic Services in the Office of Communications for the National Air and Space Museum. In addition to a wide variety of photography undertaken at the museum, he has also contributed to numerous publications and books on the museum's collections, including *In the Cockpit: Inside 50 History-Making Aircraft* (Collins Design, 2007) and *At the Controls: The Smithsonian National Air and Space Museum Book of Cockpits* (Boston Mills Press, 2001).

Allan A. Needell is the Curator of Human Space Flight in the Division of Space History at the National Air and Space Museum. He is the author of a study of the career of a major American science administrator, *Science, Cold War and the American State: Lloyd V. Berkner and the Balance of Professional Ideals* (Routledge, 2000). Needell joined the National Air and Space Museum in 1981 and is currently responsible for the museum's Apollo space flight collection.

Thomas P. Stafford is a retired Lieutenant General of the U.S. Air Force and a former NASA astronaut. Stafford piloted Gemini VI, the first rendezvous in space (1965), and commanded the Apollo 10 lunar mission (1969) and the historic Apollo-Soyuz Test Project (1975). He is the recipient of many awards in aviation and honorary university degrees.

Writing a book such as this is not something that can be done alone. When I started in this field I realized how very little I knew, and some very kind people in the space-suit world gave me a lot of help, information, and good advice. This assistance has continued for well over 15 years, and without the considerable generosity of these very kind and knowledgeable people I never could have reached the position I have, and certainly would never have been able to write this book. Unfortunately there is little I can do to repay such generosity, but I would like to thank them all for their kindness and assistance—though in no particular order.

Mark Avino—Friend, colleague, and extraordinary photographer who has so patiently documented this wonderful collection, and in the course of it, produced some of the most wonderful photographs ever taken of spacesuits.

General Tom Stafford—Astronaut and kind, generous friend, who gave me such wonderful insights and suggestions, and who was so willing to write the foreword to this book.

Allan Needell—My "boss" and valued colleague for the past 15 plus years, and a better one just doesn't exist. He has given me unfailing support, and the freedom to write, "love" the collection, pursue any direction the research took me, and the time to delve into all aspects of spacesuit development, storage, and care.

Mike Neufeld—Current Chair of the Space History Division, and a scholar. Thank you for your comments and support.

Gregg Herken—Former Chair of the Department of Space History who "gave me the collection."

Trish Graboske—Without whom this book would never have been a reality. Her dedication to getting it published has been unstinting, and truly above and beyond anything I could have expected or imagined.

Lisa Young—Spacesuit conservator during the Save America's Treasures and Smithsonian Women's Committee grants, and a willing participant in the long and sometimes very difficult realities of exploring such unknown conservation territory. Always ready to answer "oddball" questions and think outside the box—it is through her dedication that we have a way to preserve these remarkable objects.

Ken Thomas—Kind, knowledgeable, generous Ken. Always supportive, and always ready to give me the benefit of his astonishing wealth of knowledge about spacesuits, their development, construction, and history.

Bill Ayrey—Generous friend and colleague, who has for so many years patiently explained the intricacies of Apollo and Shuttle spacesuits, their history, and helped us all in so many other ways.

Jack Bassick—Who, in spite of having so many demands on his time, has always managed to answer our questions, contribute and verify information, and give us encouragement.

The Collections Division of the Paul E. Garber Facility, John Fulton, Al Bachmeier, and Rich Kowalczyk—For finding and building the environmental storage units, and somehow getting the equipment to make them work—not to mention their constant support.

Carl Bobrow—Who took on spacesuit care as a mission and became such a valued part of their care, storage, research programs, and imagery.

Samantha Snell—Who started as an intern with the Save America's Treasures program, and continues to work so hard to provide the best possible care and storage for this remarkable collection.

Sam Dargan—Who must have moved more spacesuits more often for me than can be counted, and is always willing to help in any way needed.

Cathy Lewis—Who read and re-read the draft, provided support, and kept me straight on the Soviet and Russian Space Programs.

Vic Vykukal and Bill Elkins—Spacesuit designers extraordinaire. My goodness—that anyone could design and build such incredible equipment takes my breath away. Thank you for the advice, photographs, and for reading my draft over and over.

Ron Cunningham—For breaking major barriers by thinking up ways to look at the inside of these wonderful suits and then making it all work. It is through his efforts that we have these phenomenal radiograph images.

The Museum Conservation Institute (MCI): Bob Koestler, Paula de Priest, Mary Baker, and Jeff Speakman—Who have supported us, and given Ron Cunningham the freedom to explore aspects of spacesuits through X-Rays and SEM imagery that we never would have been able to do otherwise.

Save America's Treasures—For giving us the grant that started this amazing conservation research. Without their grant none of it would have been possible.

Hamilton Sundstrand—Whose enormous generosity in matching the SAT grant in its entirety made it possible for us to undertake the daunting task of the research that was so necessary for the preservation of these wonderful objects.

Smithsonian Institution Women's Committee—Whose generosity and support through a grant enabled us to pursue the very singular problems associated with the Gemini spacesuits.

My great big, wonderful family—Too large to mention individually, but whose blind belief that I could do this book was a neat thing to have in my back pocket.

Thank you all.

Amanda Young

The spacesuits worn by the Mercury, Gemini, and Apollo astronauts are among the most asked for, and asked about artifacts in the Smithsonian national collection. It is true that explorers of remote, inaccessible, and environmentally inhospitable regions of Earth (notably of the Arctic and Antarctic regions), and test pilots since the 1930s, have required specially designed clothing of various sorts. It is a testament to the extraordinary cultural significance of spaceflight, however, that spacesuits attract far more attention than the parkas, snow shoes, flight jackets, and even pressure-suits and "crash helmets" of Earth-and-air-bound explorers.

The popularity and interest in spacesuits, of course, reflects the extraordinary cultural status of spaceflight. While human spaceflight in the United States began as a direct extension of test-flying experimental, high-performance aircraft for the military, and owes much to the precedent and traditions of Arctic and Antarctic exploration, the placing of humans into orbit, and especially the act of walking about upon the surface of the moon during the 1960s and 1970s, has had direct and symbolic meaning to the American public that is hard to overestimate.

Space exploration is most commonly dated to the October 4, 1957, launch of Sputnik by the Soviet Union. Sputnik, of course, was unmanned, as were the initial attempts by the United States to launch earth orbiting satellites. These first satellites were intended, or least justified to the public, as scientific experiments. Of course, the fact that their launch vehicles were based on the ballistic missiles being developed for an accelerating arms race made even scientific satellites symbols of military prowess and technical virtuosity. Placing humans in space aboard earth-orbiting, and then lunar, spacecraft likewise had both scientific and symbolic importance. Public interest in every aspect of such piloted spaceflight reflects the degree to which the astronauts and cosmonauts served as surrogates or representatives of the competing political and economic systems that faced each other over the many battlefields (military and nonmilitary) of the Cold War.

Earthrise – Apollo 8
NASA Image # 68-HC-870
Courtesy of NASA

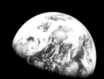

in the United States, the first very high-altitude manned programs were organized within the Air Force: the X-15 rocket plane program and the ballistic-missile-launched "Man in Space Soonest" effort were soon subsumed into the civilian National Aeronautics and Space Administration (NASA), once it was established in October 1958. The civilian effort immediately focused on ballistic rockets instead of rocket-powered airplanes. Christened Project Mercury, the NASA program established astronauts as American heroes, rescuers of American prestige badly shaken by the Soviet achievements in space.

The space race, initiated by Sputnik, extended naturally to human flight. And Americans wanted to know everything there was to know about their own brave space explorers. *Life* magazine wrangled an exclusive contract to publicize every personal detail of the astronauts' achievements, training, and even their family life. Not the least subject of interest was what they would wear while perched upon flaming rockets speeding upwards into the heavens. The famous picture of the "Mercury Seven" and their silver suits remains an iconic image of the space age.

On May 25, 1961, when President John F. Kennedy stated before a joint session of Congress, "I believe that this nation should commit itself to achieving the goal, before this decade is out, of landing a man on the moon and returning him safely to the Earth," he spurred even greater interest. The public soon appreciated that astronauts soon would have to be protected not only when inside the spacecraft, but also when floating in the vacuum of space (during Project Gemini) and walking on the lunar surface (Apollo). Spacesuits were key aspects of the technology that had to be developed. Because of the direct association with human beings, and because the technology was, at least in the popular mind, more accessible than the propulsion systems, navigation tools, and environmental control systems built into the spacecraft and launch vehicles, interest in the spacesuits and associated personal equipment increased markedly.

To this day, the amazing white suits featured in the extraordinary images of American astronauts cavorting over the lunar surface less than 10 years after Kennedy's public challenge, are among the most prized possessions of the National Air and Space Museum. And their significance is much more than symbolic. They are, in fact, technological wonders. Never suffering a serious malfunction during use, the Apollo lunar suits were the culmination of the advanced research programs that had triggered the development of new textiles, glues, plastics, and use of metals, and had used them in completely new ways. During the course of these developments, advances were made that subsequently found other uses, and technological spin-offs, from the space program, that became and continue to be a part of many aspects of daily life for millions of people around the world.

These spacesuits are in many ways, the smallest of spacecraft—designed to keep an astronaut alive and well in the most hostile environment imaginable. But they were also a "suit of clothes" in which an astronaut could do almost everything that could be done within the confines and safety of his or her spacecraft—breathe, eat, drink, keep warm or cool, communicate, and go to the bathroom. Spacesuits are, in fact, the result of decades of intense research, design, developmental, and manufacturing work, the products of which were worn by a very small group of adventurous and brave men during an extraordinary period in history.

The National Air and Space Museum has collected more than 5000 artifacts representing almost every facet of that great early human spaceflight venture. Included in this collection are a total of over 1,000 spacesuits, pressure-suits, and components (gloves, boots and helmets), including most of the spacesuits worn during the Apollo, Gemini, and Mercury missions. These artifacts, along with examples of the suits made during the earlier developmental periods and those used during training and testing, show the rich variety of thoughts and ideas that contributed so substantially to the achievements of human space flight in the 1960s and 70s. And it is those artifacts that are documented so beautifully in word and in pictures in this unique volume.

Fig. 1.1
Mark V – Modified
B.F. Goodrich, 1968
Catalog # 1980-0041-000
SI Image # 2003-27315

Chapter 1_The Early Years

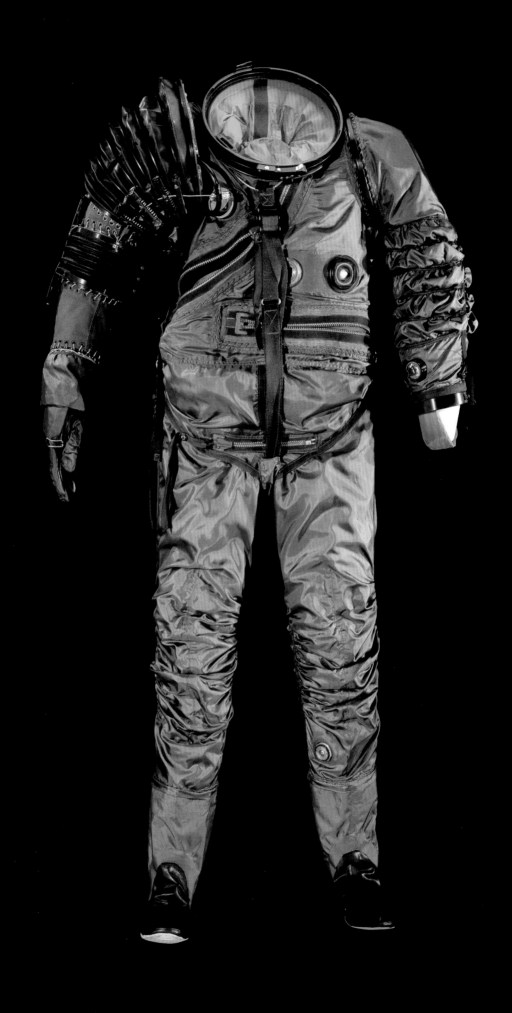

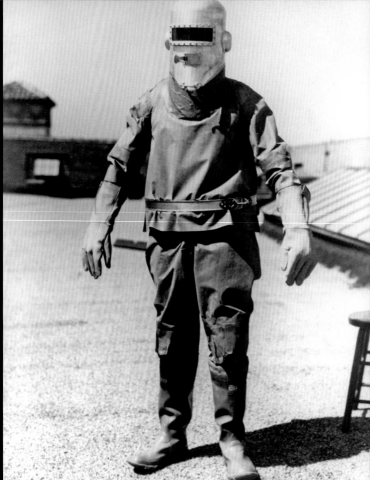

Fig. 1.2
Wiley Post – Suit #1
1934
SI Image # 84-11900

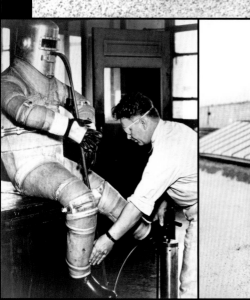

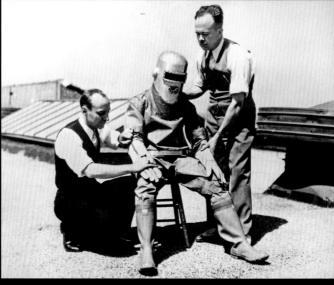

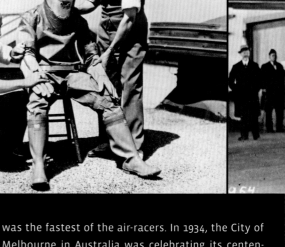

Spacesuit development in the United States of America can be traced to the early 1930s. In August, 1930, Wiley Post—oil driller, barnstormer, and later a licensed transport pilot—entered and won the Los Angeles to Chicago Air Derby, flying a Lockheed Vega. After the race, Post decided to set off on a trip around the world in an attempt to beat the speed records of the US Army Air Service's achievement of 1924 and the Graf Zeppelin of 1929. His employer, Oklahoman oilman F.C. Hall, who had named the airplane "Winnie Mae" after his daughter, provided the financial support, and in 1931 Post and navigator Harold Gatty set off, eventually breaking the speed record of the Graf Zeppelin by over 12 days. During additional flights in the following years, Post proved that he

was the fastest of the air-racers. In 1934, the City of Melbourne in Australia was celebrating its centennial, and Sir MacPherson Robertson offered a prize of £10,000 (about $50,000) to the winner of an air race between England and Australia, a distance of 12,500 miles. Post very much wanted to enter this race, but as the Winnie Mae was made largely of fabric and plywood, he realized that he would be unable to win this race in her without some major modifications to the aircraft.

Post was aware of strong air currents at 30,000-50,000 ft.—"high winds" as he called them, now known as jet streams, which would carry his aircraft at considerable additional speed. Though this would potentially allow him to win the race, he

Fig. 1.3
Wiley Post – Suit # 3
B.F. Goodrich, 1934
Catalog # 1936-0036-000
SI Image # 2002-16611

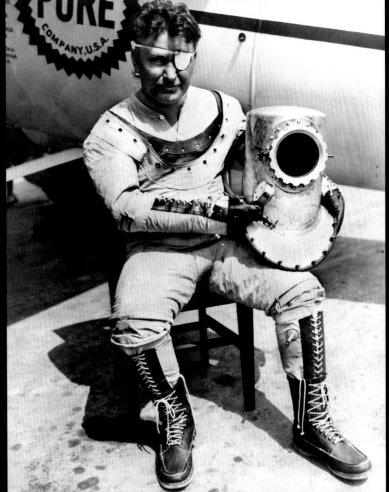

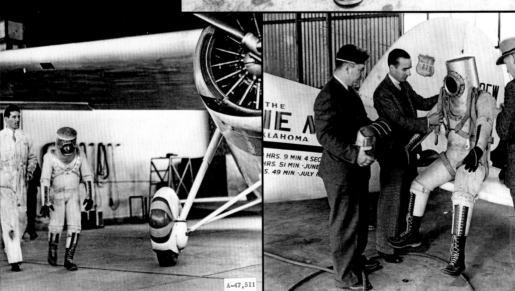

The one element beyond Post's abilities was the pressure-suit, and for this he gained the support of B.F. Goodrich. In early 1934, Post worked with the B. F. Goodrich Company in California to construct a suit capable of protecting a pilot at these high altitudes. The first suit produced (Fig. 1.2) was a double-ply, single-layer garment, constructed of rubberized parachute cloth glued together on the bias to minimize the stretching effect under pressure, and is estimated to have cost $75. The upper and lower sections closed at the waist with a heavy duty, metal "belt," the feet were sealed in attached rubber boots, and pigskin gloves protected the hands. The helmet was attached to the upper portion of the suit and weighed three and a half pounds. It had a rectangular visor for his eye (one eye having been lost in a 1926 drilling rig accident) and an additional "hatch" over the mouth, through which he could talk, eat, or drink while un-pressurized. Interestingly, the helmet had tie downs to prevent it from rising up when the suit was pressurized—a problem found later with both the soft spacesuits and the advanced extra-vehicular suits, and that was resolved in a similar fashion.

However, this suit failed to hold pressure during testing, and subsequently, Post took the remains of the suit to the Goodrich plant in Akron, Ohio. There, he met and worked with Russell Colley, a Goodrich employee who had done considerable work with aeronautical rubber products, and together they worked on a second suit. This suit (Fig. 1.4) was also of double-ply, single-layer construction, but the upper and lower sections connected with a waist clamp that closed with a series of wing nuts. "Joints" were incorporated into the elbows and knees to enable Post to move more easily while the suit was pressurized. However, overall it was too tight, which resulted in his having to be cut out of it.

Note: The dynamics of a full-pressure-suit or spacesuit are such that when the suit is pressurized, movement in the form of bending one's waist, elbows, or knees becomes extremely difficult and fatiguing. This is because as the joint is bent, the pressure bladder

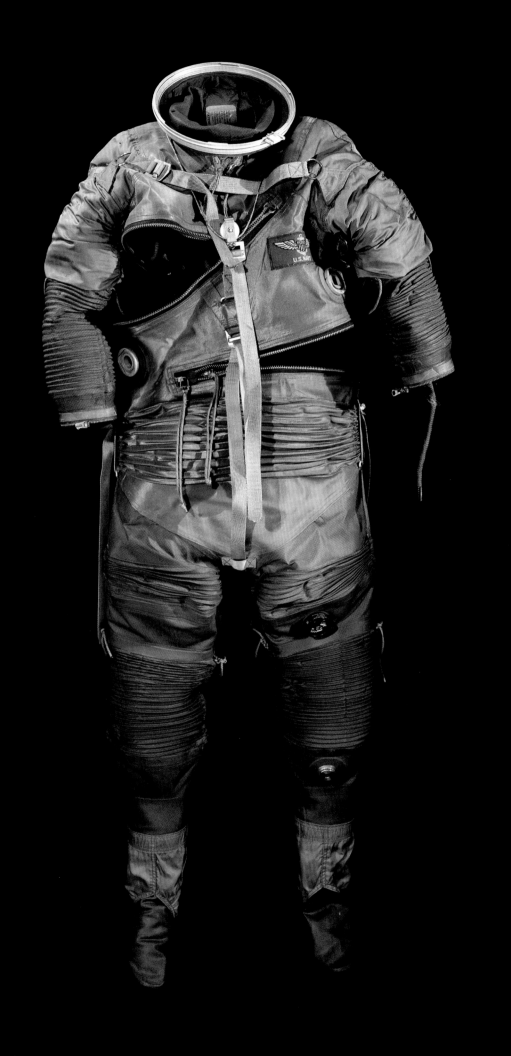

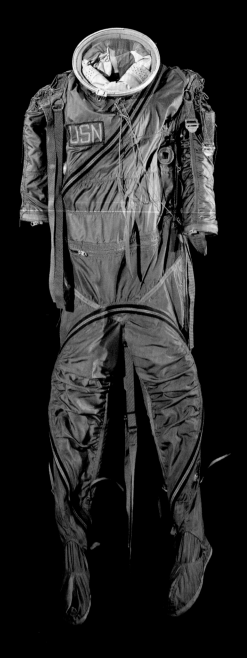

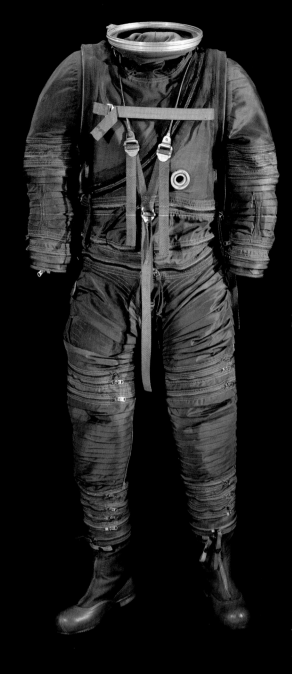

through a large opening in the neck, and the helmet was attached to the suit and tightened in place with wing-nuts through two yokes of flat metal (to maintain the neck shape and provide a stable base to which to attach the helmet). The suit was constructed so its natural shape was in the partial-sitting position as a means of making it more comfortable for Post while sitting in the aircraft. The helmet was a separate component and was the second of Post's helmet designs, constructed of heavy-weight aluminum with a round "port-hole" for visibility. As the helmet had a tendency to rise when the suit was pressurized, Post wore a pair of tie-downs crisscrossed over his shoulders and connected to a strap upon which he sat during the flight—thereby holding the suit and helmet down, and maintaining his ability to see through the port-hole. Oxygen was provided from a bottle with a tube connected to the helmet, and the suit was heated by a coil of tubing wound around the exhaust pipes of the aircraft engine, with the other end attached to the suit and controlled by a needle-valve. As the air was pulled into the suit through the tubing, it was heated by the engine, keeping Post warm. He tested the suit in a low pressure chamber at the Wright Field Laboratory, and in September, 1934, made the first flight ever in a fully pressurized suit. It was a very successful flight, reaching an altitude of 40,000 feet over Chicago, and proving that a pressure-suit could keep a man alive and warm in the extreme conditions to be found at those high altitudes.

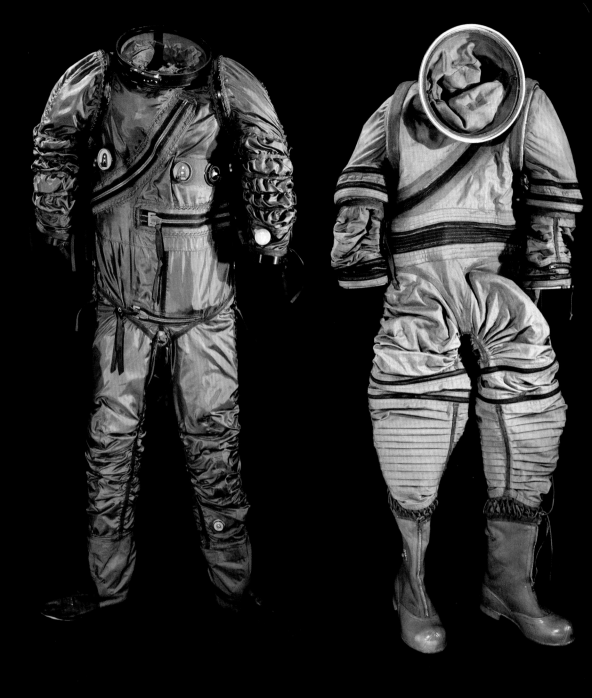

Left to right:

Fig. 1.9
Mark IV
B.F. Goodrich, 1960s
Catalog # 1971-0782-000
SI Image #2003-27305

Fig. 1.10
Mark II – Model "O"
B.F. Goodrich, 1956
Catalog # 1982-0457-000
SI Image # 2004-59968

Fig. 1.11
Mark V – Modified
B.F. Goodrich, 1968
Catalog # 1978-1413-000
SI Image # 2004-59974

Fig. 1.12
Mark II – Model "R"
B.F. Goodrich, 1956
Catalog # 1960-0198-000
SI Image # 2004-61960

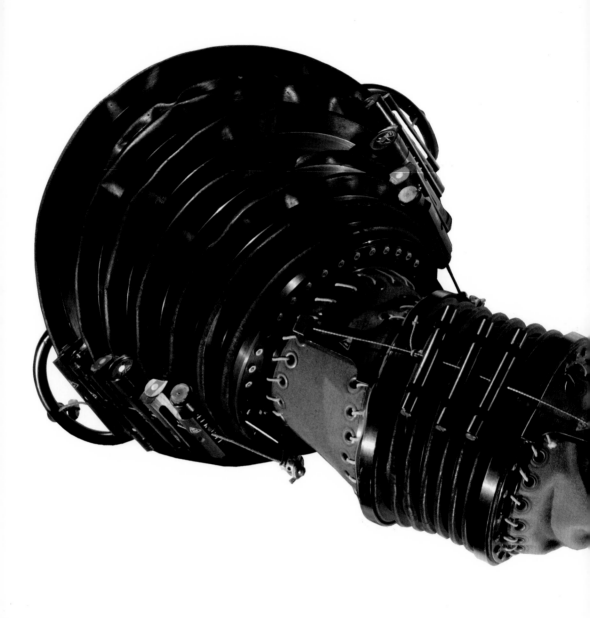

Fig. 1.13
Mark V – Modified Shoulder
B.F. Goodrich, 1968
Catalog # 1980-0041-000
SI Image # 2008-8613

Post never participated in the England to Australia race in 1934 as the supercharger had become damaged and was unable to be repaired in time, and sadly, he and humorist Will Rogers died in an airplane accident in Barrow, Alaska, in August of 1935. Unfortunately, his pioneering contributions to atmospheric dynamics and the development of pressure-suits are seldom remembered.

However, the subsequent years were an active period of pressure-suit development, with a number of people, countries, and organizations generating their own high-altitude and pressure-suit research programs. This led to record-breaking altitude flights throughout the world, which in turn generated improvements in the pressure-suits used. In

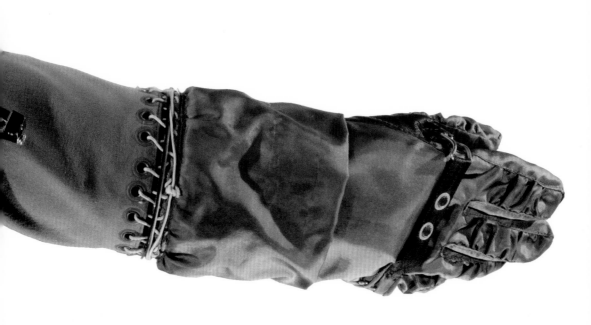

the 1940s, the ability to pressurize the cabin of an aircraft led in turn to the development of the partial pressure-suit. The partial pressure-suit involved the use of "capstans," or tubes running along the arms and down the sides of the torso and legs. In the event of an emergency, these tubes would be inflated generating counter-pressure to the body, slowing down the draining of blood from the head to the lower part of the body, and thus enabling the pilot to get down to a lower altitude—and safety. In the United States, early pressure-suit research and development was undertaken by the US Navy and the US Army Air Corps at their Aero Medical Laboratory at Wright Field in Ohio (later to become the US Air Force Aerospace Medical Research Laboratories). The B.F. Goodrich

Company of Akron, Ohio and the Arrowhead Products Manufacturing Company were active participants during this early period, building on their early work with Post, and working with both the US Army and the US Navy. Russell Colley continued to design and make pressure-suits including the famous "Tomato Worm" suit, further section refinements of which were used in the Apollo spacesuits. The "big three" of spacesuit research and development, The David Clark Company of Worcester, Massachusetts, Hamilton Standard of Windsor Locks, Connecticut, and ILC Industries of Dover, Delaware entered the pressure-suit field in various capacities shortly thereafter.

During the 1950s, the B.F. Goodrich Company's work with pressure-suits ultimately produced a series

of high-altitude, full-pressure-suits under several U.S. Navy contracts. Identified as the "Mark" series, these garments developed from a single layer of rubberized nylon to that of a two-layer construction, with a rubber interior bladder to contain the oxygen and air pressure, and a cover layer of a green, heavyweight nylon—which was primarily for protection of the pressure bladder. Although the earlier versions of these suits had attached rubber boots, in the later models the feet were not usually covered with the nylon layer, and the pilot wore regulation leather boots over the bladder. Gloves, made from a rubber bladder with a nylon and leather cover-layer, with a steel and nylon restraint system to keep them from ballooning and becoming rigid under pressure, were attached to the suit with an aluminum locking ring on the wrist, and a zipper held everything in place.

The B.F. Goodrich series of "Mark" full-pressure-suits was very successful, being lightweight, flexible and relatively comfortable, with numerous models being constructed during the development and working life of the series. A separate series of "Mark" suits was also developed by the Arrowhead Rubber Company, similar in style and color. Both series' of suits were worn by pilots of both the U.S. Navy and the U.S. Air Force, and were used during flight as well as for component modification and testing. In the late 1950s, the U.S. Navy Mark IV became the most successful model of this remarkable series of full-pressure-suits, and it was eventually modified to become the original Mercury spacesuit. The Mark IV suit primarily used the nylon cover layer as its restraint system, though it also included a system of non-stretching tapes, lacing cords, and zippers that were incorporated into the suit and designed to prevent the interior bladder from blowing up like a rigid balloon when pressurized.

The Mark V suit was the last of the series and had additional space for the wearer's movement incorporated into the cover layer. This was in the form of non-stretching tapes for restraint and extra nylon material in the shoulders and joint areas, giving the suit a slightly "puffy" appearance.

Some years later, during the early spacesuit developmental years of Apollo, the Mark V model illustrated (Fig. 1.15) was modified in the shoulder as can be seen. The shoulder joint was a concept of constant potential energy developed by Don Barthlome, and which was later applied to spacesuit design – this joint is also known as the "equal potential joint." The idea was to produce a joint system that maintained an equal volume of pressure on either side of the joint during use—in other words, it didn't change pressure or shape as the wearer moved. This concept afforded the wearer the maximum amount of flexibility while using a minimum amount of physical energy. This particular shoulder mechanism was very flexible and afforded the wearer almost unlimited movement, but the complexity of its configuration, and the materials necessary to make it work led to it having a very short life-cycle, and simpler configurations were developed later for use with spacesuits. Another factor in its not being used or developed further was its large overall size. This was such that three astronauts wearing spacesuits equipped with this mechanism on both shoulders of their suits would together have been too wide to fit into the couches of the Apollo spacecraft!

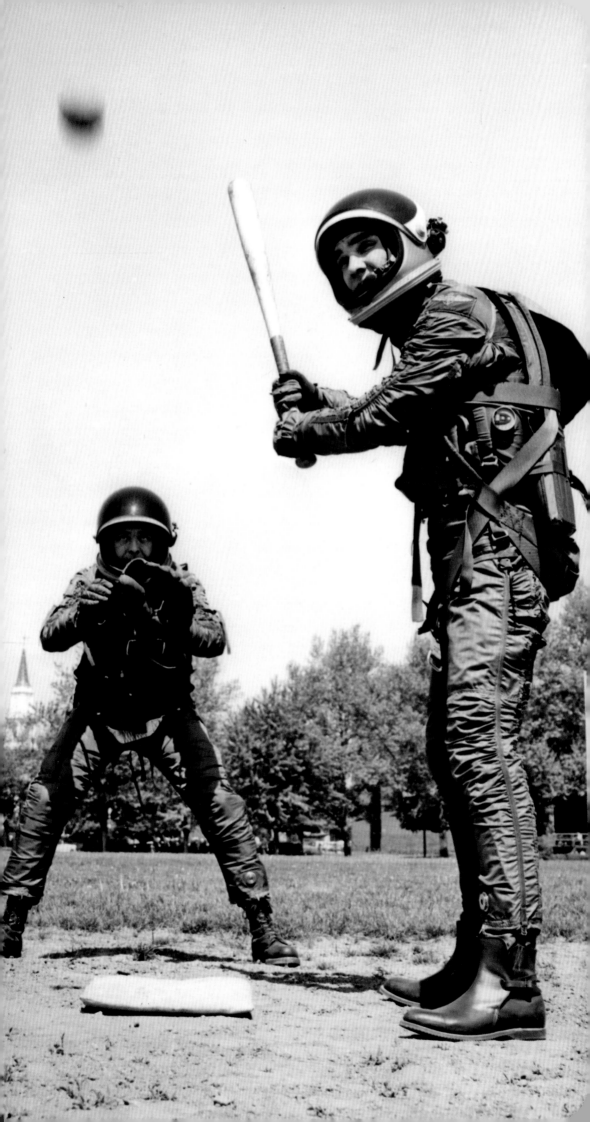

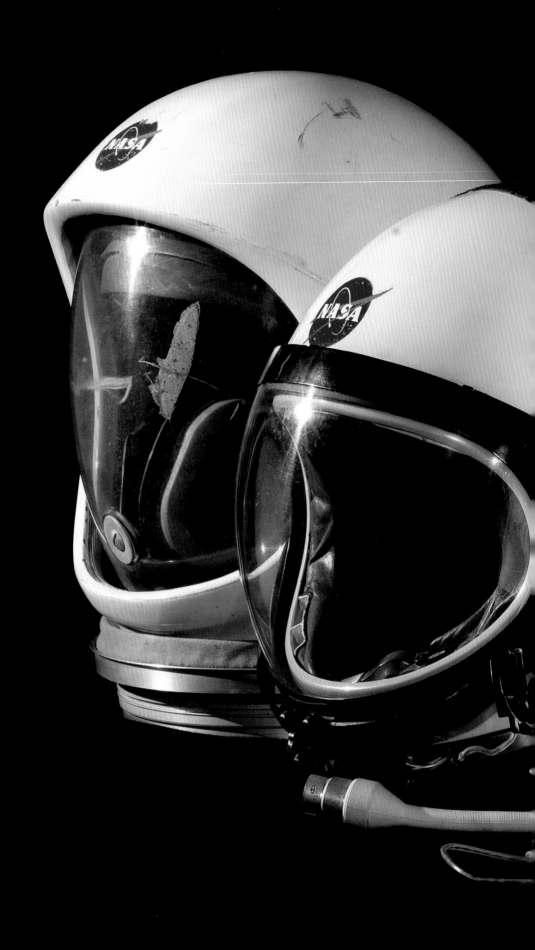

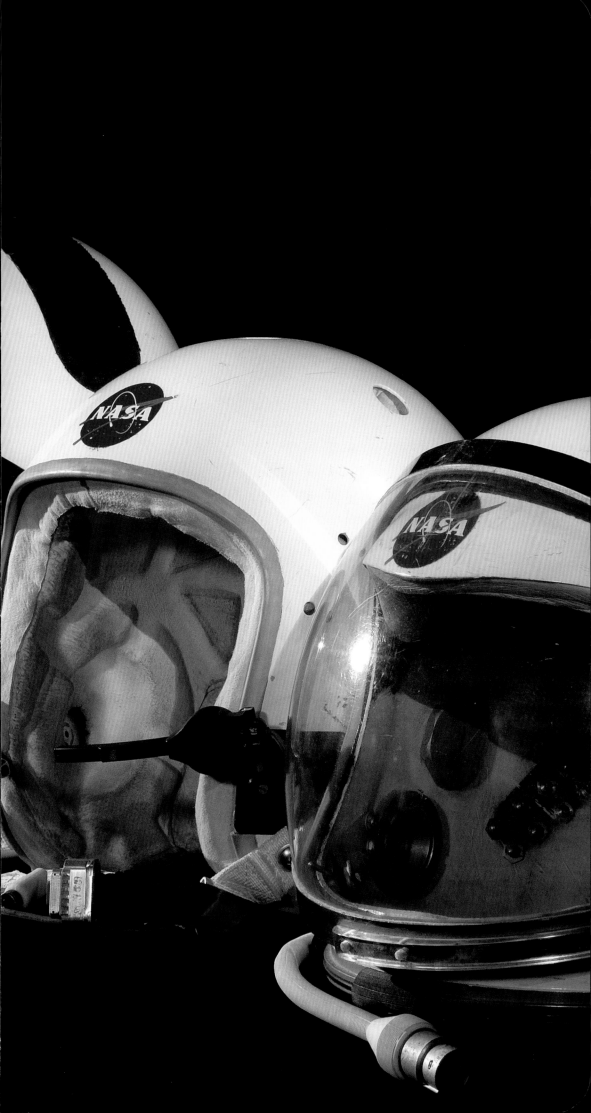

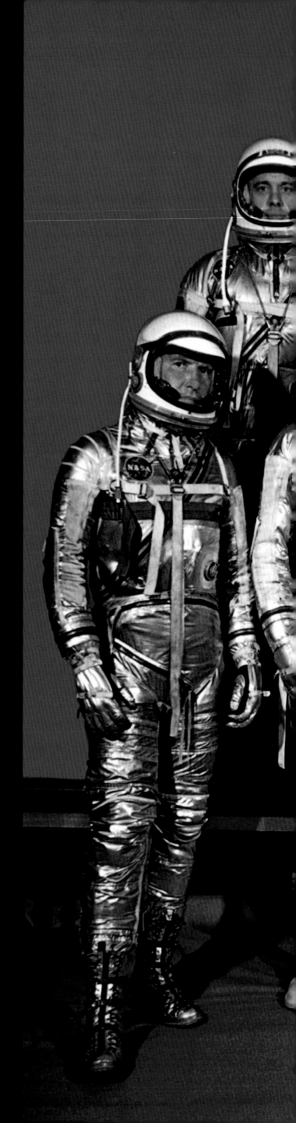

The Mercury program was the first of the United States' manned space programs, and one of the primary goals of this program was to place a spacecraft into an orbital trajectory. Although the Soviet Union's launch of Vostok 1 in April, 1961, with Yuri Gagarin on board had occurred three weeks before Alan Shepard's short suborbital hop in the Freedom 7 spacecraft, the Mercury program and its subsequent five flights proved to be highly successful for NASA, and showed that humans could go into space without undue harm.

In April, 1959, the first group of astronauts was selected by the recently established NASA. They came from a group of 110 military pilots chosen for their physical characteristics and their test pilot experience. Originally identified by NASA as the "Mercury 7," astronauts, Scott Carpenter, L. Gordon Cooper, Jr., John Glenn, Jr., Virgil I. "Gus" Grissom, Walter Schirra, Jr., Alan B. Shepard, Jr., and Donald K. "Deke" Slayton were the first group of astronauts chosen. In later years, when other groups of astronauts were chosen for the continuing space programs, the Mercury 7 were identified as the "Group One" astronauts. With all the "star" status of celebrities, these seven men were ready to do what no man had done before, all the while looking good wearing their wonderful silver spacesuits!

In 1959, NASA selected the B.F. Goodrich Company to fabricate the Mercury spacesuits. They were chosen because of the proven record of the Mark series of full-pressure-suits, and the requirements of the Mercury program. The Mercury suits were essentially "aluminized" (aluminum-coated) versions of the Mark IV high-altitude, full-pressure-suits, with the coating officially chosen for the thermal qualities of a reflective material, though its other qualities are readily apparent.

Like the Mark IV, these suits were of two-layer construction with a pressure bladder and nylon cover layer. Entry was through a long zipper passing across the chest, running from shoulder to waist and around the back. It was worn with a cotton "long-john" type garment underneath, which had Trilock coil spacers

Previous spread:
Fig. 2.1, left to right:

A4-H – Universal
Hamilton Standard, 1964
Catalog # 1973-0811-000

Spd-143-1a Ax1-L Apollo Prototype
ILC Industries, 1963
Catalog # 1973-0841-001

GT-7 – Gemini Protective Helmet
1965
Catalog # 1968-0025-000

Mercury – Training, Schirra
1960
Catalog # 1977-0551-000
SI Image # 2008-8628

Fig. 2.2
Seven Original Mercury
Astronauts
1960
NASA Image # EL-1996-00089
Courtesy of NASA

28 Chapter 2_Mercury

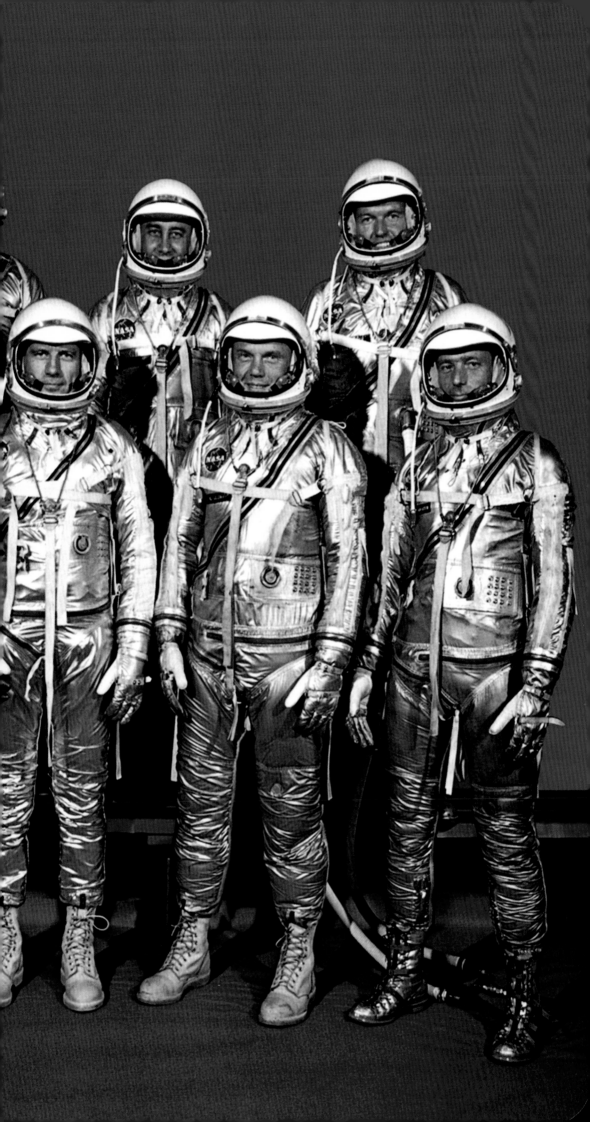

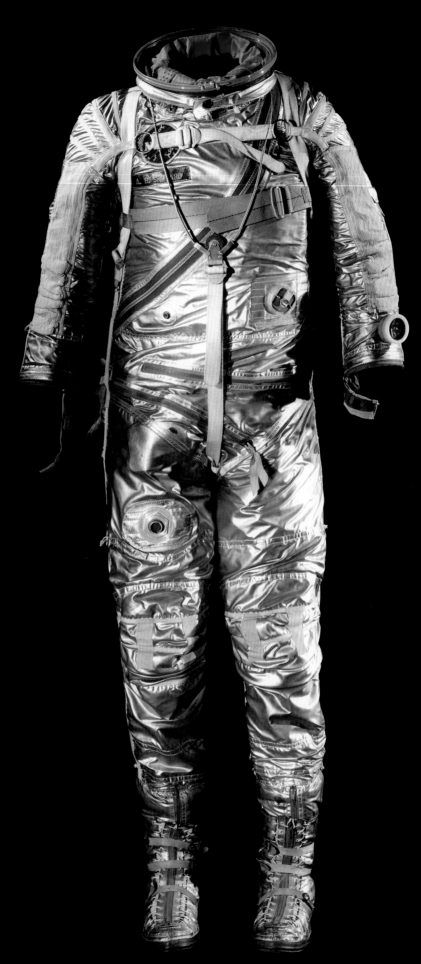

Fig. 2.3
Mercury – Shepard, Freedom 7
B.F. Goodrich, 1960
Catalog # 1977-0563-000
SI Image # 2008-8609 (front), 2008-8610 (back)

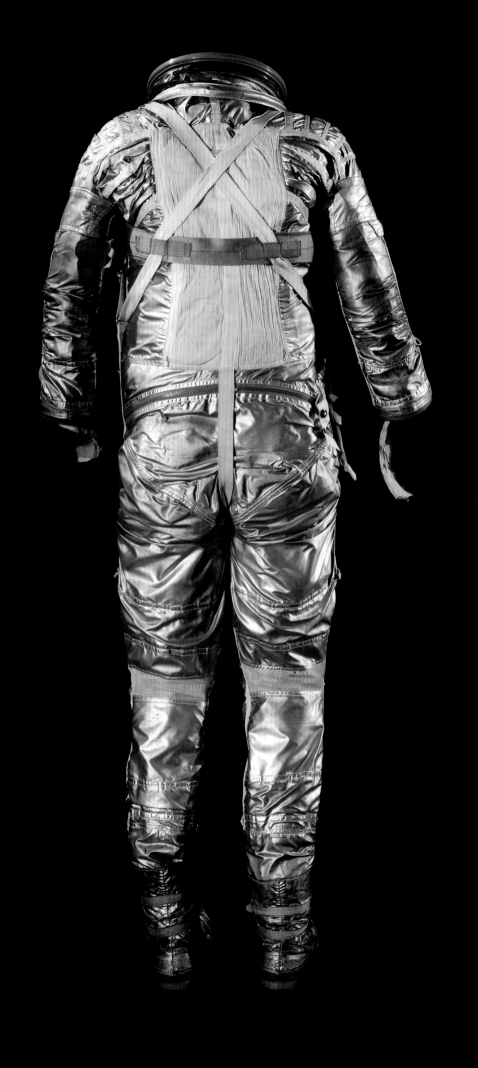

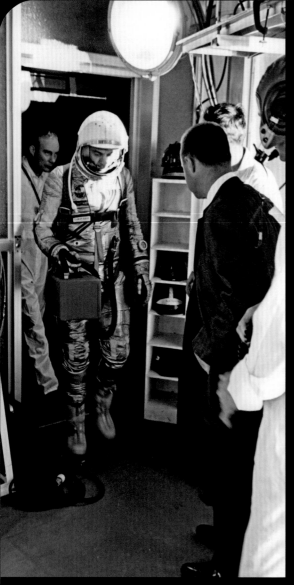

Left:
Fig. 2.4
Shepard About to Board Freedom 7
1961
NASA Image # 61-MR3-69
Courtesy of NASA

Right:
Fig. 2.5
Mercury – Glenn, Friendship 7
B.F. Goodrich, 1961
Catalog # 1967-0178-000
SI Image # 97-15265

in strategic places on the torso, thighs, and upper arms to permit air flow to the skin. The fit was snug. The suit was connected to the spacecraft life support systems with a hose and connector on the chest, through which air was pumped in order to maintain the astronaut's body temperature.

The fabric was made by the Minnesota Mining and Manufacturing Company (3M), and the silver color came from an aluminized powder coating glued to the green nylon fabric used for the exterior layer, prior to suit construction. Unfortunately, during the intervening years, this coating has in most instances, worn away. Many of these early spacesuits now have brown and green patches where the aluminized coating has deteriorated and the glue and nylon have

begun to show through, and give the appearance of being "rusty" (See Chapter 9).

The first series of the Mercury suit (Phase I) were used for training purposes only, and proved to be difficult for the astronauts to move in or to bend their arms while pressurized. Consequently, with the second series of Mercury suits (Phase II), break-lines were sewn into the shoulders, elbows and knees. This change provided the astronauts with more, but still very limited mobility in their shoulders and elbows. The Phase II suits were worn during the first five Mercury missions, (Fig. 2.3) but as the area within the spacecraft cabin was extremely limited and any sort of movement other than the astronaut's arms was difficult anyway, the suit remained un-pressurized

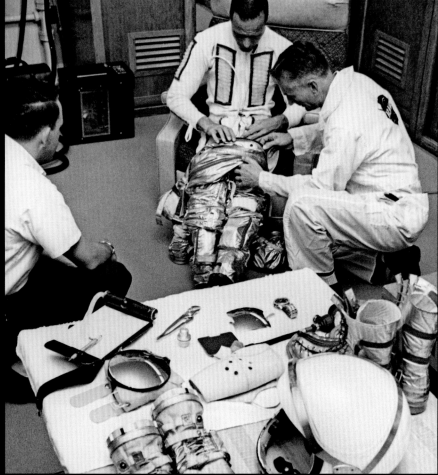

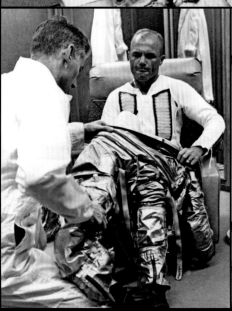

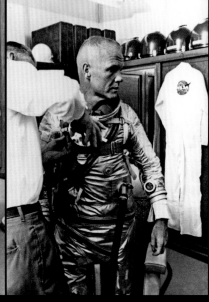

Top:
Fig. 2.7
Carpenter Suiting Up Prior to Aurora 7 Mission
1962
NASA Image # 62-MA7- (unknown)
Courtesy of NASA

Above, left:
Fig. 2.8
Glenn Suiting Up Prior to Friendship 7 Mission
1962
NASA Image # 62-MA6-67
Courtesy of NASA

Above, right:
Fig. 2.9
Glenn Suiting Up Prior to Friendship 7 Mission
1962
NASA Image # 62-MA6-96
Courtesy of NASA

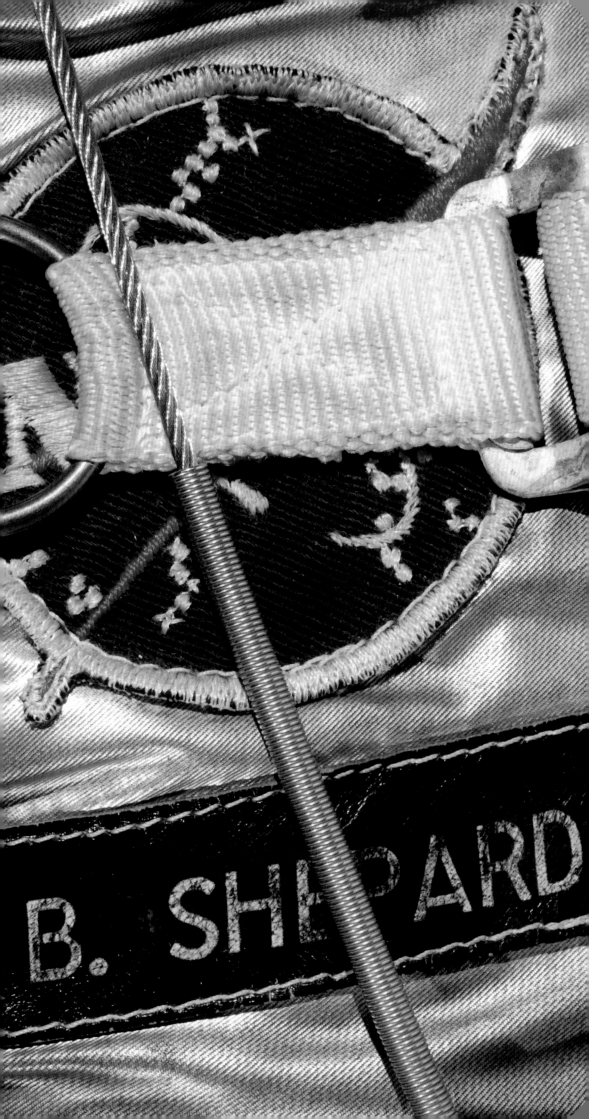

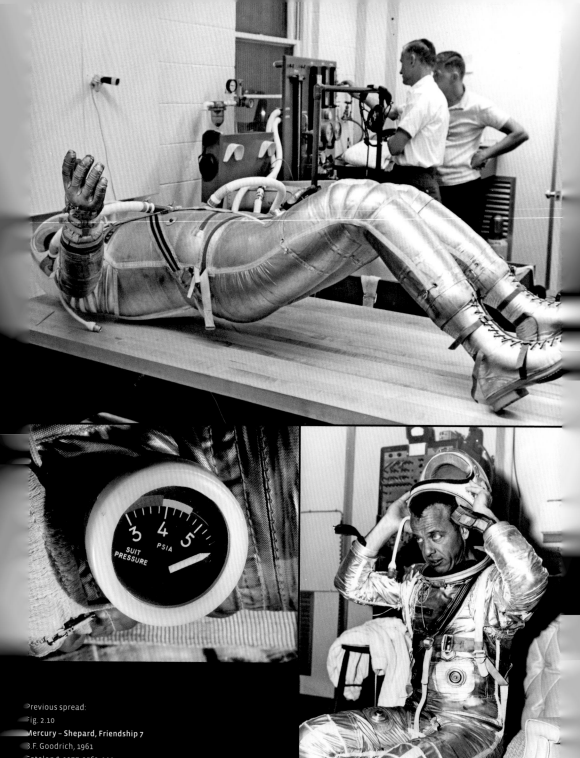

Previous spread:
Fig. 2.10
Mercury – Shepard, Friendship 7
B.F. Goodrich, 1961
Catalog # 1977-0563-000
SI Image # 2008-8625

during most of the mission. This allowed the suit to act as a back-up to the spacecraft life-support systems and would, should those systems have failed, have kept the astronaut alive until splashdown. The suit weighed 22 lb., and was designed to be pressurized to about 4.6 psi, though it was tested to withstand about four times the pressure before bursting.

The four-and-a-half-pound helmet was essentially the same helmet as was used during the Mark V program, close-fitting and made with a hard fiberglass exterior and a leather-covered, shock-absorbent lining, with a communications microphone attached. The "widow's peak" over the forehead of the earlier models (Fig. 2.1 ,front and 2.2) was cut out of most of the Mercury helmets at the astronauts' request prior

to flight, as it "got in the way," and today, few Mercury helmets remain with the "widow's peak" still intact. The boots were not integrated into the suit until the end of the program, and during the early missions were separate components, fitted to the individual astronaut's foot over the suit bladder with lacing and donned and doffed using a zipper system. For the last Mercury mission, Gordon Cooper's Faith 7 flight in May, 1963, the suit shoulders were modified to permit his arms a little more freedom of movement and relative comfort during his 34-hour, 22-orbit mission. The boots, which were less structured and more flexible than the earlier style of boots, were attached to the suit.

The success of the first six manned Mercury

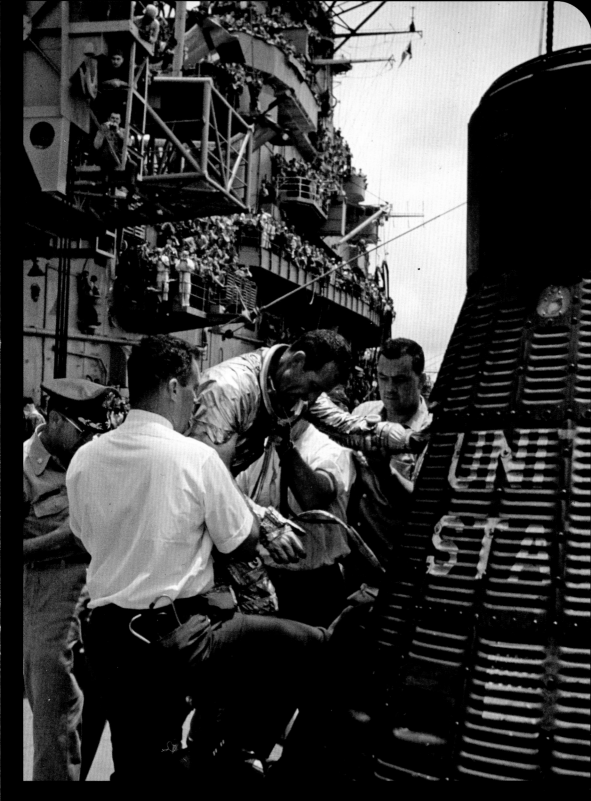

missions proved that the launch vehicles could lift a spacecraft into orbit and be safely returned to earth, and that astronauts could live, eat, and perform experiments in space. The Mercury program had also demonstrated that a world-wide network of communications was essential to spaceflight, and that the astronaut was a critical part of the mission's success. After Cooper's flight, these realizations enabled NASA officials to cancel the seventh flight, so as to proceed expeditiously to the Gemini program.

Opposite, top:
Fig. 2.11
Mercury – Pressure Test of Shepard's MR-3 Suit
1961
NASA Image # MA-615-25
Courtesy of NASA

Opposite, bottom left:
Fig. 2.12
Mercury – Pressure Gauge, Shepard, Friendship 7
1961
Catalog # 1977-0563-000
SI Image #2008-8627

Opposite, bottom right:
Fig. 2.13
Mercury – Shepard, Suiting Up Pre-flight

1961
NASA Image # S-63-2079
Courtesy of NASA

Above:
Fig. 2.14
Mercury – Cooper's Return from Faith 7 (MA-9) Mission
1963
NASA Image # 63-MA9-103
Courtesy of NASA

Following spread:
Fig. 2.15
Mercury – Carpenter Walking to Transfer Van for Aurora 7 (MA-7) Mission
1962
NASA Image # 62-MA7-92B
Courtesy of NASA

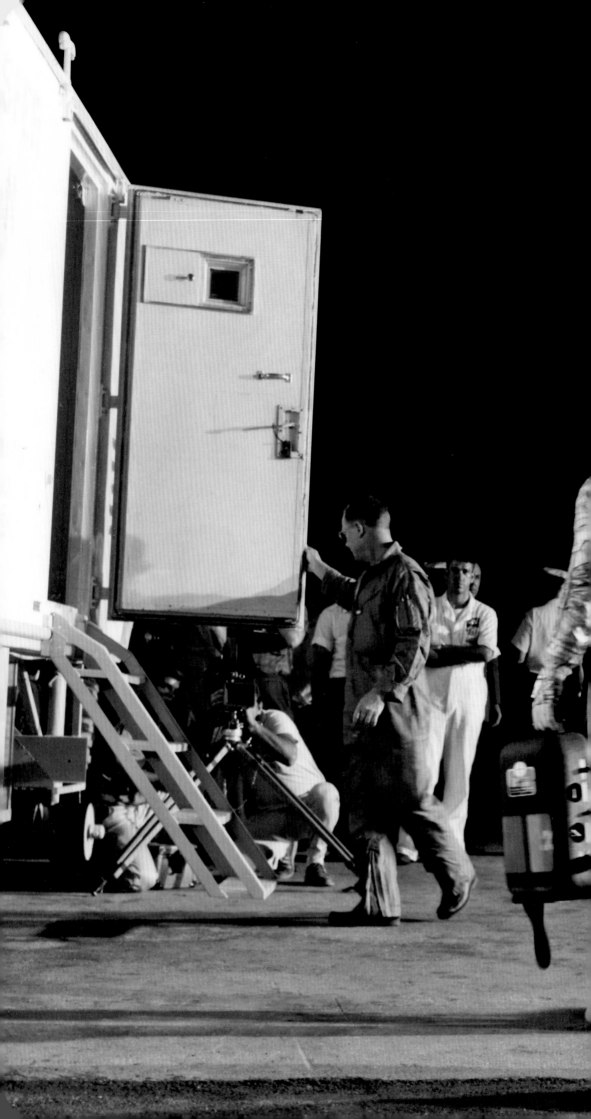

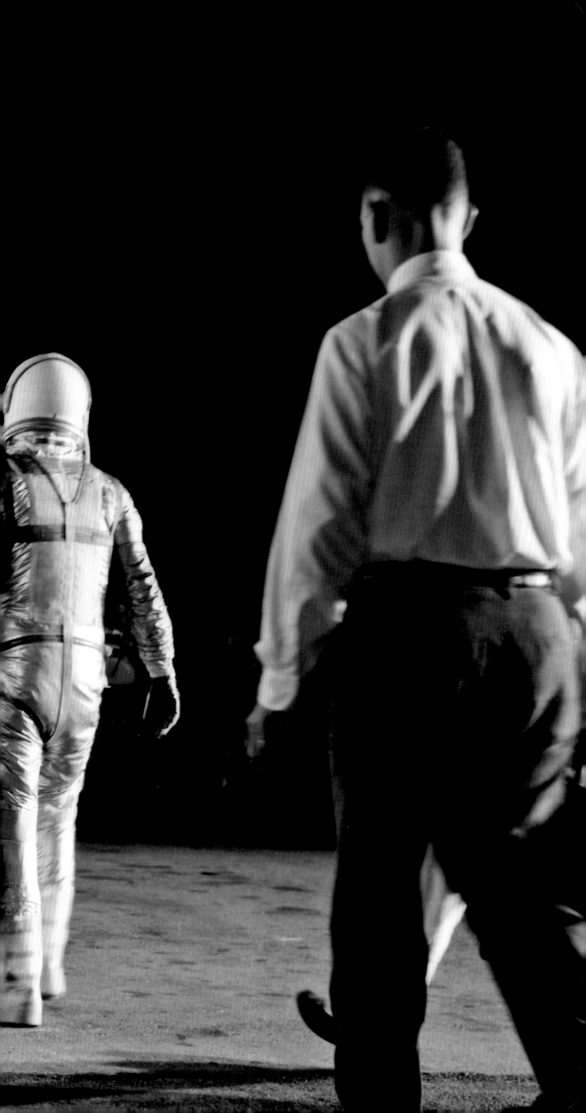

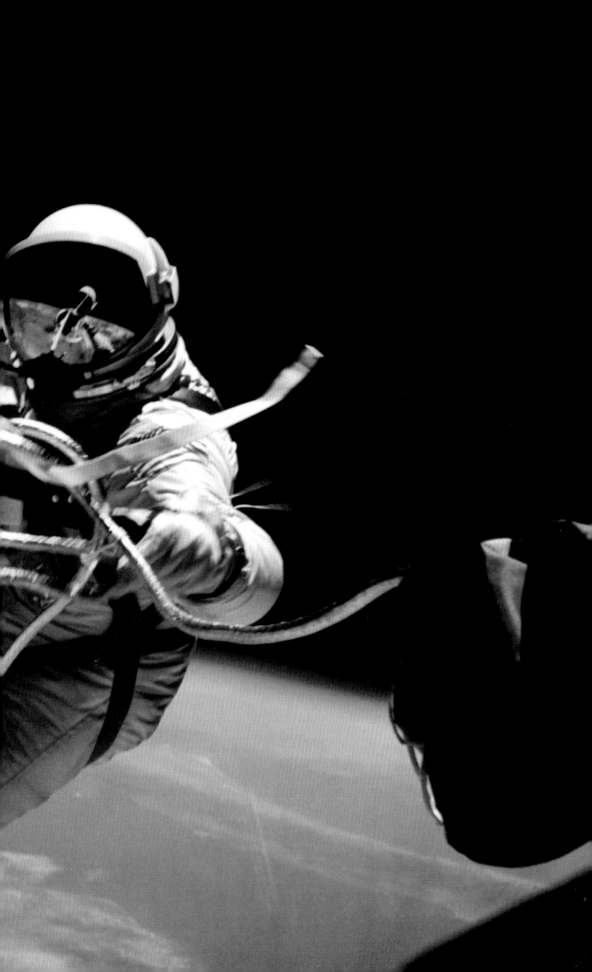

To meet Kennedy's goal of landing a man on the Moon and returning him safely to the Earth, NASA had long realized that an intermediate program between Mercury and Apollo was necessary. The Gemini program (1965–66), second of the U.S. manned space programs on the way to the moon, was announced in January, 1962, and like the Mercury program was also noted for its many "firsts." Gemini called for two astronauts in the capsule to test spacecraft systems, orbital maneuvering, rendezvous and docking, and extra-vehicular activity (EVA or "space walking"). An equally important requirement was to establish the medical effects of long-duration spaceflight. As with the previous Mercury missions, the Gemini missions were placed into orbit from Cape Canaveral, Florida,

but used the Titan II launch vehicle, a much larger ballistic missile than the Redstone or Atlas. It was during these missions that American astronauts got their first real experience at living, working, and maneuvering in space.

One of the primary objectives of the Gemini program was the successful rendezvous and docking of two spacecraft, which had to be achieved if the Apollo spacecraft was ever going to be able to dock with the lunar landing vehicle, separate, and then redock again after a landing on the moon. The Gemini missions proved that this would be possible when, in December, 1965 during Gemini VI, two spacecraft came close but never touched—followed by Gemini VIII in March, 1966 when actual docking with another

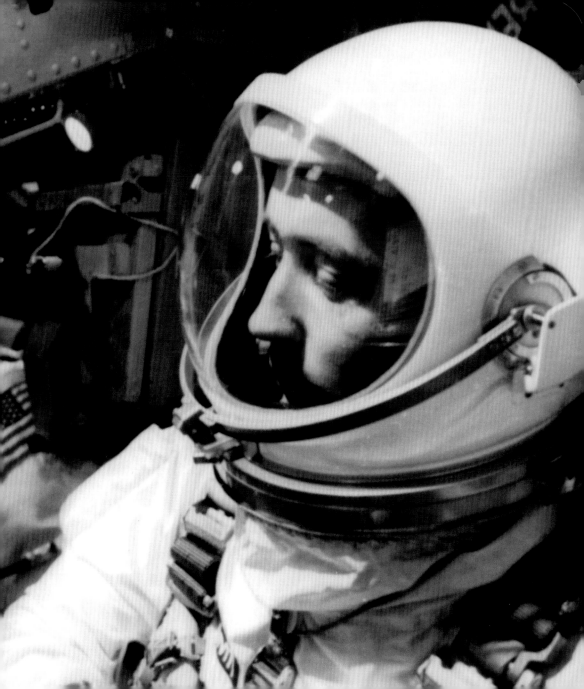

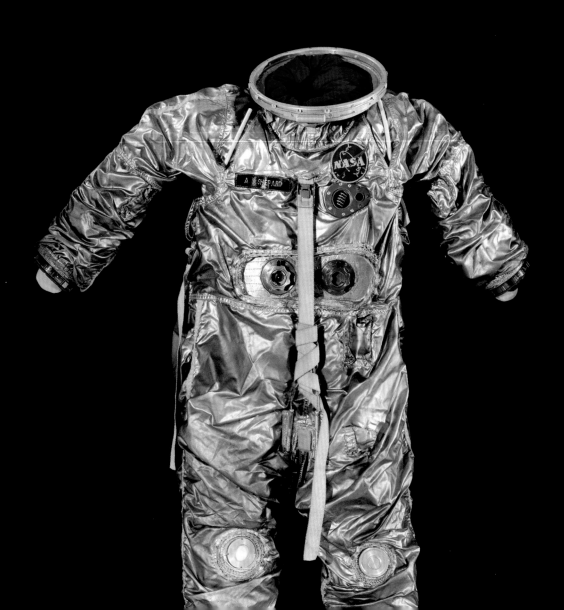

Opposite:
Fig. 3.3
G2-G – Shepard
B.F. Goodrich, 1962
Catalog # 1969-0036-000
SI Image # 2004-19149

Right:
Fig. 3.4
G2-C – Slayton, Developmental/Training
1964
Catalog # 1973-0854-000
SI Image # 2004-10874

Bottom, left to right:

Fig. 3.5
G4-C – Modified Thermal Cover Layer
David Clark Company, 1965
Catalog # 1985-0266-000
SI Image # 2004-19141

Fig. 3.6
G4-C – Cernan, Gemini 9
Pressure garment only, cover-layer used for
post-flight destructive testing
1965
Catalog # 1968-0439-000
SI Image # 2004-19139

Fig. 3.7
G3-C – Grissom, Gemini 3
David Clark Company, 1964
Catalog # 1968-0456-000
SI Image # 2004-44628

Fig. 3.8
G3-C – Young, Gemini 3
David Clark Company, 1964
Catalog # 1973-0226-000
SI Image # 2004-61966

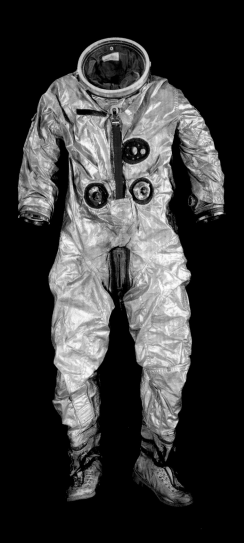

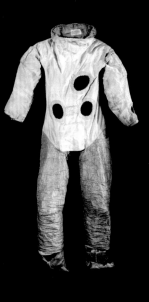
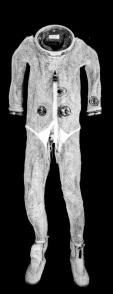
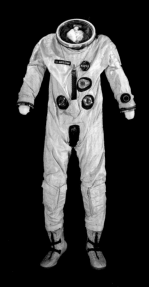
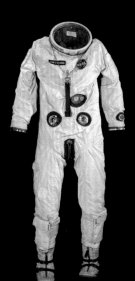

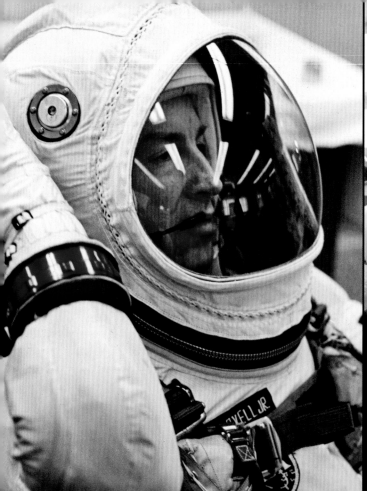

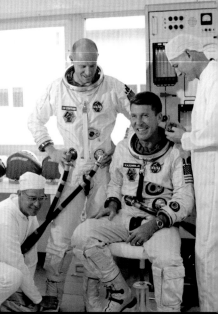

Left:
Fig. 3.9
Astronaut Jim Lovell Suited Up and Ready for Gemini 7 Mission
1965
NASA Image # 65-HC-1042
Courtesy of NASA

Above:
Fig. 3.10
Astronauts Stafford (Left) and Schirra (Seated)
Suiting Up Exercises Prior to Gemini 6
1965
NASA Image # S65-56190

astronauts, as it only had half as much cabin space as the Mercury! Gemini called for the astronauts to perform a variety of different operations from those of the Mercury program, including the ability to live and perform tasks in cramped quarters for extended periods of time, and also do "spacewalks" outside the spacecraft, which initially proved to be more difficult than expected. Those difficulties included controlled movement for the astronauts while outside the spacecraft, and their re-entry into the spacecraft.

Historically, the Gemini missions have some-times been considered "routine," and without some of the "pizzazz" of the Mercury and Apollo programs. However, they were critical to the objective of get-ting a man on to the moon, and by the end of the

Gemini program, US astronauts had totaled almost a thousand hours of spaceflight. The accomplishments achieved and information gained during this series of missions enabled the Apollo program to move forward with such remarkable speed, ultimately con-tributing to its great success, and it is a little known fact that the Gemini Program pushed the US space program ahead of the Soviet one.

The Gemini program requirements therefore called for a new spacesuit. In April of 1962, the Manned Spacecraft Center in Houston awarded contracts to B.F. Goodrich, with a similar contract being given to Arrowhead Products Division of Federal-Mogul Corporation and Protection Inc. for the design, devel-opment and fabrication of two separate pressure-suit

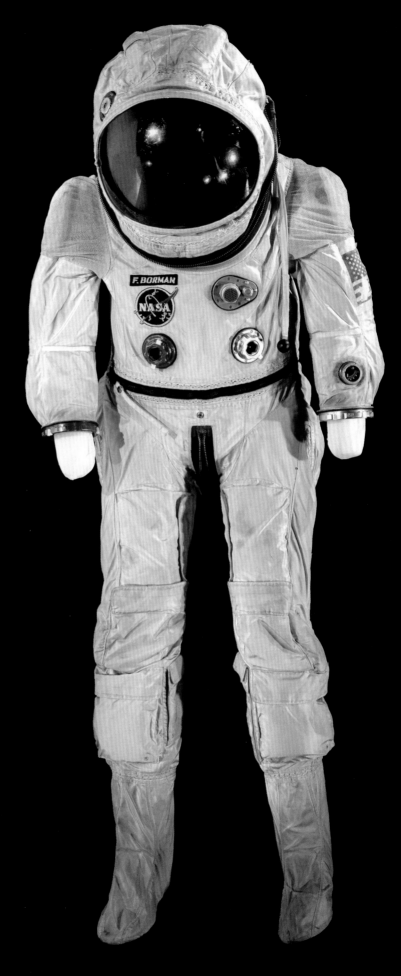

Fig. 3.11
G5-C – Borman, Back-up
David Clark Company, 1965
Catalog # 1972-1159-000
SI Image # 2002-32829

systems, though neither was mentioned as part of any particular NASA program. However, in September, 1962, the B.F. Goodrich contract was amended to identify the program specifically with Gemini. In January, 1963, the final G2-G model made by B.F. Goodrich (Fig. 3.3) was delivered to the Manned Spacecraft Center. This G2-G model was later rejected by NASA in favor of a suit designed independently by the David Clark Company, which incorporated a B.F. Goodrich helmet, gloves, and additional hardware. These early Gemini developmental suits were silver in color with the same aluminized coatings as the Mercury spacesuits, and were similar in appearance. In fact, the official photographs from the early Gemini program show the astronauts wearing these suits (Fig. 3.21).

Note: (G = Gemini, 2 = second in the series, G = B.F. Goodrich Company) and the G2-C model made by the David Clark Company, (G = Gemini, 2 = second in the series, C = David Clark Company, Inc.)

In June, 1963, the David Clark Company of Worcester, Massachusetts, was awarded the contract for the Gemini spacesuits with their G2-C model (Fig. 3.4), and the development of the second series of Gemini suits was put into production. At this point, it appears that the B.F. Goodrich Company went out of the spacesuit business as such, though it later worked with Hamilton Standard on the development and construction of spacesuits in 1964-65.

The contract for the Gemini spacesuit was signed on June 13, 1963, and called for the design and construction of a suit able to function in some very specific mission-oriented situations. This was the first time that the spacesuit was considered the prime system required to sustain life. Redundancies had to be built in to make certain of this, while still ensuring that while pressurized, the astronaut would have an adequate degree of mobility with low levels of fatigue. Additionally, the suits were required to have an acceptable level of micro-meteoroid protection, astronaut visibility, and maintenance of body temperature in the extreme heat and cold of space. The astronaut had to be able to wear the suit continuously while un-pressurized for 14 days with some degree of comfort, and function adequately when pressurized to 3.7 psi.

A second model made by the David Clark Company, had multiple layers and removable legs and arms. This suit style developed into a one-piece, full-pressure-suit of multiple-layer construction, with the entry through a pressure-sealing zipper running down the back of the suit, from the neck, under the

Fig. 3.12
G4-C Helmet – Collins, Gemini 10
David Clark Company, 1966
Catalog # 1968-0437-001
SI Image #2002-6985

legs, and finishing just above the crotch. It required the astronaut to put his feet in first and pull the suit up as far as possible, then bend over and put his arms into the suit and his head through the neck opening and then stand up. At that point, a technician would close the zipper and attach the helmet and gloves, which used sealed connecting rings with sealed bearings.

As the size of the Gemini spacecraft did not permit the astronauts to remove the spacesuit completely during the flight, comfort was of major importance, and it is believed that the Gemini spacesuit was surprisingly comfortable. The spacesuit was made with a nylon comfort layer closest to the skin, and a pressure bladder of a neoprene rubber compound. A layer of looped material called Link-Net, patented by David Clark, was integrated over the bladder as part of the restraint system, which prevented the suit from "ballooning" when pressurized. The Link-Net and exterior layers of these suits were made with a high-temperature-resistant nylon (HT Nylon) later to be called Nomex. Nomex is a long-chain molecule developed by DuPont that has extraordinary heat-and flame-resistant properties, and can be used either in sheet or honeycomb form, or as a woven fabric. It has a very high degree of fire-resistance, and has since been used in other applications, such as protective clothing in motor racing and for Fire and Rescue operations. Between the exterior cover-layer and the bladder were layers of Mylar interleaved with layers of Dacron to provide insulation. Mylar is a very lightweight, highly reflective polymer, used for thermal insulation. When interleaved together with layers of Dacron which provides air spacers between the layers, the resulting "sandwich" provides a lightweight cover-layer with highly efficient thermal and micro-meteoroid insulation qualities. These spacesuits were given the model identification numbers of G2-C by NASA, and were the first of the white suits, although the early versions still had attached silver boots.

The ability of these suits to function as required and permit the astronauts to perform the more difficult tasks while pressurized became a major focus of both NASA and the David Clark Company, such that the suit's weight and flexibility were as important as the use of the heat-resistant and flame-retardant protective materials. Three models of Gemini flight-suits were developed: the G3-C (Fig. 3.7 and 3.8) and G4-C (Fig. 3.22) and for the long-duration Gemini VII mission, the G5-C (Fig. 3.11). The G4-C came in two configurations:

Top, left:
Fig. 3.13
G4-C Helmet – Conrad, Gemini 5
David Clark Company, 1965
Catalog # 1968-0452-001
SI Image #2002-13949

Top, right:
Fig. 3.14
G3-C Helmet – Schirra, Gemini 6
Modified to A1-C for Eisele training
David Clark Company, 1964
Catalog # 1068-0442-001
SI Image #2004-26001

Middle, left:
Fig. 3.15
G3-C Helmet – Grissom, Gemini 3
David Clark Company, 1964
Catalog # 1968-0456-001
SI Image #2004-42980

Middle, right
Fig. 3.16
G4-C Helmet – Cooper, Gemini 5
David Clark Company, 1965
Catalog # 1968-0447-001
SI Image #2005-5991

Bottom, left:
Fig. 3.17
G4-C Helmet – Stafford, Gemini 6 and Gemini 9
David Clark Company, 1965
Catalog # 1968-0444-001
SI Image #2005-5992

Bottom, right
Fig. 3.18
G3-C Helmet – Young, Gemini 3
David Clark Company, 1964
Catalog # 1973-0226-001
SI Image # 2005-7557

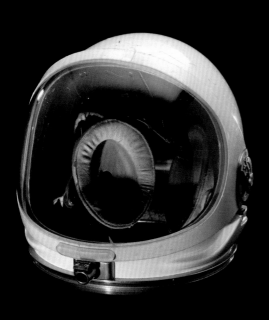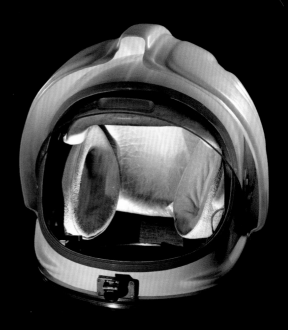
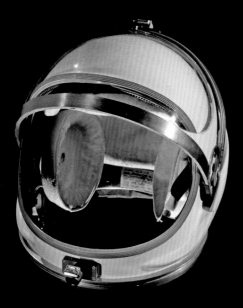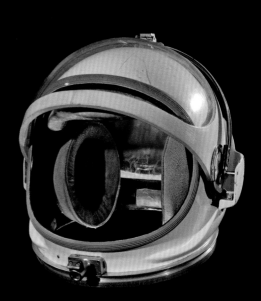
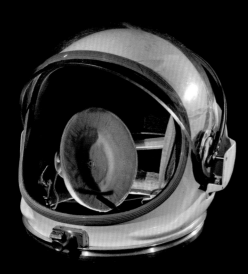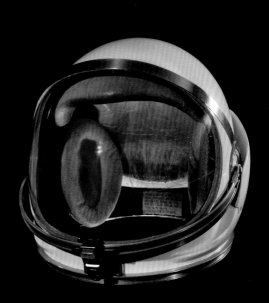

the IV or Intra-Vehicular style, designed to be worn only by the astronaut who remained in the spacecraft, and the EV or Extra-Vehicular model, designed to be worn by astronauts whose mission included going outside the spacecraft during "spacewalks." Both configurations had an interior layer consisting of the nylon comfort layer, an incorporated ventilation duct network and a neoprene-rubber bladder with Nomex Link-Net as part of the restraint system, and an exterior insulating layer that included aluminized Mylar with Dacron spacers to provide insulating air pockets between the layers. The IV configuration had fewer layers of insulation than the EV model which had an additional seven layers of aluminized Mylar with Dacron spacers, along with an additional layer of

HT-Nylon (uncoated Nomex) to protect the astronaut from micro-meteoroids while outside the spacecraft. The IV configuration of the Gemini spacesuit weighed 34 lb. here on earth, and the EV model, with its additional layers of insulation, weighed 47 lb., though that weight includes the life support umbilical.

The G3-C, G4-C and G5-C models of these spacesuits were used during the Gemini missions and like the Mercury suits, maintained the astronauts' body temperature with forced air. An air hose connected the suit to the spacecraft's environmental control systems, through which cool air was forced. This gentle air flow passed through nylon-coil tubes within the spacesuit, thus preventing the astronaut from overheating.

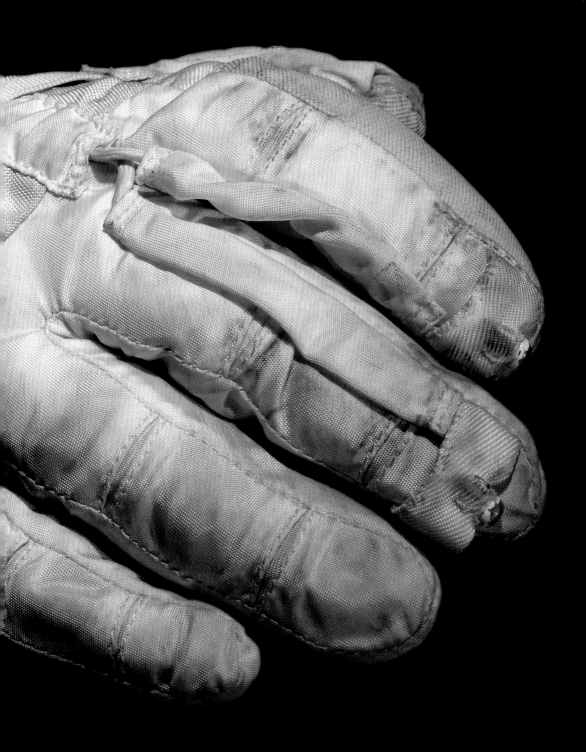

The Gemini suits used a modified version of David Clark's style of military pressure-helmet. These were made of fiberglass and epoxy, with a moveable pressure-visor, sheepskin inner comfort lining, and suede ear-pads, with two small microphones attached to the front sides for communications. Unlike the Mercury helmet however, the Gemini helmet had a visor lever (Bailer bar) with a positive locking mechanism to lock and seal the visor in place against a helmet-mounted static seal, rather than the pneumatic seals used on earlier helmets (including Mercury). This was for added astronaut safety during spacewalks in the vacuum of space, which places considerable additional pressure on the visor.

Although the Gemini suits were classified as

Fig. 3.19
G4-C Glove
David Clark Company, 1965
SI Image # 2008-1865

"soft" suits, and were relatively comfortable in the shorter term, they were not considered to be comfortable enough for the astronauts to wear for extended periods of time. Thus for the two-week, long-duration Gemini VII mission in December 1965, the spacesuits worn by Frank Borman and Jim Lovell were redesigned and fitted with integrated "soft" head enclosures. In developing this more comfortable spacesuit, NASA and David Clark made the decision to trade a certain amount of mobility and visibility while pressurized, for the longer-term comfort while un-pressurized. The G5-C suit was the result, and was affectionately known as the "Grasshopper" suit. It weighed approximately 12 lb., and included a large integrated "soft" head enclosure, under which was worn a protective "flight" helmet. A semi-rigid polycarbonate visor was integrated into the soft enclosure, which gave the appearance of a large grasshopper eye, hence the name (Fig. 3.11). A pressure-sealing zipper was incorporated into the soft head enclosure to enable its opening for greater comfort and visibility during flight. These lightweight suits were made with a neoprene bladder and an exterior layer of Nomex fabric with a Link Net restraint layer, covered by knitted Nomex in the shoulders for improved mobility. A simplified system of vent channels was integrated with the restraint system and bladder to minimize weight and bulk. This spacesuit was only used during this one mission and was, all things considered, fairly comfortable.

A second Gemini suit that was only used on one mission is the suit worn by Eugene Cernan on Gemini IX in June, 1966. His G4-C suit was modified with the addition of a covering of Chromel-R metal fabric on the legs. During the mission he was to have tested the Astronaut Maneuvering Unit (AMU), and a layer of Chromel-R was added to the legs of his spacesuit to provide additional protection from the AMU hot rocket-plume exhaust. However, during the spacewalk his visor fogged up to the point where he had no visibility at all, and there were some difficulties with communications and maneuverability. As a result he had a great deal of trouble re-entering the spacecraft. This proved that air cooling alone was not sufficient to keep the astronaut's temperature within normal bounds during periods of extreme exertion. However, as a result, Cernan was never able to test the AMU and in fact the AMU was not used again until Skylab 3, when astronaut Jack Lousma tested it in the Skylab dome. Following the Gemini IX mission, Cernan's spacesuit cover-layer was removed by NASA for testing, and only the pressure garment was transferred to the National Air and Space Museum. The cover-layer he used during training was transferred at a later date (Fig. 3.6 and 3.7).

Top, left:
Fig. 3.20
Astronauts Young (Left) and Grissom (Right) Ready for Gemini 3 Mission
1965
NASA Image # unknown
Courtesy of NASA

Top, right:
Fig. 3.21
Astronauts (Left to Right) Young, Grissom, Schirra, and Stafford in Early Gemini Suits with Portable Suit Air Conditioners
David Clark Company, 1964
NASA Image # S 64-19432
Courtesy of NASA

Bottom:
Fig. 3.22
Astronaut Ed White During First U.S. Spacewalk, Gemini 4
1965
NASA Image # S 65-30433
Courtesy of NASA

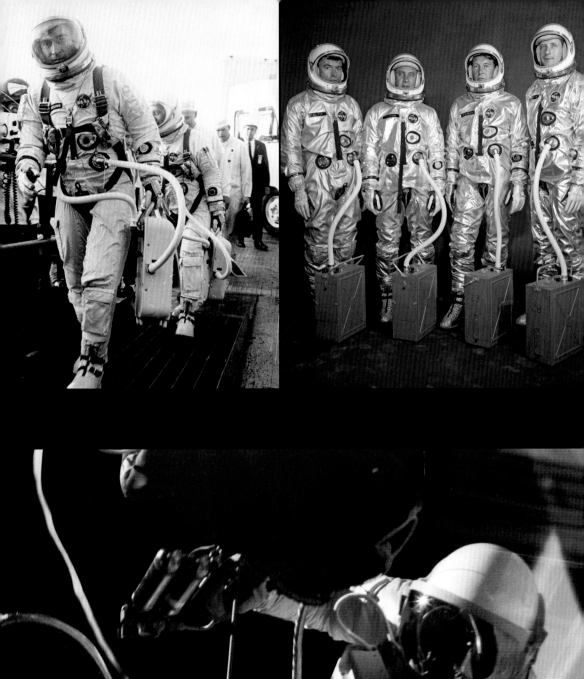
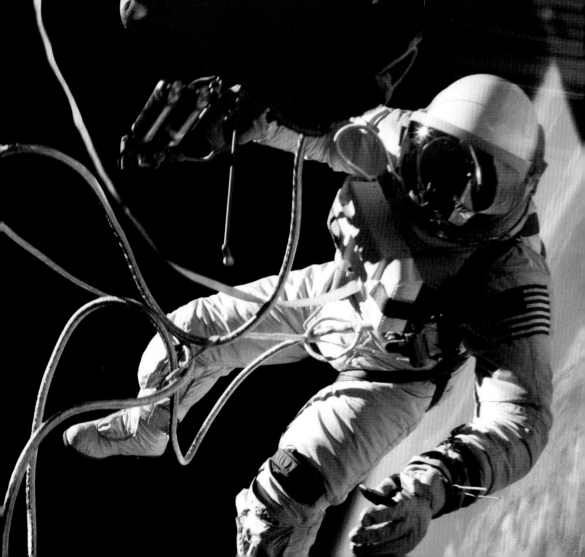

Chapter 4_Manned Orbiting Laboratory (MOL)

Fig. 4.1
RX-3 – MOL Prototype
Litton Industries, 1965
Catalog # 1982-0435-000
SI Image #2002-27180

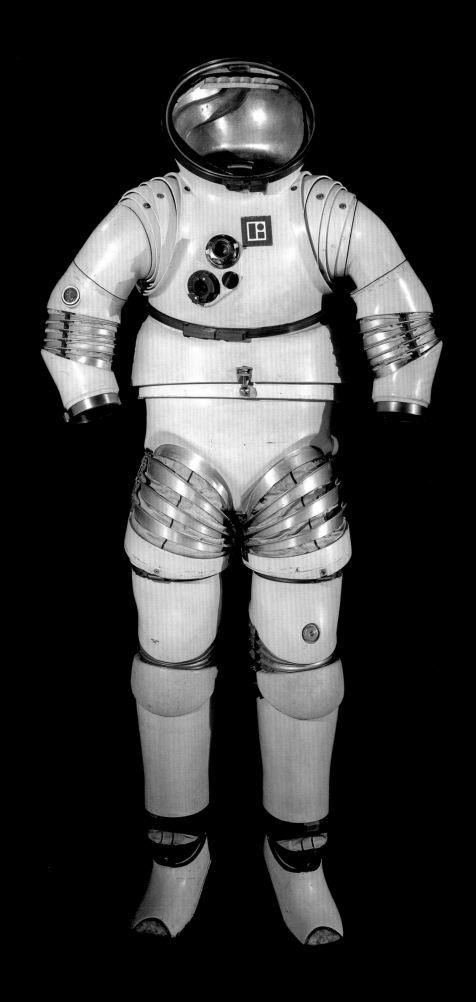

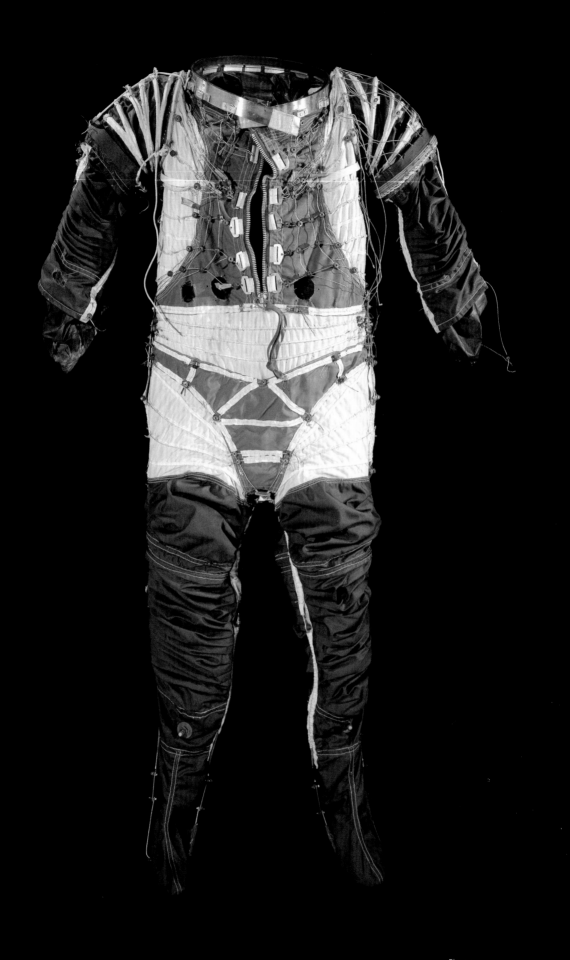

Fig. 4.2
XT-3 – MOL Prototype
Hamilton Standard, 1965
Catalog # 1980-0039-000
SI Image #2004-60885

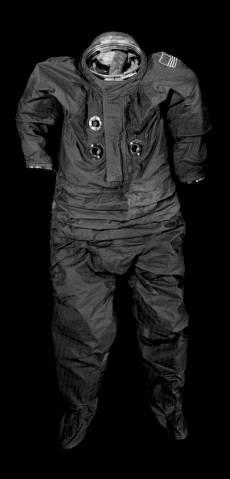

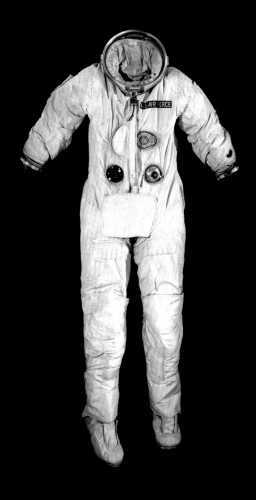

Fig. 4.3
MD-3 – Developmental
Liquid Cooling Garment
David Clark Company, 1966
Catalog # 1985-0334-000
SI Image # 2004-48738

Above, left:
Fig. 4.4
MH-5 – First MOL Training Configuration
Hamilton Standard, 1967
Catalog # 1977-1018-000
SI Image # 2004-10867

Above, right:
Fig. 4.5
MD-1 – MOL Prototype
David Clark Company, 1966
Catalog # 1985-0219-000
SI Image # 2004-25835

The Manned Orbiting Laboratory (MOL) was a Department of Defense (DOD) space station program of the 1960s. From its earliest days, the US Army Air Corps, which later became the United States Air Force (USAF), had been involved in advanced aircraft development and had provided support, personnel, and technical expertise to the National Advisory Committee for Aeronautics (NACA). The NACA in turn, would become a key element in the later creation of the National Aeronautics and Space Administration (NASA). In addition to advanced aircraft and reusable spacecraft development, the USAF was also involved in the development of the pressure-suits needed for these programs, and over the years some significant suit improvements came from these collaborations.

In 1963, Defense Secretary Robert McNamara of the Kennedy administration asked the USAF to develop a smaller and less costly space station than the programs currently envisioned by NASA. The program, called the Manned Orbiting Laboratory (MOL), finally received formal approval from President Lyndon Johnson in 1965, and the original intent of the program was defensive in nature. MOL was to be an orbital, space-based laboratory, launched into polar orbit from Vandenberg Air Force Base in California, and equipped with earth-looking cameras for military reconnaissance purposes. The polar orbit would allow the station to routinely over-fly all regions of the earth, including the Soviet Union.

The concept was to use existing designs and

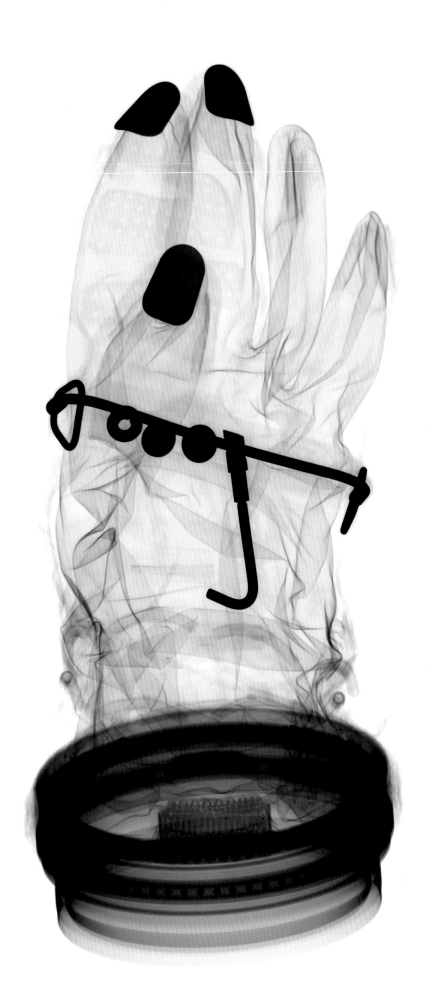

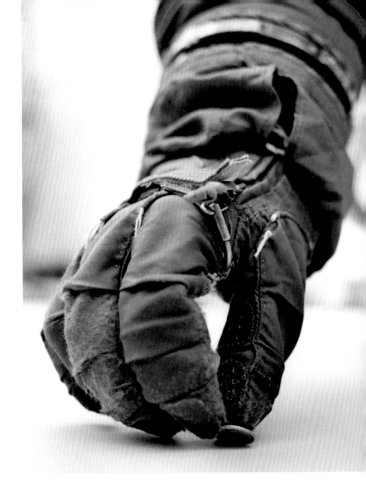

Opposite:
Fig. 4.6
MH-7 Glove – Radiograph Image
Ron Cunningham and Mark Avino, 2008
Catalog # 1985-0101-000
SI Image # 2008-1856

Fig. 4.7
MOL Pressurized Mobility Demonstration
1968
HS Image # 08-0495-002
Courtesy Hamilton Sundstrand and Gary Harris

hardware wherever possible, and would have a two-man crew who could remain in the laboratory for up to four weeks. The crew would launch and reenter in a modified Gemini capsule that attached to the laboratory, conduct scientific experiments along with their military reconnaissance duties, and their time aboard would also have provided information on the ability of humans to survive in space for long durations. After the crews' time in the laboratory, they would transfer back to the spacecraft and return to earth.

The program called for use of Gemini spacecraft and Titan III launch vehicles—similar to the hardware used during the Gemini program. The laboratory would be controlled from the ground, and the missions of 14 to 28 days would require that the crew would go to and from the laboratory as needed. However, budget problems associated with the escalating costs of the war in Vietnam, and advancements in robotic satellite technology along with the classified NRO reconnaissance satellites, caused the MOL program to be cancelled in 1969 by President Richard Nixon.

Fourteen pilots (they were not officially called "astronauts"), were selected for the MOL program. To

Opposite:
Fig. 4.8
MH-7 Glove – MOL
Showing stainless steel "fingernails"
Hamilton Standard, 1969
Catalog # 1985-0101-000
SI Image # 2008-1875

Top:
Fig. 4.9
MH-7 Gloves – MOL
Hamilton Standard, 1969
Catalog # 1985-0101-000/001
SI Image # 2002-32840

Bottom:
Fig. 4.10
MH-7 Glove – MOL
Showing sharkskin grip-pads
Hamilton Standard, 1969
Catalog # 1985-0101-000
SI Image # 2008-1870

increase safety during launch and return, plus allow the pilots to perform spacewalks, the MOL program was to include spacesuits, and from 1963 to 1966, the USAF used left-over spacesuits from its X-20 program. The first known completed "MOL spacesuit" was a prototype (XT-2) made by Hamilton Standard in 1964.

In 1964, Hamilton had put together a "Tiger Team" under the direction of Dr. Edwin Vail, who was a consultant working with Wright-Patterson Air Force Base. This research and development program produced the first series of prototype suits by Hamilton, known as the Experimental Tiger (XT) suits. While XT development initially supported the Apollo program, the third XT prototype (XT-3) was specifically designed to address MOL issues (Fig. 4.2), though after its initial build, the XT-3 was used for later mobility and entry concept evaluations. At this point, Hamilton was the prime contractor for the suit portion of the Apollo program, and was producing A5-H and A6-H suits with B.F. Goodrich.

Note: Earlier, the International Latex Corporation (ILC) had developed the Apollo A1-H through A4-H suit configurations under contract to Hamilton. In 1965, Hamilton and B.F. Goodrich produced a suit for the

ADVANCED SPACE SUITS

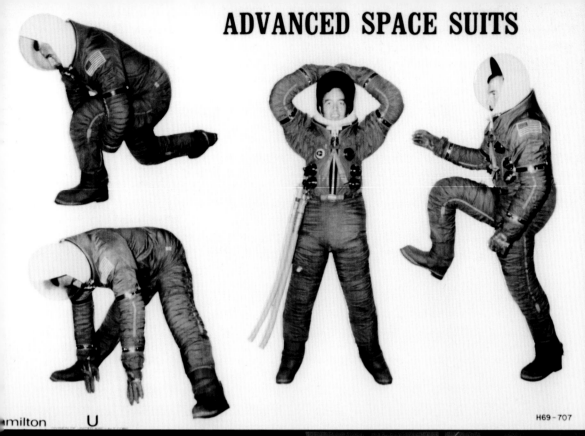

Above:
Fig. 4.11
MOL – Mobility Demonstration
Hamilton Standard, 1968
HS Image # ECA 27284 D
Courtesy of Hamilton Sundstrand

Right:
Fig. 4.12
XM2-A – MOL Prototype
Unassisted zero-G don-doff demonstration
Hamilton Standard, 1967
HS Image # ECA 36500 D
Courtesy of Hamilton Sundstrand

Opposite:
Fig. 4.13
MOL – Mobility Demonstration
Hamilton Standard, 1968
HS Image # ECA-27284 D
Courtesy of Hamilton Sundstrand

Apollo competition, which lost, removing Hamilton from the pressure-suit side of the Apollo program. In late 1965, Hamilton funded Goodrich for a MOL-specific prototype, called at the time "the Demo Suit." This appears to have been the last time Hamilton and BFG worked together on spacesuits.

In 1966, the USAF purchased four David Clark (DC) MOL prototypes, and seven (possibly more) evaluation suits from ILC. The four DC prototypes came in two configurations (Fig. 4.5), with each configuration customized for two evaluators. The ILC evaluation suits were essentially Apollo suits equipped with high-altitude pressure connectors. Also in 1966, Hamilton internally funded the creation of two prototypes,

the XM-1A and XM-2A, and made them available for USAF evaluation. The results of the testing flowed into program requirements that would be used in a competition.

As a cost-saving measure, the MOL spacesuits were more "standardized" than the NASA suit requirements, where each suit was fitted to the individual astronaut. The MOL suits were to be made in eight standard sizes, with individualized sizing ability (in the form of lacing) for final fit—and were to be able to be worn both inside and outside the spacecraft—IEVA (intra- and extra-vehicular activity) suits. In January, 1967, the USAF held a competition to choose the spacesuit best suited to their program needs, the winner to be awarded the contract to deliver

SUIT CAPABILITY

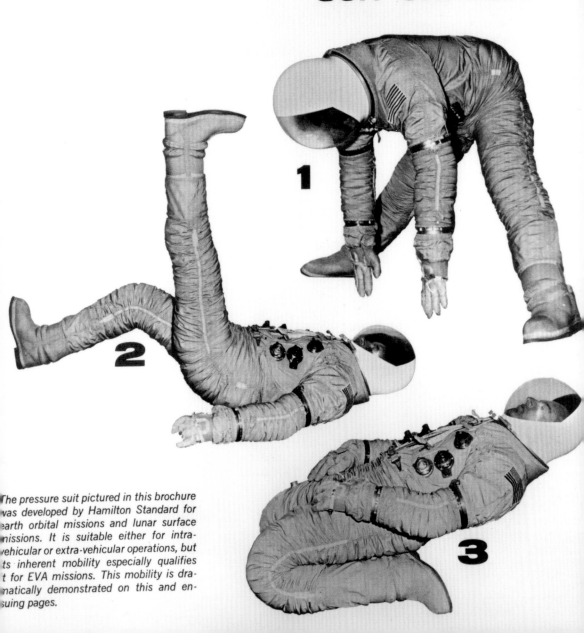

The pressure suit pictured in this brochure was developed by Hamilton Standard for earth orbital missions and lunar surface missions. It is suitable either for intra-vehicular or extra-vehicular operations, but its inherent mobility especially qualifies it for EVA missions. This mobility is dramatically demonstrated on this and ensuing pages.

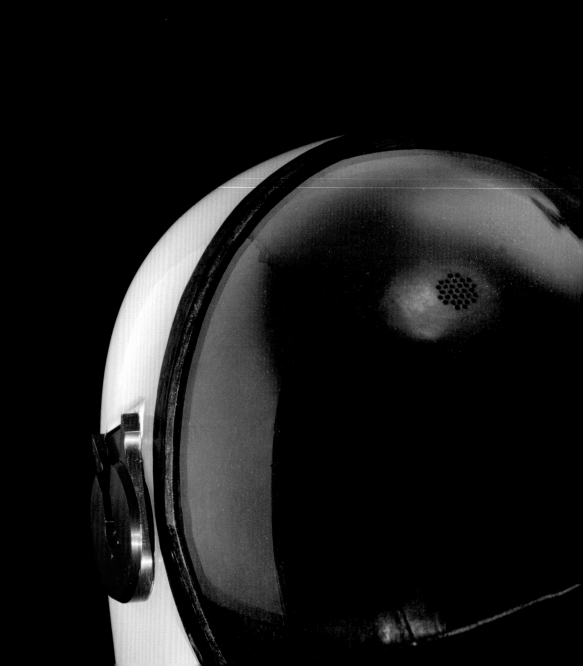

had a white beta-cloth outer layer over alternating layers of aluminized Mylar and scrim-cloth, whereas the MH-5 cover garment was of layers of blue nylon, replicating the bulk of the MH-6 cover garment. Both styles of outer garment had a single, larger, front zipper flap and longer sleeves that covered the arm bearings. Both configurations became obsolete in 1968 when the USAF requested connector and control changes, which resulted in the MH-7 training and MH-8 configurations. The MH-6 suit in the National Collection was modified to a later connector and control arrangement in 1968 to support the development of the MH-8 model.

At least seventeen MH-7 training suits were made and delivered between May 1968 and July 1969. The MH-7 weighed in at approximately 37 lb., and the only significant change from the MH-5 beyond the connectors and controls revisions on the front of the torso was that the MH-7 suits featured plain, blue nylon cover garments, with exposed entry-zipper and arm bearings.

The MH-8 flight configuration featured an Emergency Oxygen System (EOS) interface in/on the right leg, a manually adjustable 3.7 psi pressure controller in the lower-left position of the suit's front, and a pressure gauge on the left forearm. The suit was also slightly heavier, coming in at 38 lb. for the IV configuration, a little over 39 lb. for the EV configuration, and a total of 52.6 lb. with the Umbilical Life Support system in place. The location of the only known MOL MH-8 suit successfully certified for flight before the end of the program is unfortunately unknown.

The helmet was a simple polycarbonate "bubble," similar to those eventually used during the Apollo program. The main differences between the MOL and Apollo pressure bubbles were that on the MOL helmets, the non-vision areas were painted white to provide thermal insulation, and they had a higher airflow in the vent duct system. This prevented fogging, and permitted improved carbon dioxide removal.

In 1966, the USAF launched the only MOL flight, which was unmanned. Although the MOL suits never saw programmatic use, they are all remarkable pieces of equipment. After the program was cancelled in 1969, a number of the HS production suits were transferred to NASA, and were in turn transferred to the Smithsonian Institution. Also transferred were the ILC, Litton, Hamilton Standard, and three of the four David Clark prototypes. The fourth David Clark prototype is in private hands, and the B.F. Goodrich MOL prototype was cannibalized for parts and no longer exists.

Fig. 4.14
MOL Helmet
Hamilton Standard, 1968
Catalog # 1973-0859-001
SI Image # Image # 2002-12400

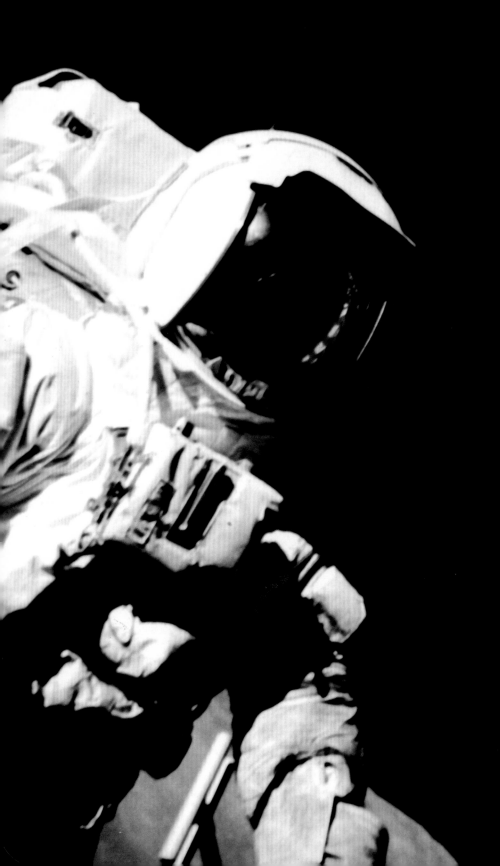

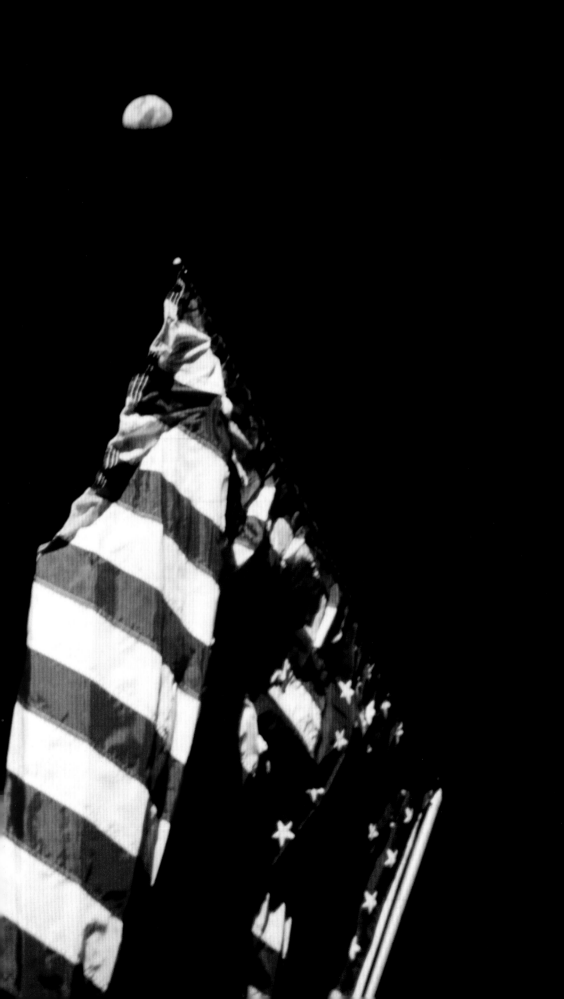

Previous spread:

Fig. 5.1

Astronaut Harrison "Jack" Schmitt Stands Beside the Flag, Apollo 17

1972

NASA Image # AS17-134-20834

Courtesy of NASA

Fig. 5.2

Edwin "Buzz" Aldrin's Bootprint, Apollo 11

1969

NASA Image # AS11-40-5877

Courtesy of NASA

By the time the first manned Gemini mission was launched in 1965, NASA's planning for the Apollo missions was already well along. The Apollo program called for three astronauts to launch and re-enter in the Command Module, two of whom would descend to the lunar surface in a Lunar Module, while one astronaut would remain in the spacecraft orbiting the moon. The first manned Apollo mission was launched in October 1968 and the landing followed in July 1969.

Once again, the new program required the astronauts to perform different tasks from either Mercury or Gemini, and this new program's requirements called for more advanced spacesuits and life-support equipment. Development of a spacesuit to be worn during the Apollo missions had begun during the Gemini program, and went in several directions, none of which resolved all the issues surrounding NASA's requirements. For that reason in 1962, NASA held a competition for an Apollo prototype spacesuit. David Clark and Hamilton Standard submitted prototypes to NASA who worked with the designs over the subsequent two years. However, following two years of testing and use, the level of suit mobility experienced with these suits did not meet NASA's expectations or requirements, and therefore, a second competition was announced—to be held in June, 1965.

Three suits were submitted in the 1965 competition, made by the David Clark Company (AX1-C), Hamilton Standard and B. F. Goodrich (AX6-H), and ILC Industries (AX5-L). ILC Industries had been primarily involved in the development and manufacture of bras and girdles (International Latex), prior to winning the various contracts to design and manufacture high-altitude pressure-suits for the Air Force in the late 1950s. Following that, they were designing and making the soft parts and restraint systems of spacesuits under contract to Hamilton between 1962 and 1965. They had manufactured the A4-H spacesuit under contract to Hamilton Standard during the early 1960s (Fig. 5.8), but this was the first time they were being considered for the role of prime contractor. Their AX5-L soft suit was ultimately selected, and ILC became the prime contractor for the Apollo suit program. Hamilton Standard continued to make the life-support systems, while the Air-Lock Corporation continued to make the fittings as subcontractors.

The first spacesuits worn on the moon in 1969 were a subsequent version of this AX5-L competition

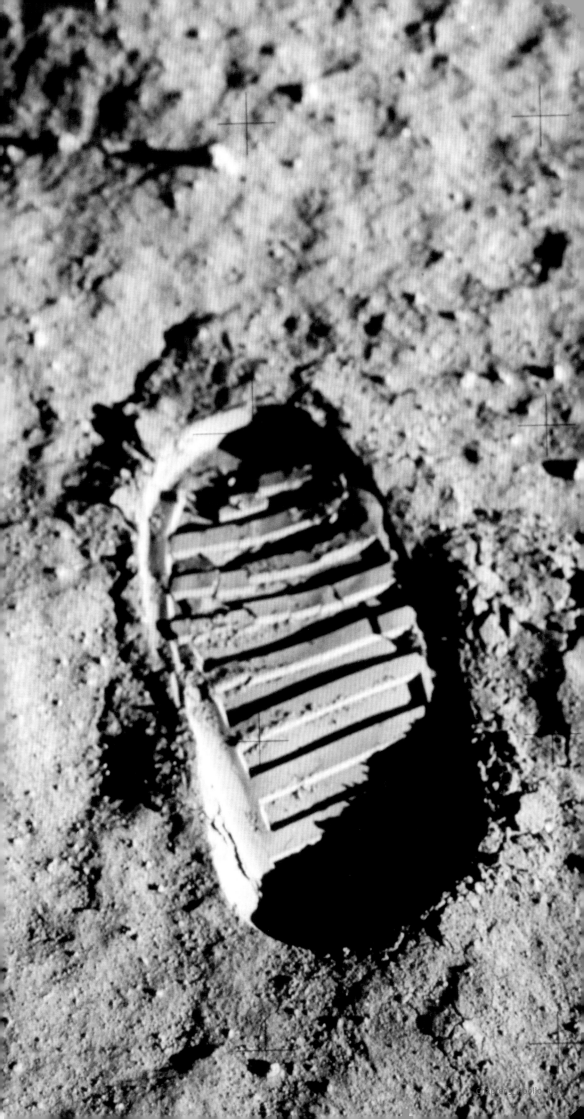

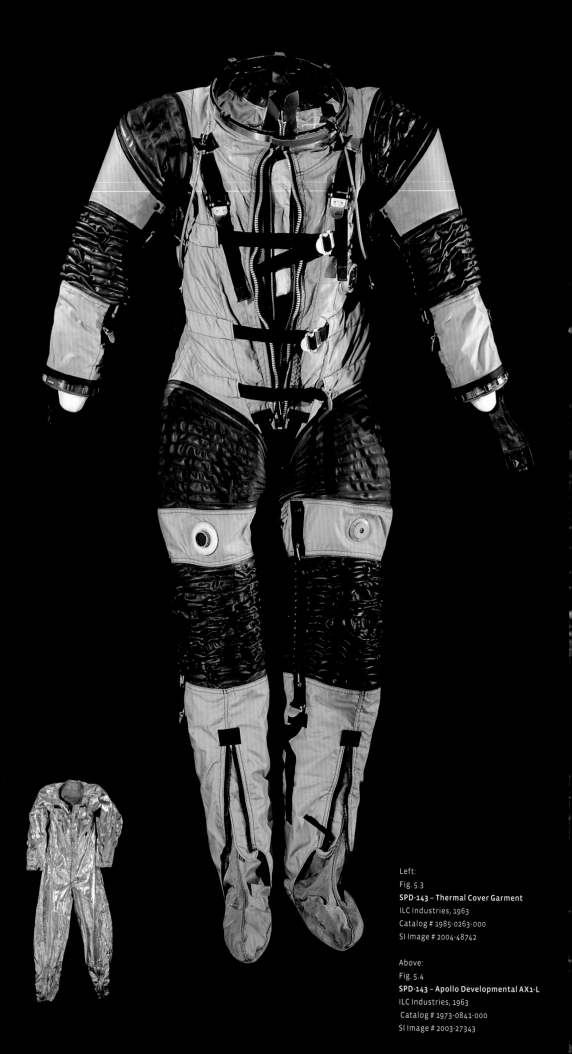

Left:
Fig. 5.3
SPD-143 – Thermal Cover Garment
ILC Industries, 1963
Catalog # 1985-0263-000
SI Image # 2004-48742

Above:
Fig. 5.4
SPD-143 – Apollo Developmental AX1-L
ILC Industries, 1963
Catalog # 1973-0841-000
SI Image # 2003-27343

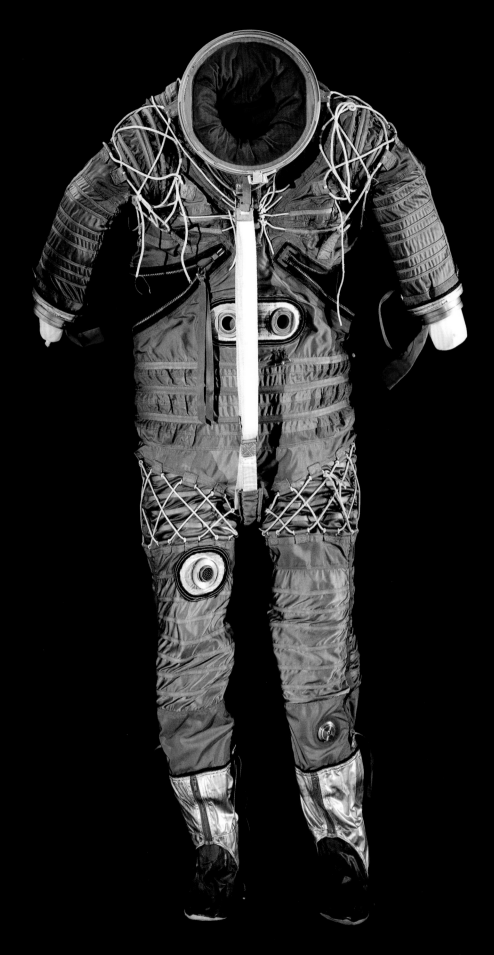

Fig. 5.5
XN-20 – Apollo Prototype
B.F. Goodrich, 1964
Catalog # 1979-1335-000
SI Image # 2003-27345

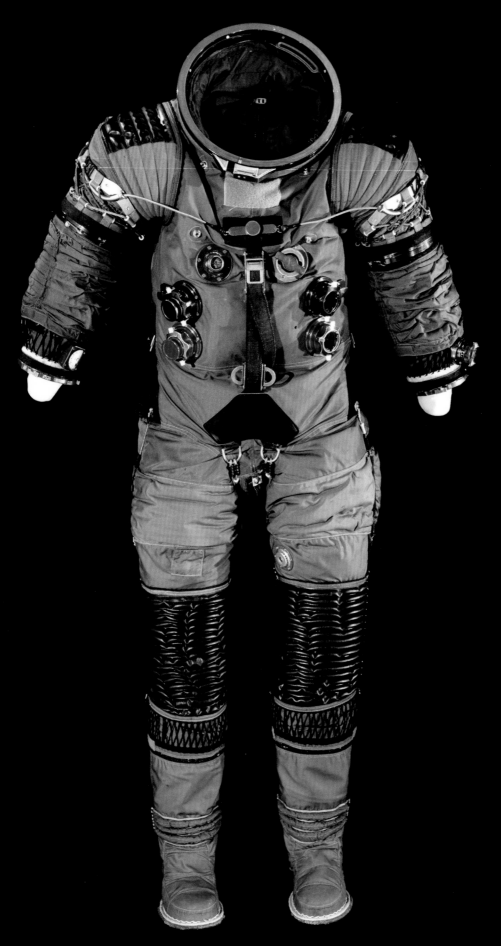

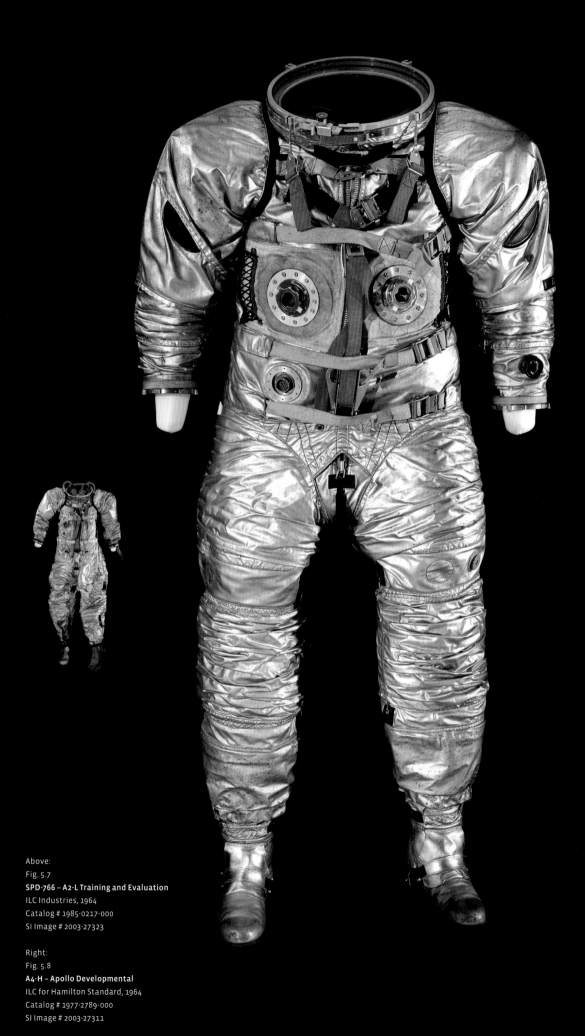

Above:
Fig. 5.7
SPD-766 – A2-L Training and Evaluation
ILC Industries, 1964
Catalog # 1985-0217-000
SI Image # 2003-27323

Right:
Fig. 5.8
A4-H – Apollo Developmental
ILC for Hamilton Standard, 1964
Catalog # 1977-2789-000
SI Image # 2003-27311

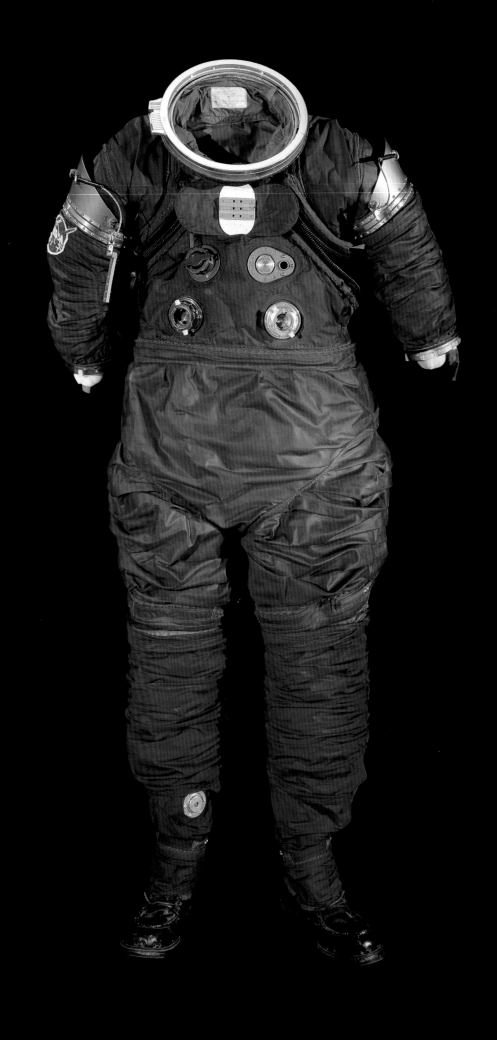

suit, and had the NASA designation A7-L (A = Apollo, 7 = seventh in the series, L = ILC Industries, Inc.). These suits were a far cry from the suit worn by Wiley Post in 1934 and also much more costly to produce. However, fixing an accurate cost per suit is extremely difficult and something of a "moving target." Not including the original R&D costs, and as after each mission NASA-required changes were incorporated into the suits for the next and/or subsequent missions, the approximate cost for the earliest A7-L suits was in the $100,000 range – by the time the A7-LB suits were being constructed for the last of the Apollo missions, the price had risen to the $250,000 range. The Apollo lunar suits are now considered "priceless."

However, holding the competitions, and final selection of the Apollo spacesuit took time, and the astronaut training program could not wait for the spacesuit development to be completed. Therefore, NASA decided to break the Apollo suit program into two sections or "blocks." Block 1 suits would be used for all pre-lunar landing missions, while Block 2 suits would be the EVA suits, to be used on the lunar surface. Given the success of the Gemini spacesuits, NASA decided that the suit to be used for Block 1 would be essentially those used during the Gemini missions, but with a slightly modified helmet. The suit was given the name A1-C (A = Apollo, 1 first in the series, C = David Clark Company), and was essentially identical to the Gemini G4-C. The helmet was also the same Gemini helmet used, but had a visor cover of Cycolac attached to protect the raised visor from scratches and the possibility of getting stuck on entering and exiting the spacecraft (Fig. 5.21). Cycolac is a thermoplastic ABS resin (acrylonitrile-butadiene-styrene), used for its high impact and flame-retardant properties. These suits were worn during the early Apollo training, and were worn by astronauts Gus Grissom, Ed White, and Roger Chaffee in the tragic Apollo 1 fire on January 27, 1967. As a result of the fire, NASA halted all forward progress while thoroughly reviewing all safety procedures and equipment. Because more time was now available for the recovery, and significant changes would include modifying the spacesuits, it was decided to move directly into developing the ILC suits for all Apollo missions.

On October 11, 1968 the first of the manned Apollo missions, Apollo 7, was launched on a Saturn IB vehicle with astronauts Wally Schirra, Donn Eisele, and Walter Cunningham on board. It was an Earth orbital flight lasting eleven days, and was designed to test the spacecraft systems, which had undergone major redesign as a result of the Apollo 1 fire. This was also to be a test of the new Apollo A7-L spacesuit, the materials of which had been re-certified to include fire-retardant Velcro, aluminum replacing some of the nylon and plastic features of the connectors, and

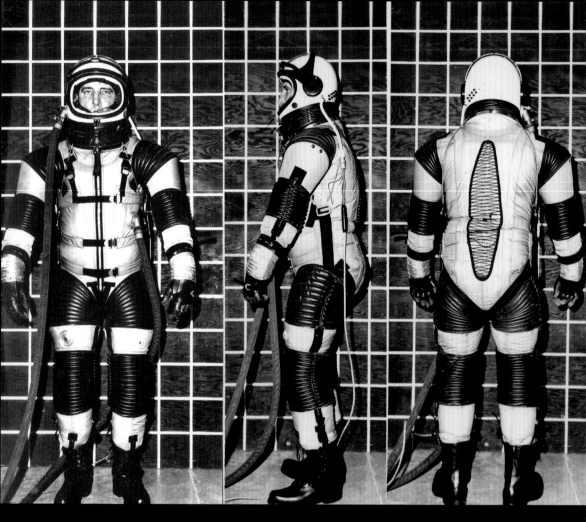

Fig. 5.10
SPD-143 – Apollo Developmental
ILC engineer George Durney in pressurized suit
1963
ILC Image # Unknown
Courtesy ILC Dover

other fire-retardant measures. The A7-L was a great success, and as with the Gemini suits, these soft suits came in both the IV and EV configurations. They were soft and flexible, and were designed so that during the Apollo missions, the astronauts would be able to remove their spacesuits and stow them away in a bag—ready to be worn again during their time on the moon or outside the spacecraft. However, while in the spacecraft, the astronauts wore either their constant-wear garments, which were made of cotton and looked like long-john underwear, or changed into an in-flight coverall consisting of a jacket, pair of trousers, and booties, made of a white Teflon fabric that was flame-resistant and had a "slippery" quality for ease of donning and doffing.

The A7-L suits were worn by Neil Armstrong and "Buzz" Aldrin on the Apollo 11 mission to the moon, and by all the astronauts through Apollo 14 (Fig. 5.30). These EV spacesuits weighed 56 lb., and when combined with the life support system (PLSS) and additional EV equipment, weighed 189 lb. here on earth. The suits were made of approximately 26 layers of material, including Teflon-coated Beta cloth, Mylar, Dacron, Kapton, and Chromel-R—a woven stainless steel that provided a high level of protection from abrasion, micro-meteoroids, and sharp objects on the lunar surface, or in places subjected to additional "wear." The IV suits were slightly lighter, weighing about 53 lb. as they had fewer layers of insulation. Like the Gemini suits, they closed with a

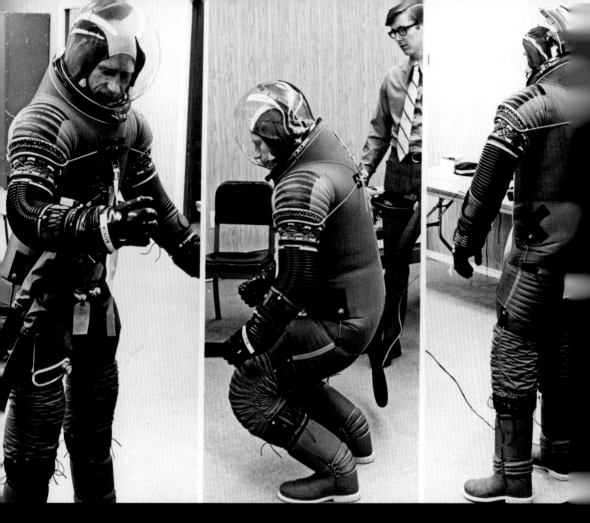

Above:
Fig. 5.11
**Astronaut Al Worden During Modified Fit-check
at ILC**
1971
NASA Image # 71-H-142
Courtesy of NASA

Below:
Fig. 5.12
**Astronaut Al Worden During Testing/Fit-check
at ILC**
1971
NASA Image # 71-H-1169
Courtesy of NASA

pressure-sealing zipper, but the Apollo spacesuits
also had a far more complicated inner restraint sys-
tem to keep the suit from "ballooning." This restraint
system included nylon "tunnel and cording," steel
cables, loop and lacing adjustments for proper fit,
and "convolutes"—a derivation of Russell Colley's
"Tomato Worm" concept in the form of a bellows-like
rubber and neoprene section that made up the flex-
ible joints, enabling astronauts to bend their arms,
knees, hips, etc. Additionally, the Apollo spacesuits
had a second "restraint" zipper on the inside of the
spacesuit, primarily to "take the pressure load"
(preventing the internal suit pressure from put-
ting too much strain on the sealing zipper). In the
A7-L suits, this zipper ran from the back of the neck

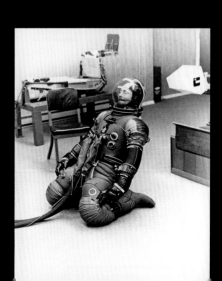

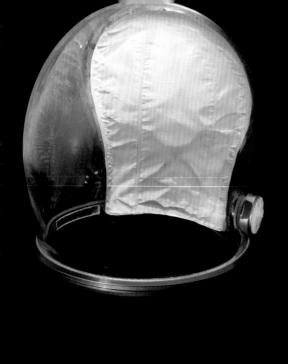
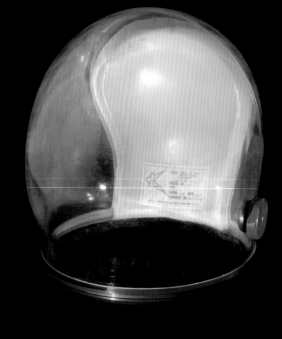
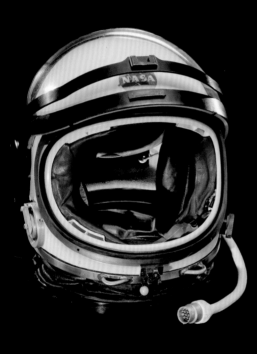
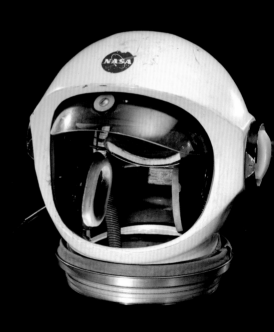
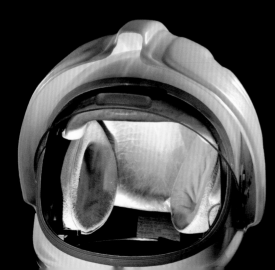

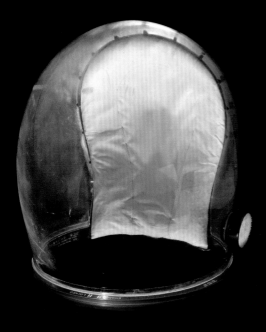

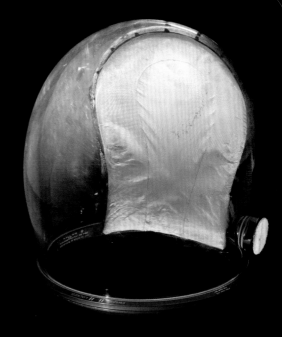

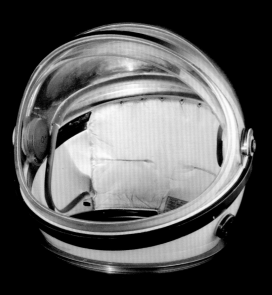

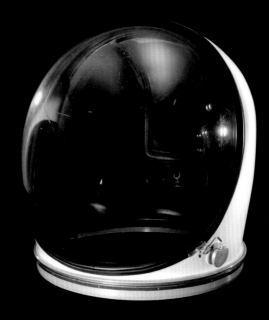

Top, left to right:

Fig. 5.13
A7-L Helmet – Apollo Pressure Bubble , Training
ILC Industries, 1968
Catalog # 1977-2538-001
SI Image # 2002-6964

Fig. 5.14
A6-L Helmet – Apollo Pressure Bubble, Developmental/Training
ILC Industries, 1967
Catalog # 1977-0355-001
SI Image # 2002-6965

Fig. 5.15
A7-LB Helmet – Apollo Pressure Bubble, Worden, Apollo 15
ILC Industries, 1970
Catalog # 1973-0059-001

SI Image # 2002-6977

Fig. 5.16
A7-L Helmet – Apollo Pressure Bubble, Shepard, Apollo 14
ILC Industries
Catalog # 1972-0588-001
SI Image # 2002-6981

Middle, left to right:

Fig. 5.17
SPD-143 Helmet – Apollo Developmental
ILC Industries, 1963
Catalog # 1973-0841-000
SI Image # 2002-7004

Fig. 5.18
A4-H Helmet – "Universal"
Hamilton Standard, 1964

Catalog # 1973-0811-000
SI Image # 2002-7007
(=Fig. 5.27)

Fig. 5.19
Phase I Helmet – Apollo Developmental
David Clark Company, 1967
Catalog # 1982-0463-001
SI Image # 2002-12384

Fig. 5.20
A4-H Helmet
Hamilton Standard, 1964
Catalog # 1973-0810-001
SI Image # 2002-12393

Bottom, left to right:

Fig. 5.21
G3-C Helmet – Schirra, Gemini 6

Modified to A1-C helmet, used by Eisele for training
David Clark Company, 1964
Catalog # 1968-0442-001
SI Image # 2004-26001

Fig. 5.22
A7-L Helmet – Apollo Pressure Bubble, Collins, Apollo 11
ILC Industries, 1969
Catalog # 1973-0042-001
SI Image # 2006-11303

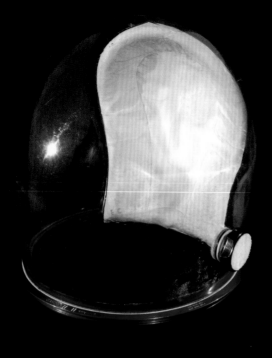

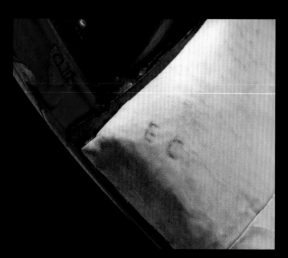

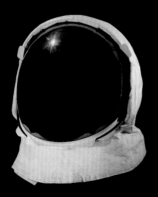

down between the legs and up to the front where it was covered with a "beavertail" flap of insulated Beta cloth.

The torso of the Apollo spacesuit had numerous red and blue hose connectors. The IV suits were equipped with one blue "good air" and one red "bad air" connector, with a blue electrical connector, and one small blue diverter valve. The suit internal-pressure gage was on the left wrist. The EV suits were equipped with a second set of "good and bad air" connectors, along with a blue water port. The second set was so that while suiting up to go out on to the lunar surface, the astronauts could connect their suits to the landing vehicle's life support systems. When the portable life support system was in place and secured, they could attach the life support hoses to that as well and then disconnect the other set of hoses from the vehicle systems. This prevented the astronaut from overheating while suiting up, and ensured that all systems were working correctly before disconnect from the Lunar Module's life support systems. The diverter valve could channel either 50% or 100% of the oxygen up into the helmet depending on the setting. When connected to the Lunar Module, there was typically 12 cubic feet of airflow, so the diverter valve could be set to deliver 50% of the air flow to the helmet and 50% to the arms and legs by way of the air ducts built into the restraint system. When connected to the PLSS, the output flow was about 6 cubic feet of oxygen, and the valve was then set to provide 100% of the oxygen flow to the helmet. The wrist disconnects were always red for the right arm and blue for the left, with the corresponding glove disconnects on the spacesuit color coordinated.

In part because of the size and make-up of the inner restraint system, the A7-L spacesuit had very little built-in movement ability in the neck region,

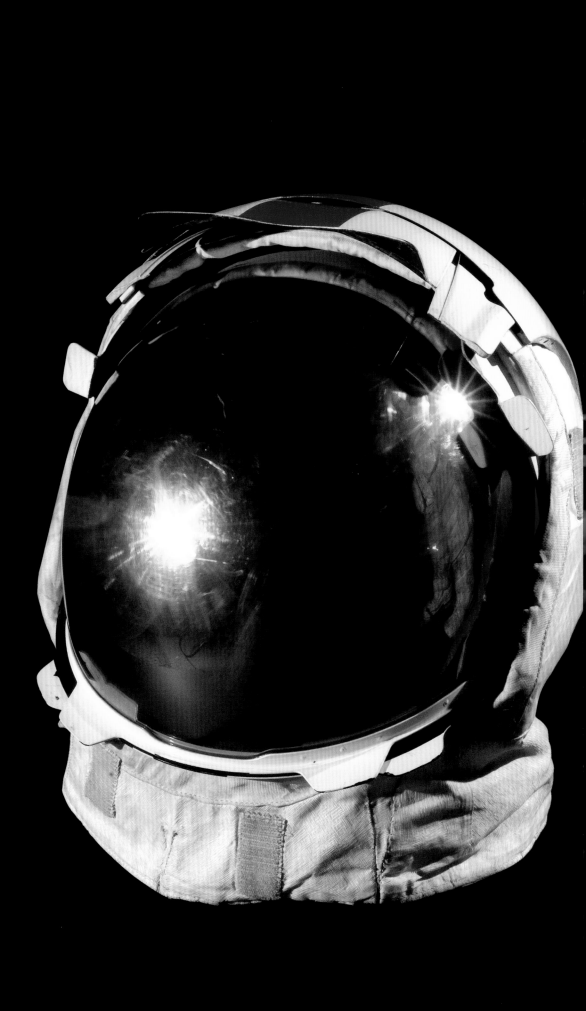

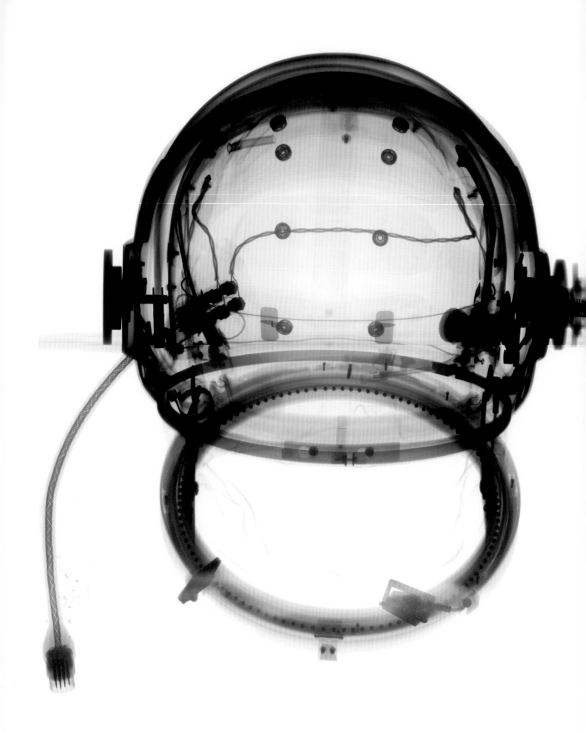

and therefore the neck opening had to be lower and wide enough for the astronaut to move his head easily. This in turn called for a new helmet design to enable the astronaut to move his head within the helmet (Fig. 5.13).

The pressure bubble helmet used with the Apollo spacesuits came into use for two reasons. The first was the inability of the neck region in the spacesuit to move when the astronaut moved his head, but the second reason was that the helmets of the Mercury and Gemini programs were direct derivations of the high-altitude flight helmets, which were close fitting and had a moveable visor. In the vacuum of space the possibility of a visor breaking or coming loose was not a risk to be taken lightly, and NASA

therefore opted for the pressure bubble helmet. This helmet was similar in style to the MOL helmet, and was vacuum-molded of polycarbonate which has a very high resistance to breakage, and even molded in this complex shape, was remarkably free of distortion. The comfort pad at the rear of the helmet was lined up with the air flow system of the suit, permitting 50% or 100% of the oxygen to move into the helmet (depending on the diverter valve setting), thus preventing possible carbon-dioxide build-up. However, built-in communication systems were not feasible in a clear bubble helmet, so the communications carrier cap was designed. Affectionately known as the "Snoopy Cap" after the cartoon character so popular at the time, the communications systems

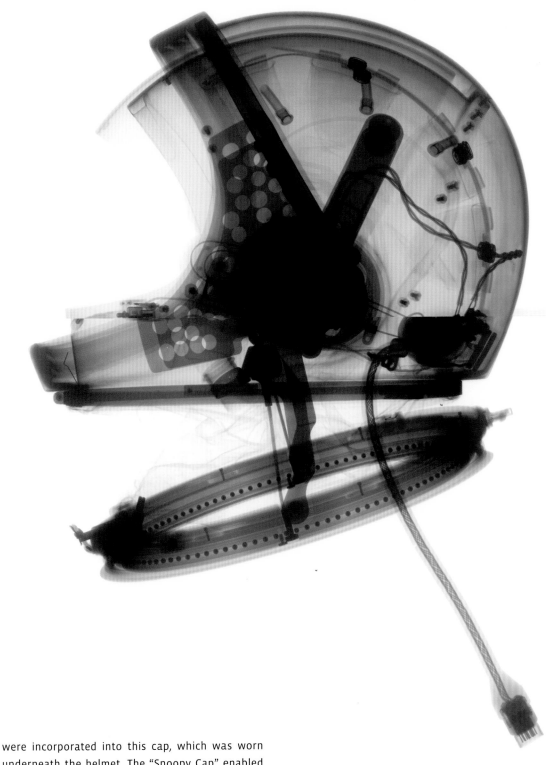

were incorporated into this cap, which was worn underneath the helmet. The "Snoopy Cap" enabled the astronauts to move their head within the helmet, giving them a wide field of vision.

While on the moon, the astronauts were issued with other specialized equipment to protect them from the sharp rocks, extreme temperatures, and the high levels of ultraviolet (UV) light to be found on the lunar surface, away from the protective atmosphere of earth. The most memorable of these is the extra-vehicular gold-visored helmet seen in all the images of astronauts on the moon, which is actually an over-helmet, made by Ling Temco Voight (LTV) under contract to ILC. Weighing about four and a half pounds, and worn over the pressure bubble helmet,

Fig. 5.27
Radiograph Image of A4-H "Universal" Helmet
Hamilton Standard, 1964
Ron Cunningham and Mark Avino
Catalog # 1973-0811-000
SI Image # 2008-1854
(=Fig5. 18)

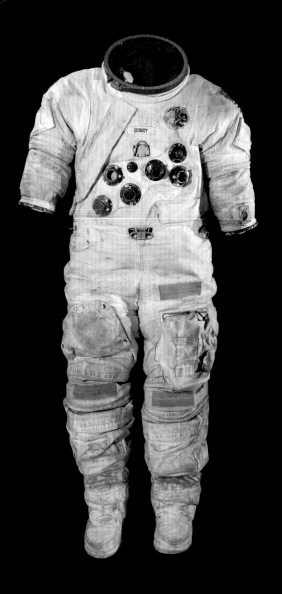

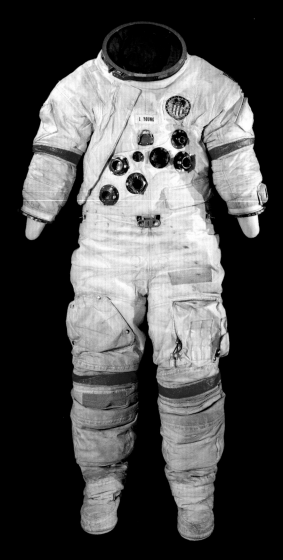

Left:
Fig. 5.28
A7-LB Extra-vehicular Suit – Schmitt, Apollo 17
ILC Industries, 1972
Catalog # 1974-0183-000
SI Image # 2003-27353

Right:
Fig. 5.29
A7-L Extra-vehicular Suit – Young, Apollo 16
ILC Industries, 1971
Catalog # 1974-0149-000
SI Image # 2003-27355

this EV helmet had two visors—the interior visor was made of ultraviolet-stabilized polycarbonate, which provided micro-meteoroid and UV protection, and the exterior visor, which was made of polysulfone with a 24-karat gold coating, reducing the amount of visible light entering the helmet, thus limiting the interior heat level build-up. The helmets were covered with padded Beta cloth and had a large collar with Velcro closures, also made of Beta cloth. This collar protected the neck-ring disconnect from heating up in the lunar day. Most of these gold-visored helmets were left on the moon, and there are only six in the Museum Collection—those worn on the Apollo 11, 15, and 17 missions (Fig. 5.25 and 5.26).

During Apollo 11 and 12, it became apparent

that identification of the Commander and Lunar Module Pilot in the television images coming back to earth and in the photographs returned from the moon was not going to be easy, so a quick and accurate method of identification was required. Therefore, from Apollo 13 on, the EV helmet had a red "Commander stripe" over its upper surface, and at the same time "Commander stripes" were added to the upper arms and thighs of the spacesuit worn by the mission commander (Fig. 5.29 and 5.30).

The other very specialized spacesuit components used on the moon were the EV gloves and Lunar Overshoes (boots). While on the lunar surface, the astronauts wore gloves known as EV gloves that provided additional insulation and protection. They were

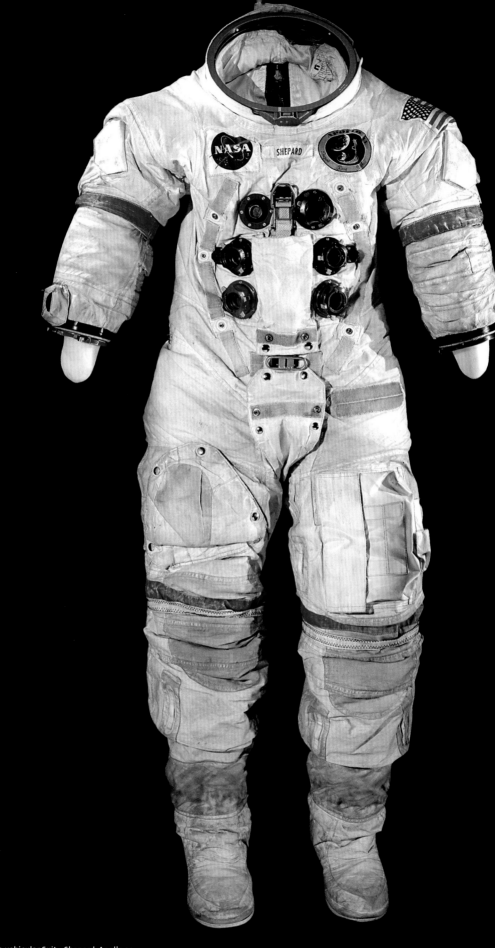

.30
Extra-vehicular Suit – Shepard, Apollo 14
dustries, 1970
og # 1972-0587-000
2003-27359

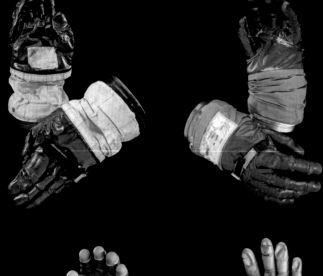

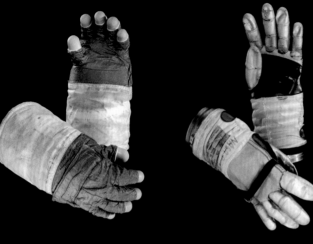

Top, clockwise from left:

Fig. 5.31
A7-L Intra-vehicular Gloves – Young Apollo 10
ILC Industries, 1969
Catalog # 1973-1287-002/003
SI Image # 2004-10890

Fig. 5.32
A6-L IV Gloves
ILC Industries, 1966
Catalog # 1977-0355-002/003
SI Image # 2002-32812

Fig. 5.33
AX1-L Gloves – Apollo Prototype
ILC Industries, 1963
Catalog # 1973-0841-002/003
SI Image # 2002-32813

Fig. 5.35
A4-H Gloves – Apollo Development
ILC Industries for
Hamilton Standard, 1964
Catalog # 1973-0810-002/003
SI Image # 2002-32854

Fig. 5.34
A7-LB EV Gloves – Duke, Apollo 16
ILC Industries, 1972
Catalog # 1974-0150-002/003
SI Image # 2002-32849

Below:
Fig. 5.36
Silicone Fingertips Of Apollo Extra-vehicular Glove
ILC Industries
SI Image # 2008-1876

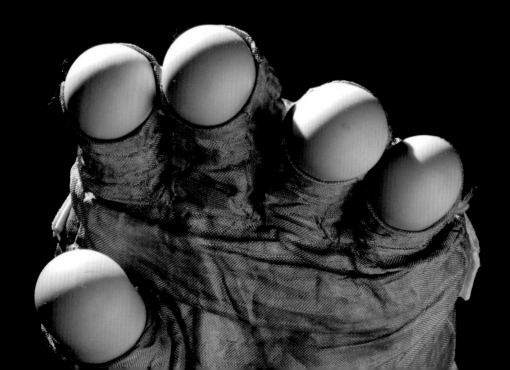

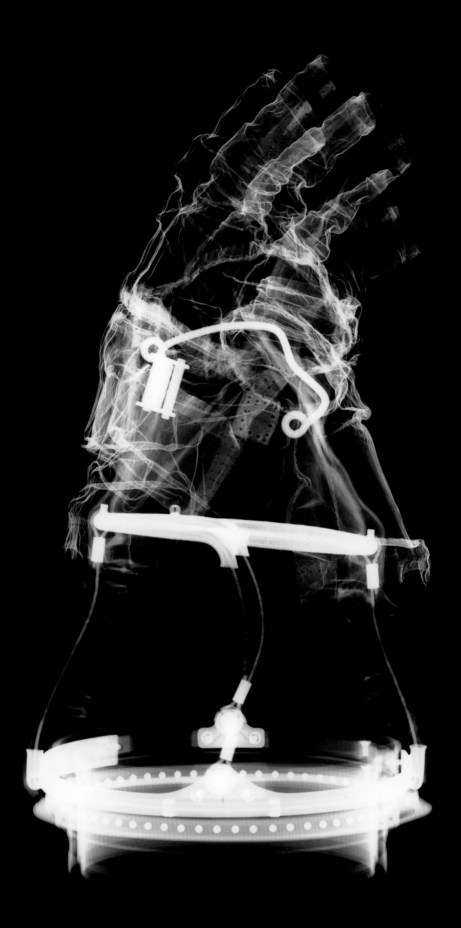

Fig. 5.37
**Radiograph Image of Harrison Schmitt's Apollo 17 Lunar
Glove**
ILC Industries, 1972
Ron Cunningham and Mark Avino
Catalog # 1974-0183-006

essentially modified IV gloves, as worn during launch. The EV gloves weighed less than three pounds, and covered the entire hand and wrist. They were made with an interior bladder of rubber/neoprene similar to the IV glove, to which the EV shell of Teflon-coated Beta cloth and Chromel-R, with insulating layers of Mylar, Dacron, and Kapton film was attached. The blue silicone fingertips enabled the astronaut to have a surprising amount of feeling in his fingers. The EV and IV gloves were attached to the suit with anodized aluminum disconnect rings—always red for the right glove and blue for the left (Fig 5.31).

The boots that made the famous footprints on the moon were in fact overshoes worn only while on the lunar surface. There are only two pairs of these boots in the Collection that were actually worn on the moon—those worn by astronauts Gene Cernan and "Jack" Schmitt on Apollo 17. The overshoes worn on the other missions, including Apollo 11 were, like many of the gold-visored helmets, left on the lunar surface for weight considerations, and did not return from the missions. The overshoes weighed approximately five pounds and consisted of Chromel-R uppers, with Beta cloth tongue and lining, and thirteen layers of aluminized Mylar and Kapton film for insulation and additional protection. The blue silicone soles had a further two layers of Beta felt between the layers of Kapton film as an extra layer of protection against the extremes of heat and cold, as well as sharp rocks while on the lunar surface. These overshoes were designed to protect the spacesuit boots without making it any more difficult to walk or bend the foot, and though they appear somewhat cumbersome, were surprisingly flexible (Fig. 5.41). The last three Apollo missions, Apollo 15, 16, and 17, were designed to enable the astronauts to travel

Above:
Fig. 5.38
Lunar Overshoes – Harrison Schmitt, Apollo 17
ILC Industries, 1972
Catalog # 1974-0183-007/008
SI Image # 2008-9213

Right:
Fig. 5.39
Lunar Overshoes – Harrison Schmitt, Apollo 17
ILC Industries, 1972
Catalog # 1974-0183-007/008
SI Image # 2008-9212

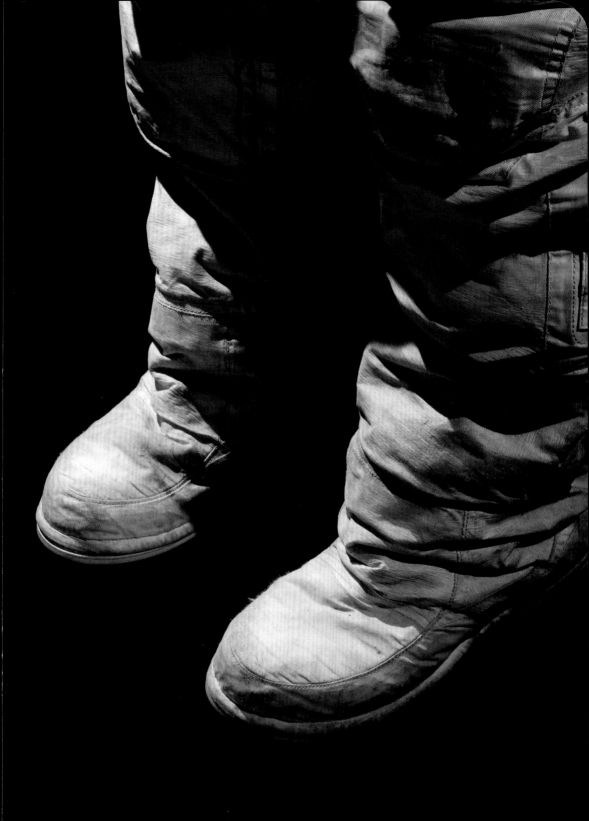

Fig. 5.40
**"Buzz" Aldrin's Apollo 11
Boots**
ILC Industries, 1969
Catalog # 1973-0041-000
SI Image # 2008-9206

Fig. 5.41
Lunar Overshoes – Harrison Schmitt, Apollo 17
ILC Industries, 1972
Catalog # 1974-0183-007/008
SI Image # 2008-9209

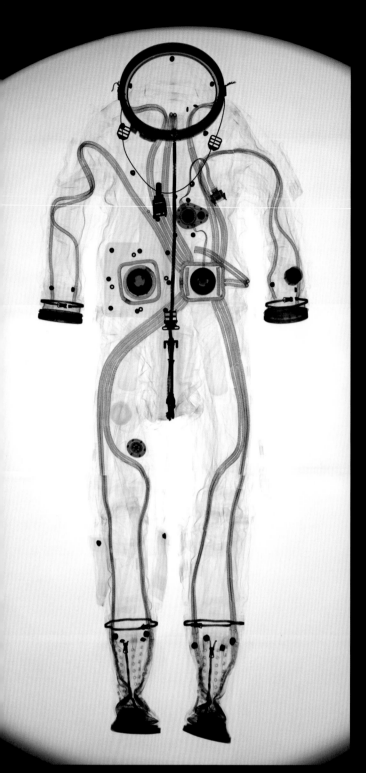

Fig. 5.42
Radiograph Image of A1-C Suit
Used for Apollo training
David Clark Company, 1966
Ron Cunningham and Mark Avino
Catalog # 1973-0826-000
SI Image # 2009-0965

farther afield from the Lunar Module in their explora-
tion of the moon and the quest for different geological
samples. To do this, the astronauts took the very spe-
cialized, battery-powered lunar roving vehicle (LRV)
with them. This vehicle enabled the astronauts to
travel greater distances, explore the landscape, and
carry the samples collected back to the lunar land-
ing vehicle. The spacesuits worn on these missions
were similar in construction to the A7-L model used
during the earlier missions, but as the A7-L was a suit
designed primarily for walking and bending from the
waist, using a lunar roving vehicle (LRV) meant that
the astronauts would need suits that were modified
to enable them to sit without putting undue stress on
the zipper, and bend their knees more easily. These

modifications added a little weight to the suit which
now weighed approximately 67 lb. However, when the
additional EV equipment and life support systems
were added in, these A7-LB suits weighed 201 lb. here
on earth.

These suits were constructed from the same
materials as the A7-L models, but just weighed a
little more. Weight was always a major concern with
anything that went into space, but the required
modifications had unavoidably added a few pounds
to the total weight of the spacesuit. The most obvi-
ous and visible differences between the A7-L and the
A7-LB suits, were that the A7-LB had a wider seat than
the A7-L, which necessitated a change in zipper loca-
tion, which in turn required that the hose connectors

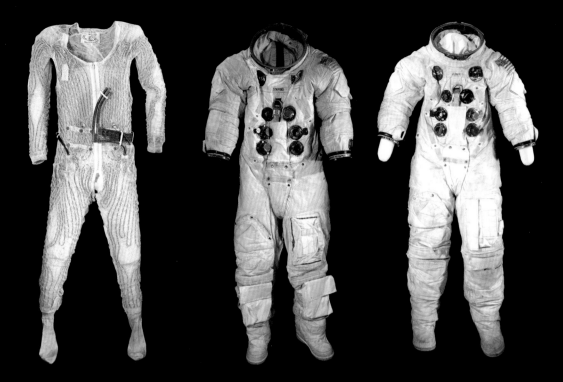

Top, left to right:

Fig. 5.43
Liquid Cooling Garment – Apollo
Not flown
ILC Industries, 1968
Catalog # 1973-0120-000
SI Image # 2004-25833

Fig. 5.44
A7-L EV – Stafford, Apollo 10
International Latex Corporation, 1968
Catalog # 1975-0597-000
SI Image # 2004-59982

Fig. 5.45
A7-L EV – Aldrin, Apollo 11
ILC Industries, 1969
Catalog # 1973-0041-000
SI Image # 2005-22509

Below:
Fig. 5.46
**Astronaut Russell Schweickart Stands on LM
"Spider's" Porch During EV Activities, Apollo 9**
1969
NASA Image # AS9-20-3094
Courtesy of NASA

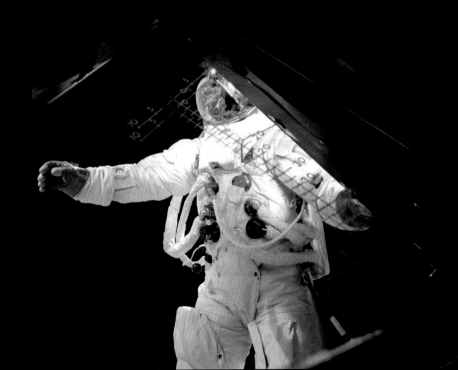

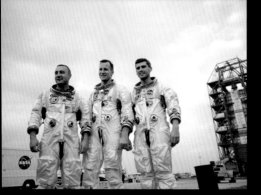

on the chest be repositioned. The zipper therefore had to be repositioned from the back of the suit to the side, which in turn necessitated moving all the life-support hose connectors. Less visible changes included a waist convolute of rubber/neoprene and, in the neck, an additional cable that enabled an up or down tilting position of the helmet, with tie-downs to prevent the suit from riding up when the astronaut sat in the rover (similar to the problems Wiley Post had encountered in 1934). These changes added approximately nine pounds to the fifty-six pounds of the A7-L EV suit (Fig. 5.30).

Cooling and Ventilation:

While wearing a spacesuit, maintaining the astronaut's body temperature is of paramount importance. The extremes of temperature in the vacuum of space mean that whatever kind of garment an astronaut wears while outside the spacecraft, it has to be able to keep the extreme heat and cold out, and body temperature in. The lack of oxygen and air pressure in this extreme environment are other major factors, and therefore the spacesuit is also designed to keep oxygen and pressure in while keeping everything else out, with virtually no leakage. A side effect of being in this absolutely closed garment is that an astronaut inside a pressurized spacesuit is in danger of overheating and collapse in a remarkably short period of time—without some method of breathing, cooling, and air circulation.

During the Mercury program, the spacesuits were ventilated through an air-hose attachment connected to the spacecraft, and worn with a cotton undergarment with coiled nylon fabric spacers to keep the spacesuit from sticking to the body, and thus preventing the air from circulating. The spacecraft systems pumped oxygen into the suit through the air-hose, and the pressure from this pumping action gently pushed the oxygen throughout the suit —albeit slowly, facilitated by the nylon spacers and the properties of the cotton knit (Fig. 2.6).

The Gemini astronauts wore a plain, one-piece undergarment also made of cotton knit, but without the

Above:
Fig. 5.47
Apollo 1 Astronauts (Left to Right) Grissom, White, and Chaffee in front of Launch Complex 3
1967
NASA Image # 67-PC-0016
Courtesy of NASA

Opposite:
Fig. 5.48
A7-L – Armstrong, Apollo 11
ILC Industries, 1969
Catalog # 1973-0040-000
SI Image # 2008-9204

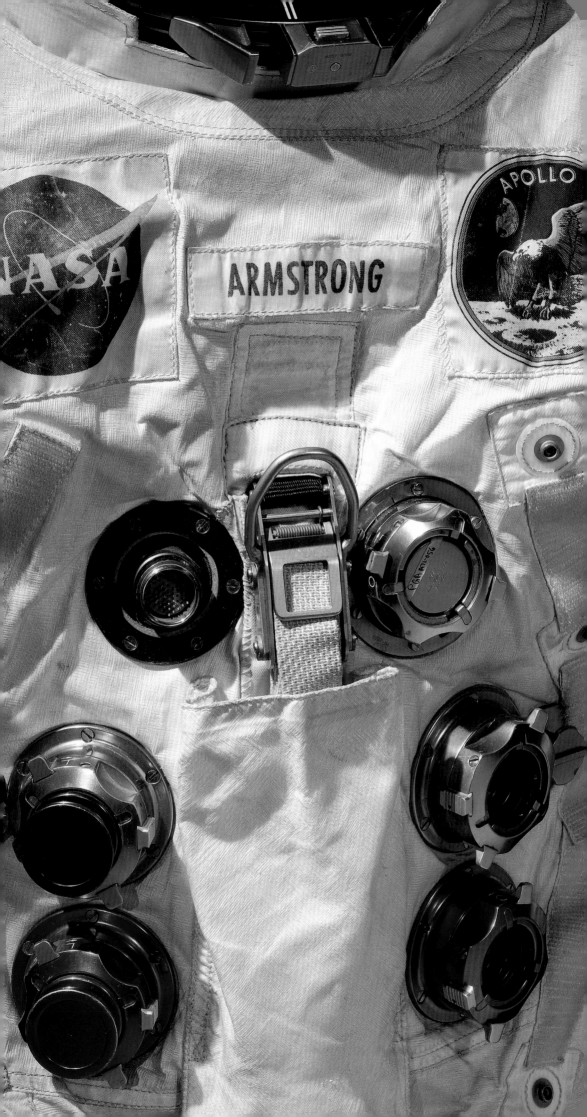

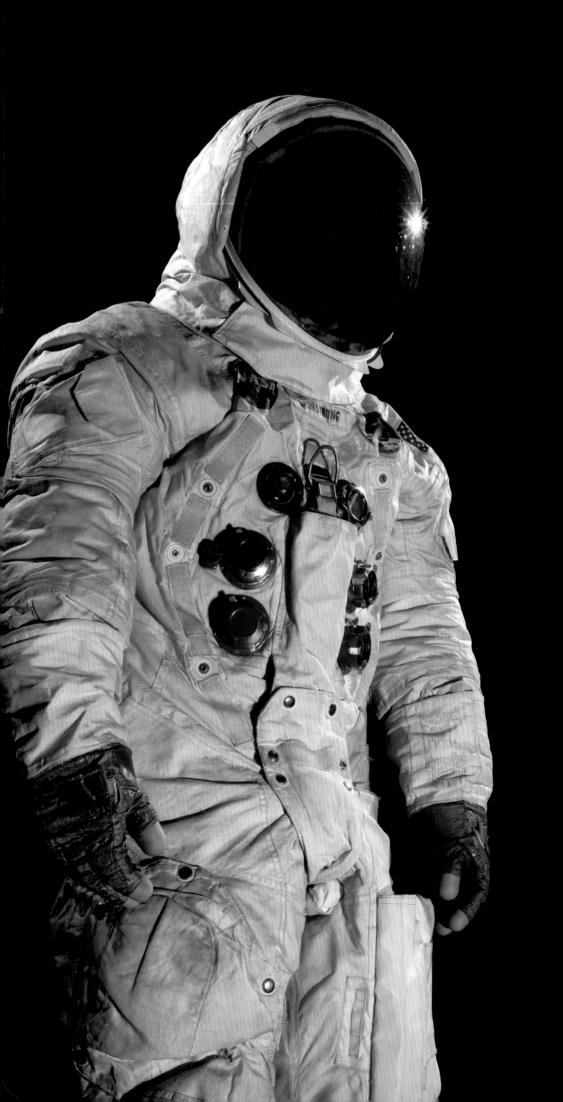

nylon spacers. Gemini spacesuits were ventilated by a series of air channels within the spacesuit, the inlet of which was attached to the spacecraft with a hose, the connector of which was on the chest of the spacesuit. The channels were made of fine stainless steel coils covered with Lycra mesh and a neoprene cover. As with the Mercury program, oxygen was pumped through the hose connector, and distributed throughout the spacesuit body through the channels. Warm air flowed out of the red exhaust connector, back into the environmental systems loop. The Gemini helmets had either a "spray bar" – a series of small holes above the visor through which oxygen was pumped into the helmet, or larger ports on the sides of the helmet, in order to keep the interior of the visor clear.

With Apollo, the mission requirements meant that the cooling and ventilation system had to be completely redesigned. As it was impossible for the astronauts to remain tethered to the lunar landing vehicle while on the moon's surface, this equipment had to be completely self-contained. Furthermore, it was impractical and unrealistic for the astronauts to carry sufficient air and pumping equipment to maintain a safe body temperature with an air-cooled system. The Liquid Cooling Garment (LCG) was developed for this purpose following its initial development by the Royal Air Force for potential use by their pilots. It was a "long-john" –type garment of nylon spandex mesh with a network of polyvinyl chloride (PVC) tubes running through it at evenly spaced intervals. The lining was of knitted nylon, and the feet of knitted cotton. This garment was powered by the Portable Life Support System (PLSS) while on the lunar surface, or from the spacecraft or lunar module while in those vehicles, and provided a very efficient method of keeping the astronaut cool (Fig. 5.43).

Opposite:
Fig. 5.49
A7-L – Armstrong, Apollo 11
ILC Industries, 1969
Catalog # 1973-0040-000
SI Image # 2008-10759

Below:
Fig. 5.50
Astronaut Harrison Schmitt on Lunar Surface, Apollo 17
1972
NASA Image # AS17-145-22157
Courtesy of NASA

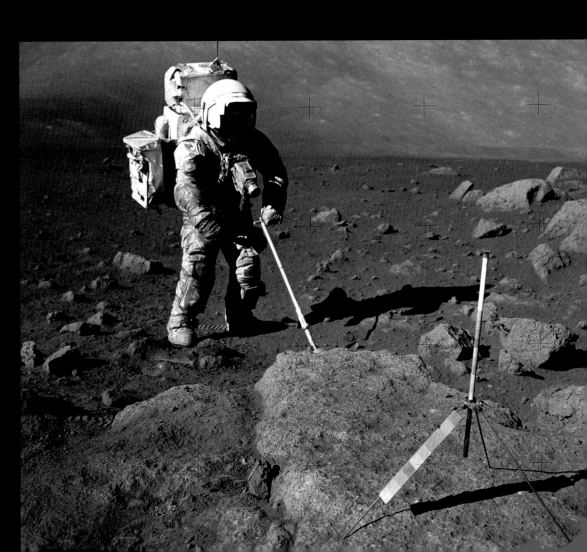

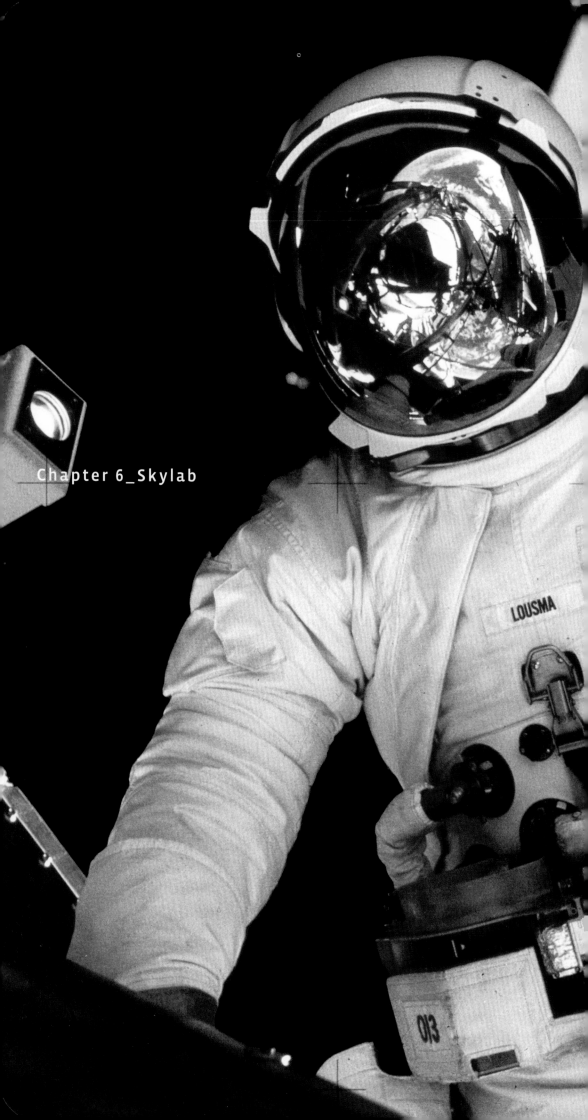

The last major program of the Apollo era was the Skylab orbital workshop which was launched from Cape Canaveral on May 14, 1973. Conceived in 1966 and originally called the Apollo Applications Program, Skylab was intended to test the astronauts' ability to remain in space for extended periods of time, and to conduct a series of other experiments.

Note: *Skylab was not the first space station ever launched—the Soviet Union had launched Salyut I on April 19, 1971, and though Soyuz 10 achieved docking with Salyut 1, it was not boarded. On June 6th, 1971, Soyuz 11 docked successfully and the crew boarded Salyut 1 for a three week stay. Tragically, during the return trip, their Soyuz spacecraft decompressed after retro-fire, when the modules separated before atmosphere re-entry, and all three cosmonauts died of hypoxia and air embolism. Salyut II was launched in 1973, but never saw manned entry or habitation as it was damaged during launch and eventually broke up in orbit. The Soviets later launched several more Salyut stations and its successor, the Mir.*

Skylab weighed approximately 100 tons with a working volume of over 283 cubic meters, and up to that time was the largest object ever placed in earth orbit. The workshop was the last time a craft was launched on the Saturn V vehicle, which had been used for all the lunar missions, with the crew for the three missions being launched on the Saturn IB vehicle.

Nine people orbited the earth in the Skylab workshop from May, 1973 through February, 1974 in crews of three, achieving a total of 513 man-days in orbit. The first mission on May 14, 1973, was the launch of the workshop itself, with the first crew being launched 10 days later on May 25. The first manned mission, called Skylab 2, lasted 28 days, with the subsequent missions lasting two and almost three months respectively, during which time the astronauts conducted experiments in (among other things) the life sciences, solar physics, earth-observation, and student experiments, and took approximately 182,000 photographs.

The Skylab missions are considered to have been highly successful, though less than an hour after the launch of Skylab 1, it appeared as though the whole program would be doomed. The combination micro-meteoroid and sun shield tore loose during launch, taking one of the solar arrays with it. The second solar wing was found to have become jammed as a result and was unable to be deployed, placing the workshop in grave danger of overheating and without the power to maneuver. The crew of Skylab 2 was scheduled to launch the day after the workshop, but the flight was delayed by about 10 days in order to develop repair

Previous spread:
Fig. 6.1
Astronaut Jack Lousma During EVA, Skylab 3
1973
NASA Image # 73-HC-741
Courtesy of NASA

Opposite:
Fig. 6.2
A7-LB EV – Bean, Skylab 3
ILC Industries, 1972
Catalog # 1976-1193-000
SI Image # 2003-27375

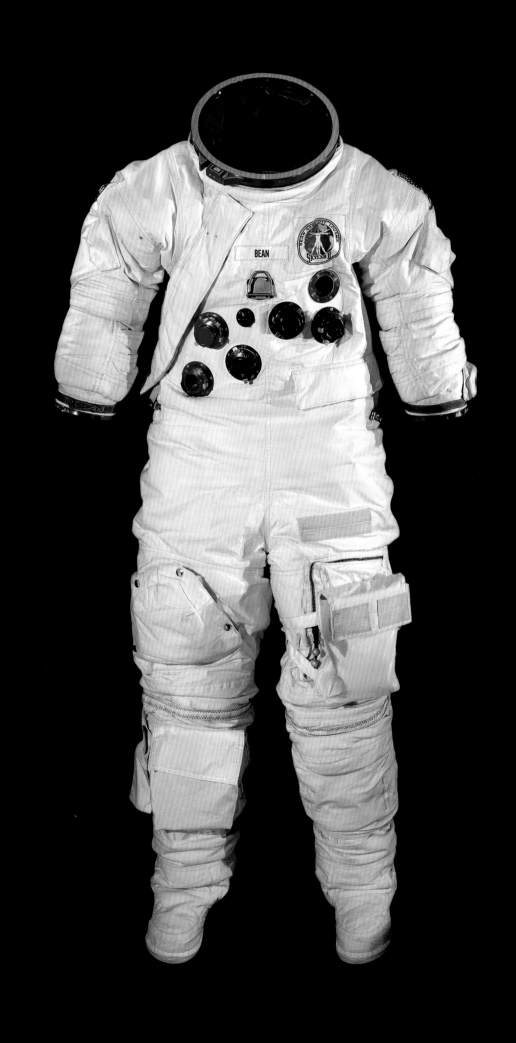

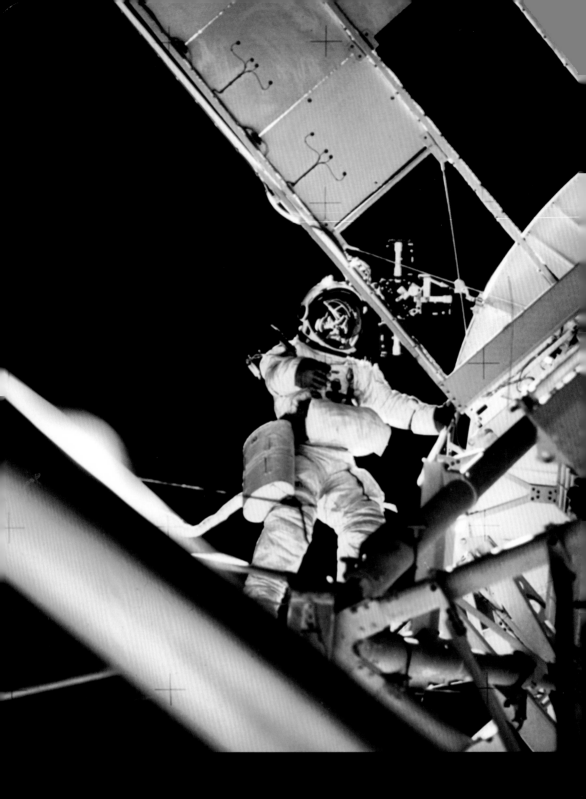

procedures and test them. After launch on May 25th, 1973, Commander Pete Conrad maneuvered the Apollo vehicle into "formation" with the crippled Skylab vehicle, while astronaut Weitz attempted to un-jam to solar array, while standing in the open Apollo hatch. This was unsuccessful, and after numerous attempts the Apollo was able to dock with the Skylab vehicle, and the crew was able to begin repairs. The crew set up a "parasol" as a replacement sunshade which lowered the internal temperature enough for the crew to enter, and they spent their initial time on the workshop fixing the improvised parasol so that the workshop wouldn't overheat. Two weeks later they were able to free the solar array, thus providing electricity to the workshop.

The Skylab orbital workshop remained in orbit for a little over six years, and in July, 1979, five years after the last crew left, it re-entered and burned up in the atmosphere, signaling the end of an era.

The spacesuits worn during the Skylab missions were the "600" series of the A7-LB full-pressure-suit. About 35 of these suits were made in the early 1970s, however, the current locations of most of these suits are unknown, with the exception of the nine flown Skylab suits that are all in the National Air and Space Museum's collection.

The Skylab EV spacesuits were a slightly "trimmed down" version of the Apollo lunar suits, but otherwise it is difficult to tell them apart. The suit had slightly fewer insulating layers and the boots had a

Fig. 6.4
Skylab Boots with Triangle Cleats – Weitz,
Skylab Back-up and STS-9
Blue for the left boot, red for the right boot
B.Welson and Co., 1972
Catalog # 1984-0707-000/001
SI Image # 2008-13192

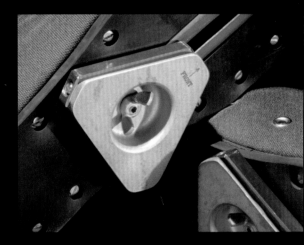

Opposite:
Fig. 6.3
Astronaut Owen Garriott During
EVA, Skylab 3
1973
NASA Image # 73-HC-741
Courtesy of NASA

"Z" shaped plate on the interior and corresponding plate on the exterior of the heel to help hold the foot in place. The astronauts were issued EV as well as IV gloves, but although the Skylab suits did have "walking feet," they were not issued with EV boots as they were not going to walk on the moon. The gold-visored EV helmet was less bulky, and did not have the Beta cloth cover layer or collar.

During the time the astronauts were to spend in the workshop itself, it was unnecessary and would have been impossibly bulky for them to have worn the EV spacesuits, and so lightweight coveralls were provided. The in-flight coveralls used during the Skylab program were similar to those used during Apollo in that they were jackets and trousers, worn with a cotton undershirt, but they had an interesting pair of boots. Designed to provide the astronauts with the feeling of "up and down," and the ability to stay in one place and in the "upright" position while at the table, or working at the console, the cotton boots had triangular cleats attached to the soles, with which they could "lock" their feet into the matching grid that divided the workshop into its two levels (Fig. 6.4).

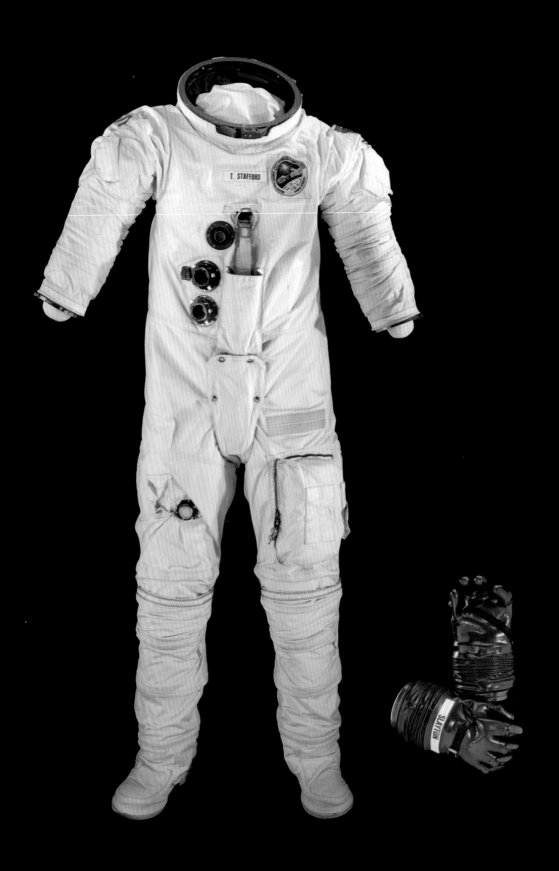

Above, left:

Fig. 7.2

**A7-LB – ASTP Configuration – Stafford,
Apollo Commander**

ILC Industries, 1974

Catalog # 1977-2536-000

SI Image # 2002-32836

Previous spread:

Fig. 7.1

**Soyuz Spacecraft Taken from Apollo During
ASTP Mission**

July, 1975

NASA Image # 75-HC-492

Courtesy of NASA

Above, right:

Fig. 7.3

A7-LB IV Gloves – Slayton, ASTP

ILC Industries, 1974

Catalog # 1977-2537-002/003

SI Image # 2002-32798

Opposite:

Fig. 7.4

**Astronaut Donald "Deke" Slayton and
Cosmonaut Valery Kubasov Signing the
Historic ASTP Joint Certificate**

1975

NASA Image # AST-03-171

Courtesy of NASA

The final mission of the Apollo era was the highly successful and politically significant Apollo-Soyuz Test Program (ASTP) that took place in July, 1975. This mission, in which the U.S. Apollo spacecraft docked with the Soviet Soyuz 19 spacecraft, is best known for the historic "handshake in space" when astronaut Tom Stafford and cosmonaut Alexi Leonov met through the opening between the two spacecraft. The goodwill gesture was initiated by President Richard Nixon and Soviet President Andre Kosygin in 1972, and though the historic handshake is the most visible event remembered, the mission did result in some technological developments, including a common docking system, and docking and undocking maneuvers. The missions were launched on July 15, 1975, within seven and a half hours of each other, with rendezvous and docking about 52 hours after the Soyuz launch. They remained docked for approximately 44 hours before separation. The Soyuz crew was in space for a total of about five days while the Apollo was in space or nine.

The spacesuits used during this mission, given the designation of the 800 series, were the final Apollo suits used in space. They were similar to the A7-LB Skylab Command Module Pilot (CMP) models, but somewhat lighter. They were built in the Intra

vehicular configuration, without the double set of hose connectors on the chest. As the mission was orbital in nature, and did not call for any extra-vehicular activity, the astronauts were not equipped with the EV or lunar protective equipment, such as the gold-visored helmets and EV gloves and boots. The suits only had pressure bubble helmets and IV gloves.

As with the other Apollo flights, the astronauts launched wearing these suits, but changed into their in-flight coverall garments once reaching orbit – one of the reasons for the remarkably good condition of the ASTP suits. Unfortunately for the historical completeness of the ASTP suits at the National Air and Space Museum however, the pressure bubble helmets were retained by NASA at the end of the program for testing and further use and therefore the flown helmets are not in the Collection.

It is believed that nine or ten of these "800" series suits were made in the middle 1970s, and though all three of the ASTP suits worn by astronauts Tom Stafford, Deke Slayton and Vance Brand are in the National Collection, the flight back-up suits, and the back-up crew's prime suits are not in the collection. They were retained by NASA at the end of the program, and their current location is unknown.

Chapter 8_Advanced, Long-Term Lunar Exploration or Advanced Extra-Vehicular Suits (AES)

Fig. 8.1
EX1-A – Radiograph Image
AiResearch Corporation, 1968
Catalog # 1982-0454-000
SI Image # 2008-14049
Ron Cunningham and Mark Avino

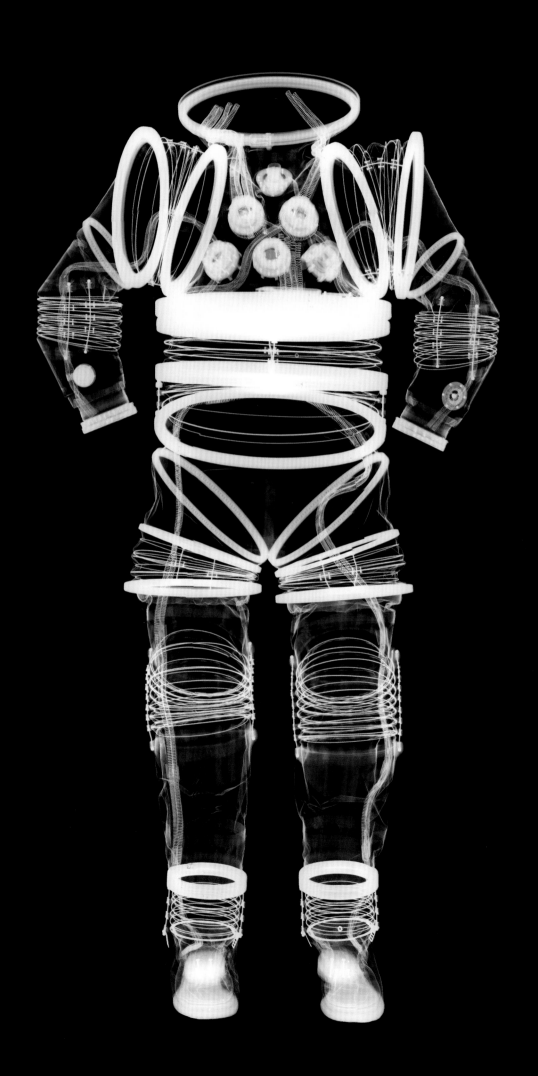

EVA CONSTANT VOLUME SPACE SUIT (LITTON)

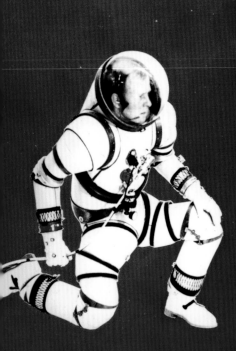

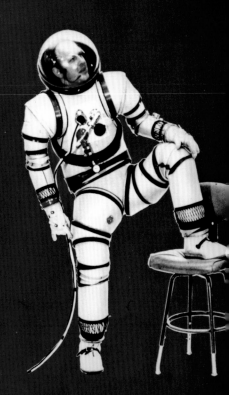

KNEELING CAPABILITY

STEP-HEIGHT CAPABILIT

86D

Above:
Fig. 8.2
CVS Suit Capability Demonstration
Litton Industries, 1969
NASA Image # S-69-101
Courtesy of NASA

Opposite:
Fig. 8.3
CVS Donning and Doffing Demonstration
Litton Industries, 1966
NASA Image # S-66-11458
Courtesy of NASA

During the years in which so much time, effort, and money was being put into the development of the "soft" Apollo spacesuit, NASA was also working on an additional line of suit research. This was partly NASA "hedging its bets," in case the development of the soft suit did not progress according to plans, and partly the desire to create a suit that could be used on extended lunar missions, and eventually in the zero-gravity of a space station.

In 1954, the USAF was looking for a way to solve the problems associated with vacuum tubes, which were used in all types of electronics, but suffered from overheating and were unreliable. In order to repair or change the interior of the tube, someone would have had to be able to get inside the vacuum tube—which of course was impossible. Dr. Siegfried Hansen was working at the fledgling company of Litton Industries in California on vacuum tubes, and realized that if he could work in a vacuum he would be able to correct some of these problems. In order to facilitate this, the USAF built a vacuum laboratory at Litton, ultimately building a much large chamber—one large enough for a man to work in. Dr. Hansen realized that he would have to wear a specialized suit while inside this large vacuum chamber—one that could be pressurized to 5 psi, but mobile enough for a man to work on the tubes under those conditions. After much research and trial, Dr. Hansen developed a "hybrid" suit, the upper portion of which was made from aluminum, with arms using Cardanic linkage

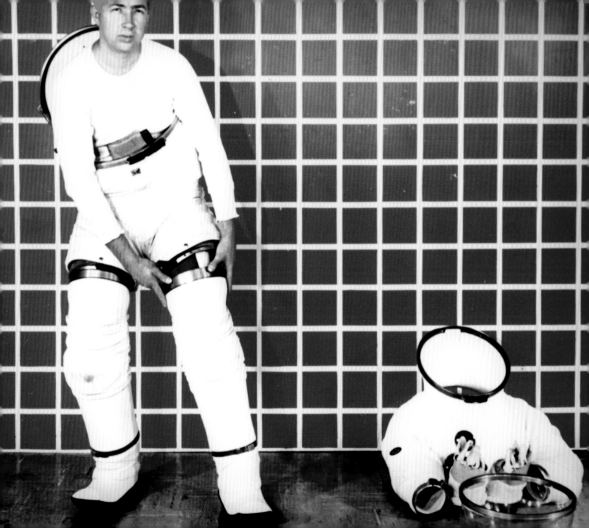

EVA CONSTANT VOLU
(AIRI

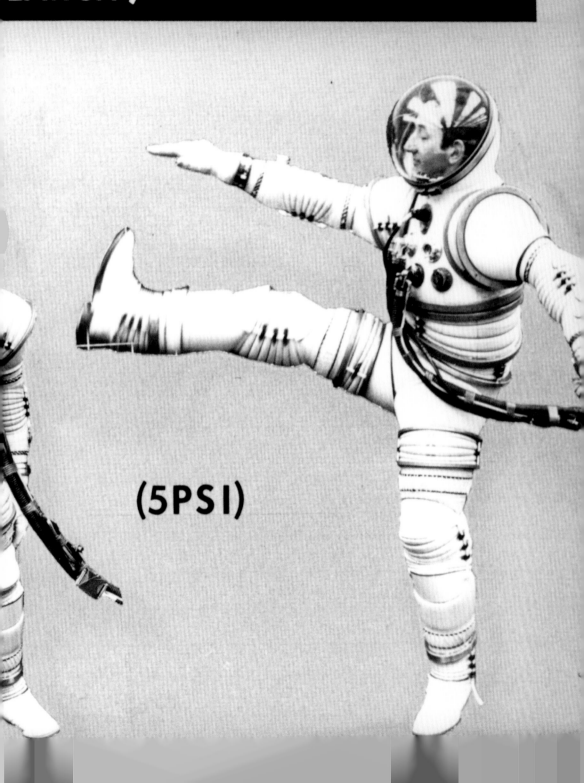

(5PSI)

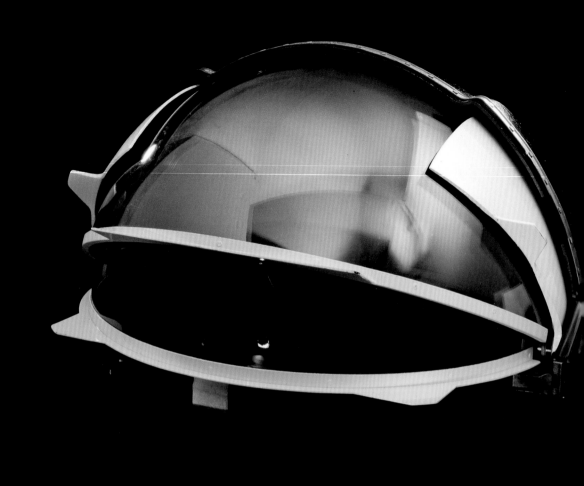
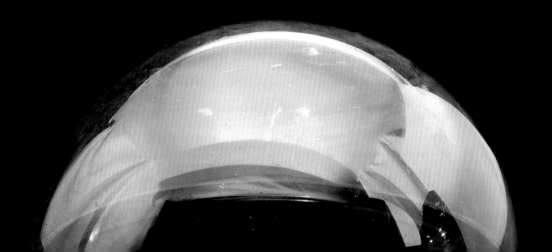

and astronaut fatigue. The advantages of these joint systems were that the wearer could bend and move in a fully pressurized suit while maintaining constant volume—without the internal pressure changing. The amount of physical effort required to operate the suit was thereby decreased, with the resulting reduction of astronaut fatigue. The disadvantages of these suits included their weight, which was always a little more than the soft suit, their higher center of gravity, and their stowage difficulty in the Apollo spacecraft.

Note: The exception to this is the AiResearch AES suit. This suit only weighed 37.8 lb. not including the thermal meteoroid garment (TMG), and fit in the Apollo A7-L storage bag.

The research that was conducted by William "Bill" Elkins and G. Fonda Bonardi while producing the Litton suits, and the potential that they showed for long-term lunar exploration and astronaut safety, was such that the program was continued long after the "soft" suit was selected and used during the Apollo program. These developmental full-pressure-suits originally came under the auspices of the Apollo Applications Project, though were eventually collectively named the "Advanced Extra-Vehicular Suits" (AES) and include those originally designed for lunar exploration, long-term lunar exploration and zero gravity use. The program at Litton closed during the early 1970s, but the one at Ames ultimately continued until the 1990s, during which period some of the most advanced and fascinating full-pressure-suits ever fabricated were produced. Modified versions of these AES suits were the basis for the current deep-sea diving suits, and those currently being designed for zero gravity, the return to the moon, and Mars exploration.

The RX-1 was not designed for any specific mission, though the aim was that features of the suit would eventually be used on the lunar surface. This was part of the first phase of development of an "Advanced Extra-Vehicular Suit" (AES) Program though eventually it became known as part of the Apollo Applications Program. The RX-1 had a "soft" waist section which didn't work well under pressure, so in 1963 the suit was re-constructed with a "hard" waist and renamed the RX-2. This suit weighed about 83 lb. and had integrated helmet, boots, and gloves. It was constructed with a bandolier-type closure system, rolling convolute joints in the hips and shoulders, and operated at 5 psi. The crank in front was to raise the height of the internal seat (a bicycle seat) so that the wearer could see out of the helmet visor while seated (Fig. 8.9).

The RX-2A was made in 1965 under a new NASA contract. Like the RX-2, it was not considered an operational suit, but was designed to demonstrate the feasibility of a rigid, constant volume suit near flight weight, and came in at about 80 lb. It had a "quick-detach" hemispherical helmet made of polycarbonate,

Top:
Fig. 8.5
RX-3 – Hemispherical EV Helmet, Developmental
Litton Industries, 1965
Catalog # 1976-0872-001
SI Image # 2002-12385

Bottom:
Fig. 8.6
RX-3 – Hemispherical Pressure Helmet, Developmental
Litton Industries, 1965
Catalog # 1976-0872-002
SI Image # 2002-12387

and the suit itself was made of a sandwich-type structure with a layer of aluminum, foam-filled honeycomb, and a fiberglass exterior. The hip joints were reduced in size without sacrificing range of mobility, and a similar joint was used in the waist (Fig. 8.13). The RX-2A was fitted with a dual-plane closure system which closed horizontally over the front torso, but turned a corner under the arms and continued up to the base of the neck. In addition to more comfort for the wearer, this gave the suit a smooth back surface to which the life support system could be attached without difficulty.

The RX-3 was delivered to NASA in November, 1966, and once again, was not considered an operational suit. However, later versions were planned for use in long-term lunar exploration, and it was designed to have life support attachments. It was modular in construction, of 20 components made in standard sizes. Constructed in a "sandwich" composition a quarter inch thick, of an aluminum pressure layer with honeycomb interior and glass fiber and gelcoat exterior, the suit weighed about 60 lb. It also had a dual-plane closure system. The operator had to get into the suit while it was flat on the floor, assisted to his feet by a technician, the upper torso was slipped over his head and closed, and then the helmet was attached. The interior of the "Dutch boy" boots were built up with HT-1 Nomex for additional thermal protection as the RX-3 was designed for extended lunar exploration, and it was to use Apollo fittings and life support systems. It was planned that a thermal garment would be worn over the suit, though it is unknown if that was ever made (Fig. 8.12).

Note: Litton also built a modified RX-3 for the USAF-MOL competition in 1967 with built-in ejection seat attachment (See Fig. 8.12 and Chapter 4).

The RX-4, designed and built during 1966 and 1967, is somewhat difficult to differentiate from the RX-3. The main visible difference is the molding of the upper torso where the life support connectors are placed. The suit was for the development of a flight-qualified full-pressure-suit, including the thermal coverings, and incorporated the sun visors on the helmet. It had rolling convolute joints which weighed almost half of the total suit weight, for a total of approximately 63 lb.

The RX-5 and RX-5A were developed during 1968 and 1969, and sought to integrate the best of the previous designs. The suits each weighed a little under 60 lb., had a single-plane closure, hemispherical helmets, and had a greater degree of mobility than previous models. Unfortunately, neither of these two suits are in the National Collection.

The Litton RX series of suits were designed for joint mobility and testing, and demonstrated the feasibility and advantages of a suit with constant internal volume and an advanced joint system. However, as

Fig. 8.7
RX-1 – Radiograph of Arm Unit
Litton Industries, 1962
Catalog # 1972-0536-001
SI Image # 2008-1860
Ron Cunningham and Mark Avino

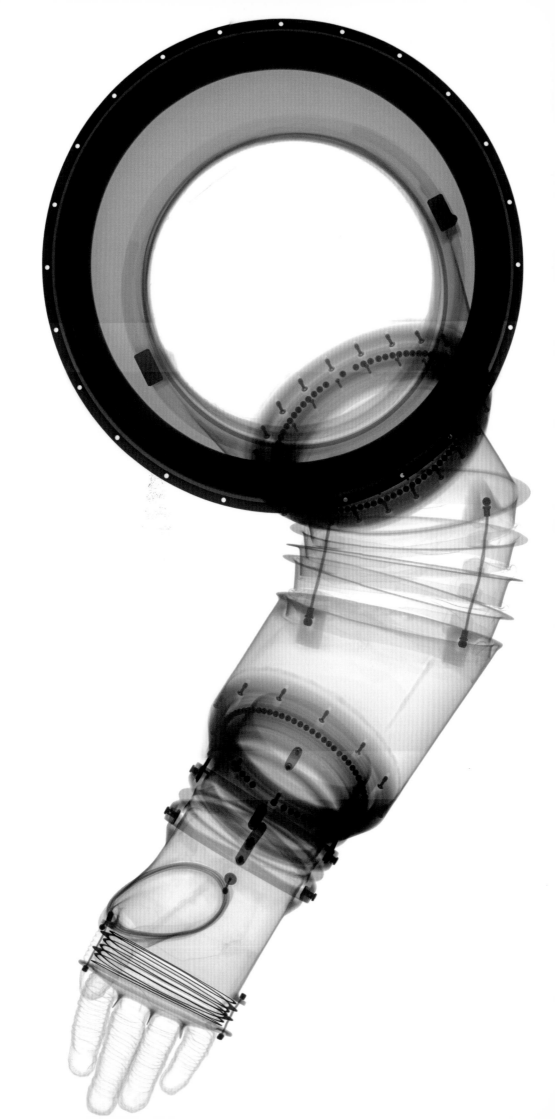

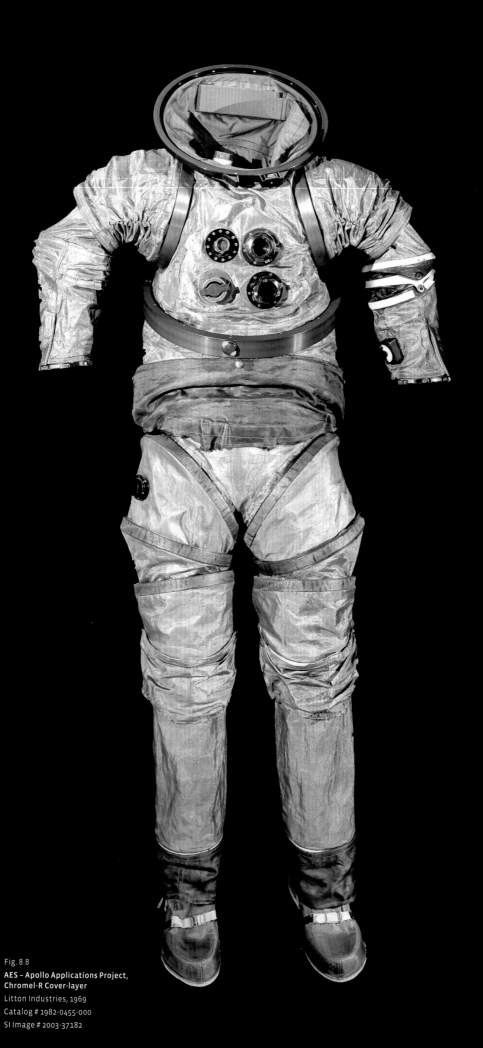

Fig. 8.8
**AES – Apollo Applications Project,
Chromel-R Cover-layer**
Litton Industries, 1969
Catalog # 1982-0455-000
SI Image # 2003-37182

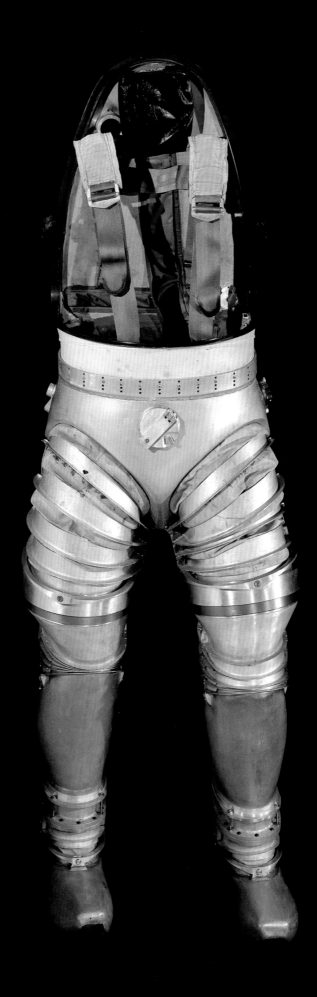

Above:
Fig. 8.9
RX-2 – Apollo Applications Project
Litton Industries, 1963
Catalog # 1972-0536-000
SI Image # 2005-14756

Right:
Fig. 8.10
RX-2 Legs with RX-2A Partial Torso
Litton Industries, 1964
Catalog # 1973-1015-000
SI Image # 2004-10863

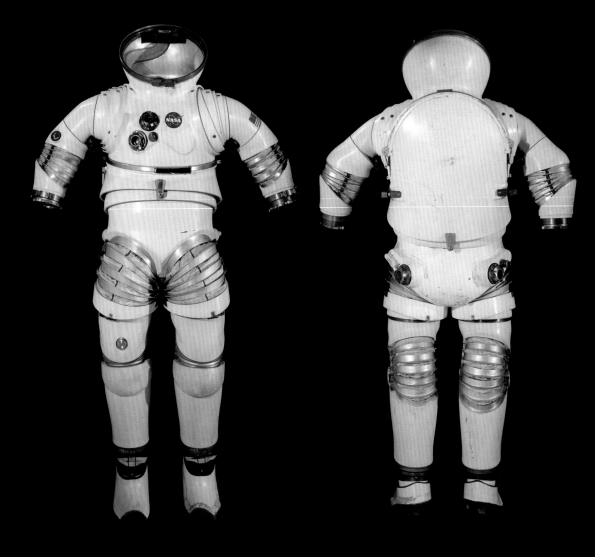

Fig. 8.11
RX-4 – Front and Rear Views
Litton Industries, 1966
Catalog # 1976-0873-000
SI Image # 2004-10869 (Front)
 2004-10870 (Rear)

so much importance was placed on these systems, they used standard Air-Lock connectors, and did not have specially-designed gloves either. Consequently, any available gloves were used—usually Gemini. The helmets however, were made for the individual suit, and after the RX-2 were hemispherical in shape. This provided unimpeded vision, and in some instances could be rotated if vision was impaired by scratches. The boots were all of the "Dutch-boy"-style, and were integrated into the suit.

By 1964, the NASA–Ames Research Center Bio-Technology division was also constructing hard suits as part of the NASA requirements for a system for long-term lunar exploration or zero-gravity use. During this time, Hubert "Vic" Vykukal designed and constructed

the AX-1 prototype. This suit weighed 72 lb., and was made primarily of fiberglass, with metal bellows sections in the waist and thighs. It operated at 5 psi of pure oxygen, and had a modified bandolier-type closure with rotary joints. Rotary joints affected the inner volume of air less than other types of joint and Mr. Vykukal's considerable work on these joints was responsible for their successful use in spacesuits. It was air cooled and used standard Apollo gloves. Unfortunately, some years ago, the arms were accidentally put on the Excess Property List and disposed of, and it is unknown what happened to them (Fig. 8.21).

Built in 1968, the AX-2 was the follow-along to the AX-1. The AX-2 was also a suit with rotary joints, and had modular sizing with a steel bellows waist

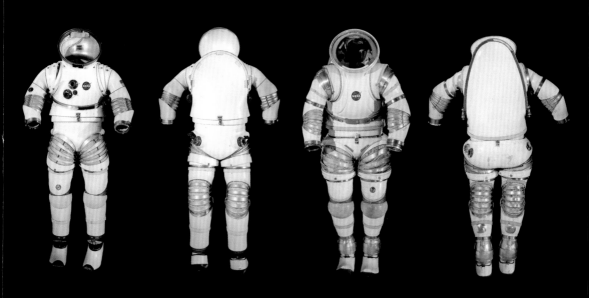

Fig. 8.12
RX-3 – Front and Rear Views
Litton Industries, 1965
Catalog # 1976-0872-000
SI Image # 2004-10880 (Front)
 2004-10881 (Rear)

Fig. 8.13
RX-2A – Front and Rear Views
Litton Industries, 1964
Catalog # 1982-0453-000
SI Image # 2004-10882 (Front)
 2004-10883 (Rear)

closure system enabling easier bending. Like the AX-1, it operated at 5 psi of pure oxygen, and was air-cooled. Made of fiberglass and foam laminate, it weighed about 72 lb. The integrated helmet was a spare MOL polycarbonate one, cut down to size (Fig. 8.18).

In 1974, Vykukal and the team at NASA–Ames Research Center designed and built a suit with an operational pressure of 8 psi. The AX-3 program was to see if it was possible to construct a suit with a higher internal operating pressure, which would minimize the pre-breathe time, thus reducing the possibility of the "bends." The AX-3 was considered a "hybrid," so called because it used several types of joints and materials. It had a dual-plane closure system with rotary joints, and was constructed with fiberglass and foam laminate

hard structures, and single-wall laminated Nomex "soft" sections. Once pressurized, these soft sections became rigid, giving the suit all the advantages of hard suits, with those of a soft suit while un-pressurized, yet without the weight. The boots were therefore able to be flexible, and the hemispherical helmet provided the maximum visibility. This suit proved that a fully functioning, high-pressure-suit, able to operate at 8 psi was possible (Fig. 8.16).

The AX-4 was designed in 1981, but was never constructed. However, the AX-5 (of which two were eventually made), was constructed in the late 1980s. Designed to operate at 8 psi, this suit was made of T-6 aluminum with chemical resistant coatings, and like the AX-1 and AX-2, contained no fabric sections at all.

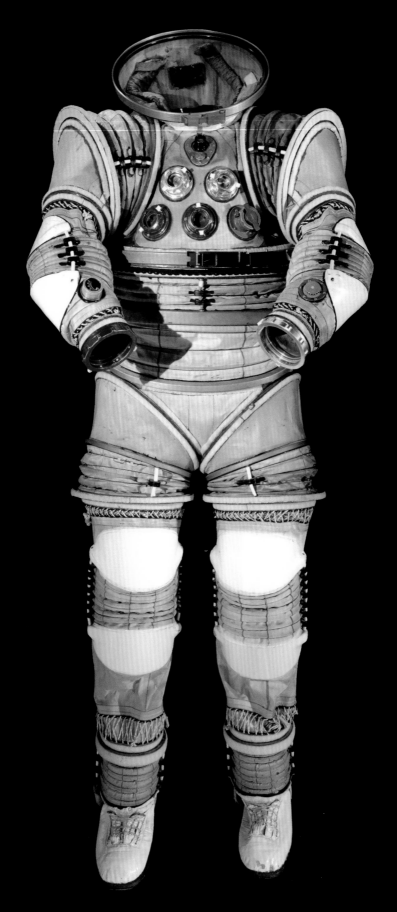

Fig. 8.14
EX1-A – Apollo Applications Project
AiResearch Corporation, 1968
Catalog # 1982-0454-000
SI Image # 2004-10884

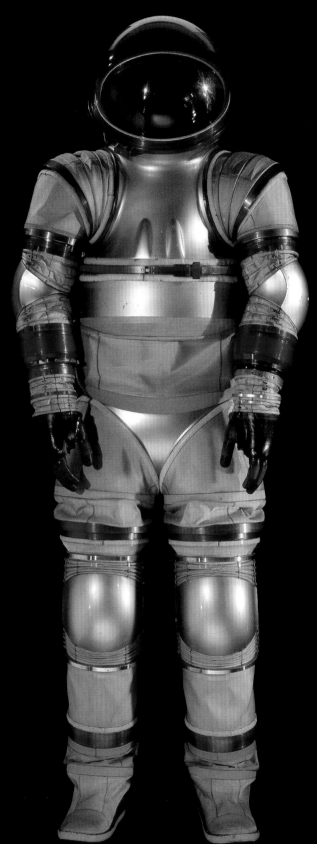

Above:
Fig. 8.15
B1-A "Hybrid" AES
Litton Industries, 1969
Catalog # 1979-0690-000
SI Image # 2004-44551

Right:
Fig. 8.16
AX-3
NASA – Ames Research Center, 1974
Catalog # 2004-0265-000
SI Image # 2004-55438

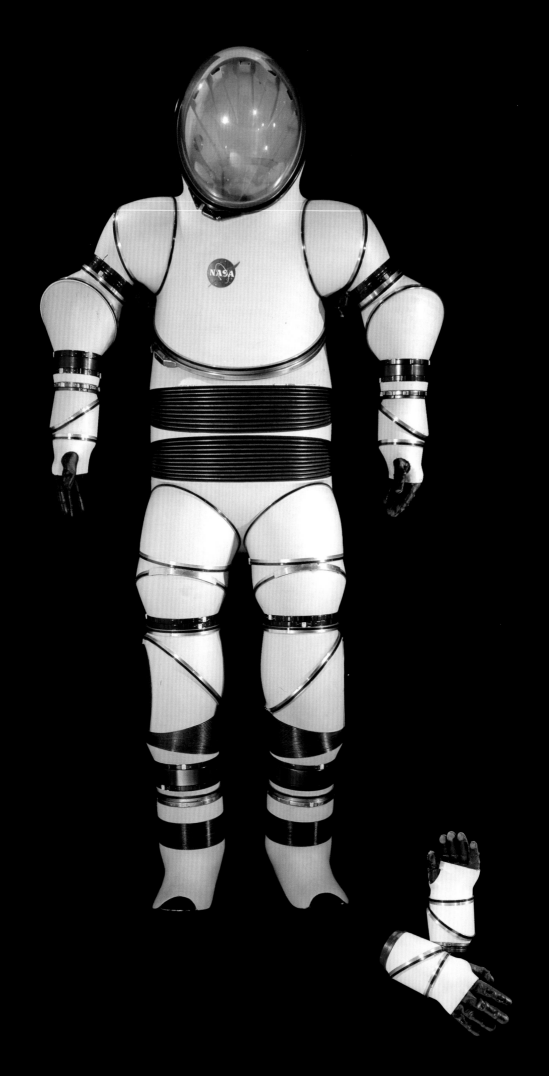

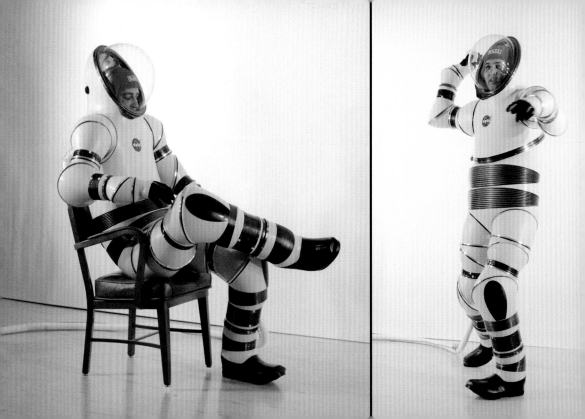

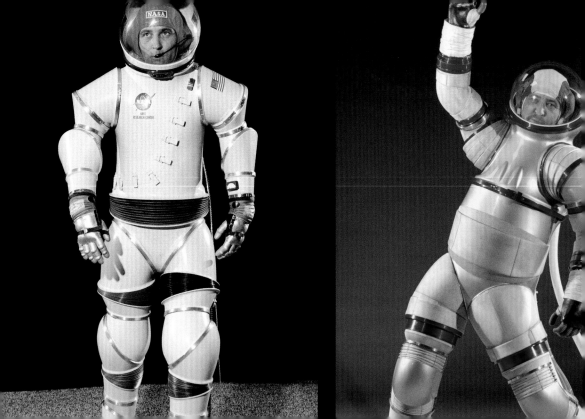

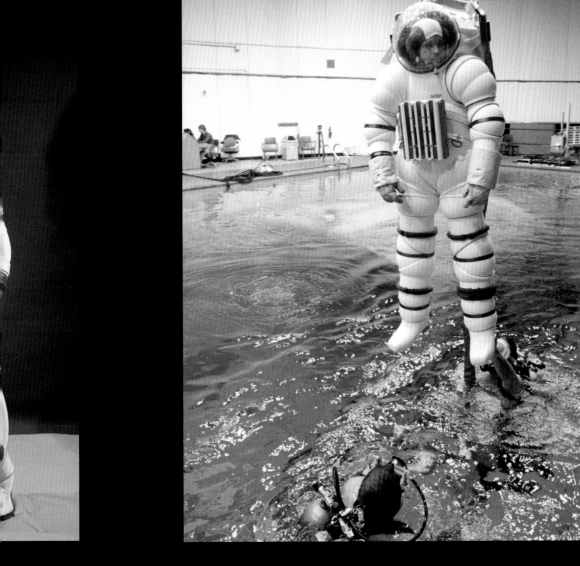

extraordinary joint systems to provide the wearer with an unprecedented range of motion, while fully pressurized. Some of the finest minds in the Nation produced this innovative spacesuit research that was done during the 1960s and 1970s, resulting in the design and construction of these extraordinary suits. With their exceptional joint systems, materials, and design, they initially appear to be clumsy and uncomfortable—however, they were and are in fact, amazingly versatile and easy for the wearer to maneuver while pressurized. The joint systems in these suits still "move" at the slightest touch and, though difficult to display, these pressure-suits are a particularly intriguing and historically valuable part of the National Collection.

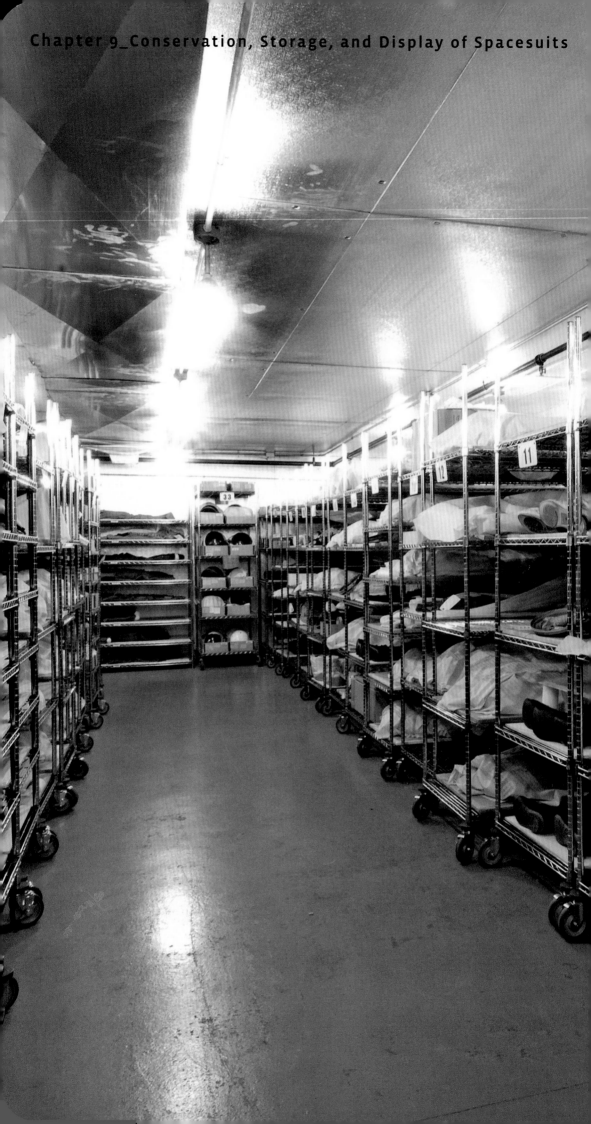

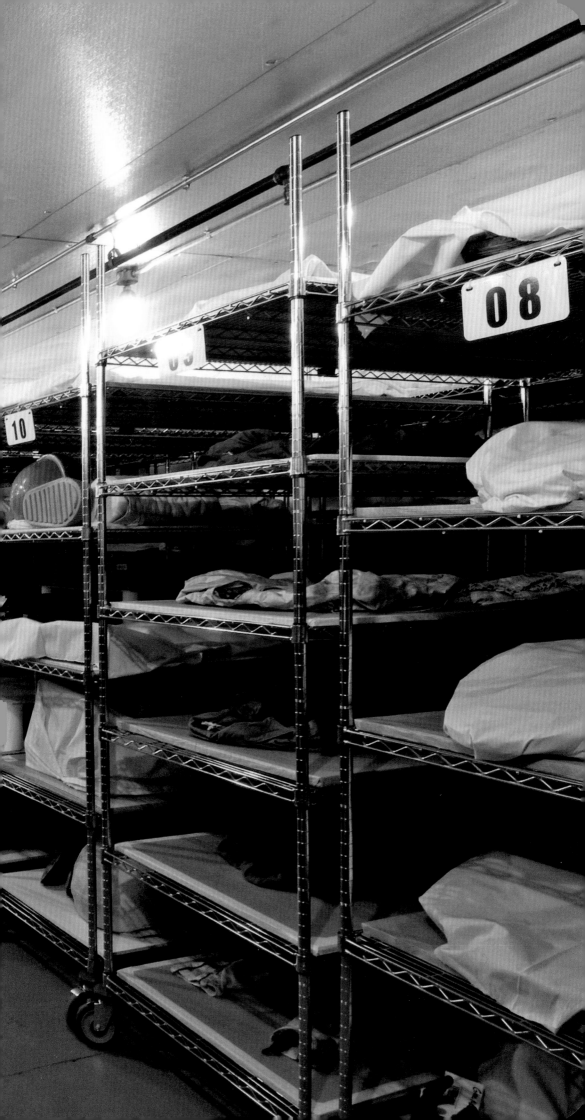

The spacesuits developed for and used during the U.S. space programs of the 1960s and 1970s required the development, fabrication, and innovative use of extraordinary materials—the suits were made of a combination of these modern materials, natural materials, and metals—all the best materials available to the spacesuit designers at the time. The life spans of some of these new and man-made materials were unknown, and though combined with natural materials, such as rubber—the life span of which was known—long-term survival and condition of these materials was not well understood. The end result has been that most of the spacesuits from the early space programs of the United States have deteriorated to a point where display is impossible.

The staff at the National Air and Space Museum, have spent many years researching the problems associated with long-term care and storage of these materials, and caring for this collection has its own particular set of problems and rewards. Spacesuits deteriorate because of what they are, the materials used during their construction, and their life—not necessarily because they went into space or didn't—and stabilizing and preserving this collection is a lifetime's work. The materials in full-pressure/space-suits range from natural cotton, leather and rubber, metals including woven stainless steel (Chromel-R), steel, and aluminum, to polyesters, nylons, plastics and fiberglass, and paint. Sections of these spacesuits were connected to each other with glues, tapes, and cording, and it is these areas that frequently have deteriorated first, victims of time, chlorine-strong neutral buoyancy tanks, hard training, and less than ideal storage conditions. Additionally, there are areas that have been changed or repaired using materials like masking or duct tape which cannot be removed because of the damage that would probably be caused to the object, or even because of its historic nature. At NASM, we do not "restore" or replace parts on spacesuits, rather keeping them as they came to us from NASA, in their original or historic configuration, opting instead to preserve the original pieces to the best of our ability.

In the past, it was believed that as spacesuits had withstood the extremes of space, they would last forever, but these early spacesuits and the materials from which they are made have become extremely fragile with time, and need to be displayed and stored in very specialized conditions. This includes narrow parameters of light, temperature, and humidity, along with specialized materials to support them while in storage and on display, in order to preserve them for future generations. The newer spacesuits, such as those used on the Shuttle, use no natural materials at all, but even so, the prognosis for their long-term survival is also unknown.

In previous years, it was only realized that the spacesuit would have a relatively short useful life. Rubber was known to start its process of deterioration in a relatively short time, which was one of the reasons why spacesuit bladders were only constructed approximately six months prior to flight. The spacesuits were flown one time and then "downgraded" by NASA to "Not for Flight," and either used for training purposes or transferred to the Smithsonian

are now stored in environmentally controlled rooms at a temperature of 68 degrees Fahrenheit with 35% Relative Humidity, in complete darkness, and with inert "soft" mannequins inserted to minimize damage. When lent for display, borrowers agree to a strict set of conditions, including temperature, humidity, and light conditions, and the NASM installation of an inert display mannequin, designed to maintain and spread the weight of the spacesuit evenly, supports the spacesuit throughout the period of exhibition.

The preservation research undertaken by NASM under the auspices of the Save America's Treasures grant, additional research done with the help of the Smithsonian Institution Women's Committee grant of 2005, and the ongoing research with NASA and the Smithsonian's Museum Conservation Institute (MCI) assists other museums with their spacesuit and pressure-suit storage and display. Recent spacesuit research undertaken by NASA will help in the design parameters for the suits to be used for the return to the Moon and possible travel to Mars, and continues to influence advanced clothing and hazardous equipment design. The work done by the NASA-Ames Research Center has found its way into safety garments for underwater exploration, and Mars suit studies in Houston and NASA-Glenn Research Center still build on the materials and technologies used in the very first lunar exploration. The nylons and glues have helped revolutionize dentistry and other medical applications, and the science that wearing these suits has enabled the astronauts and specialists to conduct in space, is just beginning to be appreciated.

Top, from left to right:

Fig. 9.7
Badly Deteriorated Pressure Bladder of SPD-766 "A2-L"
2001
Photo by Samantha Snell

Fig. 9.8
Deteriorated Rubber in Convoluted Shoulder Section
2001
Photo by Samantha Snell

Fig. 9.9
Bad Internal Mannequin
2001
Photo by Samantha Snell

Fig. 9.10
Mannequin Made of Wood and Duct-tape, removed 2001
Photo by Samantha Snell

Fig. 9.11
Bad Internal Mannequin
2001
Photo by Samantha Snell

Bottom, left to right:

Fig. 9.12
Deteriorated Cover-layer of Early Apollo Suit
2001
Photo by Samantha Snell

Fig. 9.13
Example of Damage Done for Exhibit Purposes
Removed 2001
Photo by Samantha Snell

Fig. 9.14
Deteriorated Apollo A6-L Boot Soles
2001
Photo by Samantha Snell

Fig. 9.15
Conservator Lisa Young and Amanda Young Working on Cernan's Apollo 10 Suit
2001
Photo by Samantha Snell

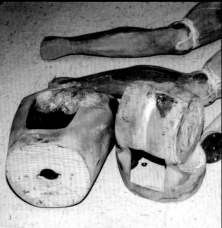

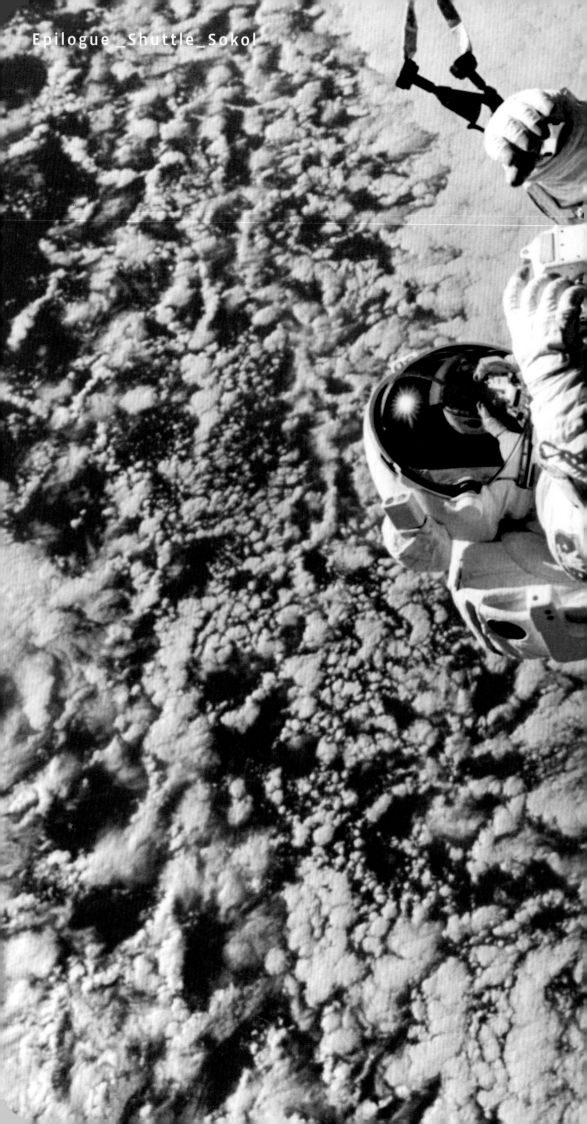

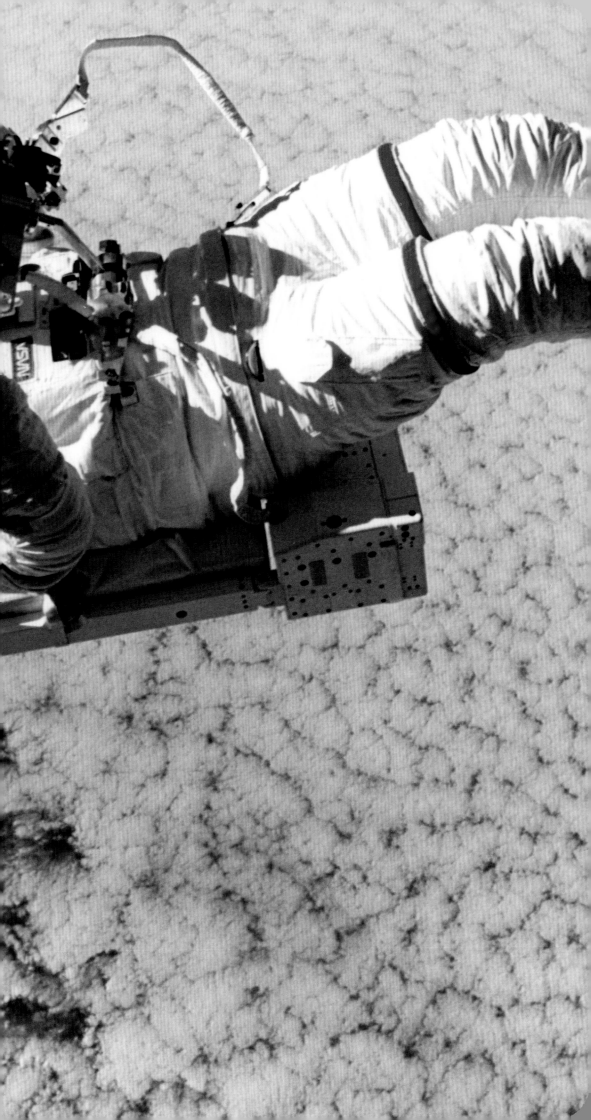

A book such as this would be somewhat incomplete without the mention of the U.S. spacesuits developed and used after the Apollo era, and those developed and used in the Soviet Union/Russia. Unfortunately at this time, the National Collection is not well represented from this period in history, as the spacesuits used both on the Space Shuttle and in the Russian programs are still in active use.

SHUTTLE:

Though the "go-ahead"—along with funding—for development of the Space Shuttle vehicle was given in 1972, planning and development of the next spacesuit system had begun some years earlier, and by 1971 was actually tied to the Shuttle. The Shuttle extra-vehicular suit, known as the Extra-vehicular Mobility Unit (EMU) was based on aspects of three earlier programs and developments. One was the Litton flat pattern joints' work of the late 1960s, which was developed further by ILC and NASA during ILC's development of several suits, including the Intra-vehicular Spacesuit Assembly (ISSA), the Emergency Intra-vehicular Suit (EIS), and the Orbital Extra-vehicular Suit (OES). The second was the work done by Hamilton during development of MOL and Skylab Integrated Maneuvering Life Support System, and the third was influences from the work done during the Apollo Applications Project (AAP) and the advanced AES suit development that had come from those programs.

By 1973 NASA had decided that because (unlike the suits and vehicles of previous programs), the Shuttle Orbiter as well as the EMU were to be re-usable, a modular style of spacesuit construction would be the most cost-efficient method of construction. The suits would be assembled from a supply of different sized components, legs, arms, torso, sizing rings, etc., enabling each to be configured to fit any astronaut, male or female, large or small. Whereas the Apollo suits had been a single garment, fitted to a particular astronaut with single bearings in the arms only, the Shuttle suits could be assembled to fit any astronaut by the use of bearings and seals on the torso, legs, and arms.

By the time NASA held the Shuttle EMU competition in 1976, the requirements were for a reusable, robust, cost effective, and compact system, with standardized sizing elements and a six-year useful lifespan. The suit was not to use zippers ("slide fasteners") for entry, or metal cable-restraint lines as in Apollo, and as a cost-saving measure was required to use the Apollo helmets left over from the earlier programs. An additional cost-cutting feature was that NASA decided not to fund a competition prototype. However, Hamilton teamed up with ILC and produced one prototype, the SX-1 (Shuttle Experimental #1). This suit was made with a "Kevlar and no cable restraints" system, in which the restraint system was based primarily on the Kevlar fabric rather than the elaborate cable systems used on the Apollo suits. To prolong the life of the suit, no natural rubber was used anywhere

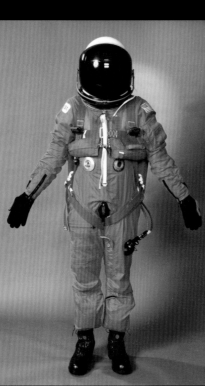
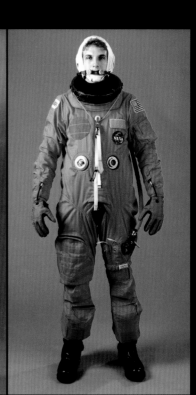

In the suit. Other longer-life materials included a new material called "Ortho Fabric," which was a Gore-Tex/Teflon/Nomex/Kevlar textile, used for the exterior covering. The suit also featured a hard upper torso (HUT) similar to the Litton suits of the 1960s, through which the life support systems (fluids and air) flowed, along with a bearing waist and joint system. The SX-1 was radically different from the Apollo suits, and won the competition, becoming the basis for all the later Shuttle EMU suit models.

The differences between the Apollo suits and the Shuttle Extra-vehicular Suits are many. The Shuttle suit contract did not include a "walking" brief, since it was not designed to be worn on the lunar surface. As a result, it requires greater effort to take walking strides, and does not have a great deal of ability for the wearer to flex the ankles and knees. The suit is also heavy (the complete unit weighs approximately 275 lb. here on earth), but these limitations are of little consequence since the suits are stored in the air-lock on-board the Shuttle Orbiter and the Space Station, and are used only by space-walking astronauts in zero-gravity.

Another difference between the Shuttle EMU and the Apollo lunar suit was the internal operating pressure. The Apollo suit operated with a 3.7 psi internal pressure, and therefore required the wearer to pre-breathe pure oxygen in order to rid the body of nitrogen. Though the Shuttle suit was originally intended to operate with an 8 psi internal operating pressure, requiring little or no-pre-breathe time, thus minimizing the dangers associated with rapid

P.134-135:
Fig. E.1
Astronaut Mark Lee Floating Freely without Tether During STS-64 EV Activities
1994
NASA Image # STS 064-45-014
Courtesy of NASA

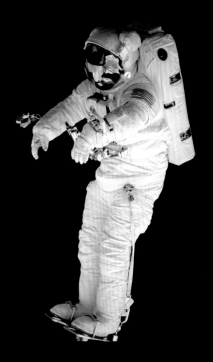

Fig. E.2
Mission Specialist on Foot Restraint Attached to Robot Arm During STS-57 EV Activities
1993
NASA Image # STS-057-89-067
Courtesy of NASA

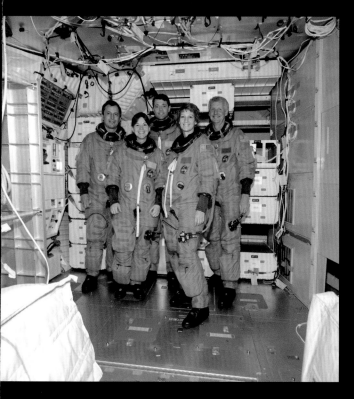

From left to right:

Fig. E.3
Sokol – 1994
Radiograph image of Norman Thagard's suit
Catalog # 1997-0069-000
SI Image # 2009-0967
Ron Cunningham and Mark Avino

Fig. E.4
S-1032 Launch-entry Suits
David Clark Company, 1989
NASA Image # S-88-52685 (Left)
 S-91-32412 (Right)
Courtesy of NASA

Fig. E.5
STS-93 Crew Emergency Egress Training
1998
NASA Image # S-98-10983
Courtesy of NASA

decompression, development costs forced the suit to be constructed first with a 4.0 psi and finally with a 4.3 psi operating pressure. It should be noted however, that the AX-3 Hybrid AES, developed at NASA–Ames Research Center in 1975 had proved that a working 8 psi internal pressure-suit was possible. This was followed by work ILC did on the Mark I and Mark III 8 psi suit in the 1980s that was intended to be an advanced version of the Shuttle spacesuit.

The Space Shuttle astronauts launch wearing "Launch-Entry suits" which are made by the David Clark Company, makers of the Gemini suits, and were developed from high-altitude pressure-suits worn by the US Air Force during the early 1980s. During the early missions, the astronauts wore blue cotton coveralls during launch, but after the Challenger tragedy of 1986, these were changed to the partial pressure Launch-Entry suits (LES), which have evolved into the Advanced Crew Escape System (ACES) full-pressure-suits worn today. These suits provide some protection in the event of fire, loss of cabin pressure, or bail-out. The National Collection includes one example of the partial-pressure LES—which, however, was not flown. This suit operated at 3.2 psi and exerted pressure on the wearer's body mechanically, with the inflation of the internal bladder. It also included an integrated anti-gravity suit, designed to prevent blood from collecting in the lower portions of the wearer's body during the G-forces experienced during re-entry (Fig. E.4).

SOKOL:

In the early 1970s, Zvezda, the Soviet spacesuit and life-support systems' manufacturer, designed and constructed the first of the Sokol (Falcon) full-pressure-suits. Soviet (and later Russian) cosmonauts wear these suits during the most dangerous periods of spaceflight—launch and landing, and have been used ever since they were first designed. There have been several versions of the Sokol suit, the latest of which is the Sokol KV-2 that is in use today. The Sokol suit was not designed for extra-vehicular activities, and for that purpose, Zvezda designed the Krechet suit in the 1960s, which has an integrated life support system. Today, cosmonauts on board the International Space Station use a similar suit for EVAs, also with an integrated life support system—the Orlan suit. Both the Sokol KV-2 and the Orlan EV suit operate with an internal, pure oxygen pressure of 5.8 psi.

In contrast to the contracting arrangements between NASA and US spacesuit manufacturers, the Soviets and Russians have used the same spacesuit manufacturer since the dog Laika went into orbit in 1957. For that reason, the interior construction of the recent Sokol suits is very similar to the suit that Yuri Gagarin wore in 1961, though the exteriors have changed to match advances in the spacecraft and life support.

Unfortunately, the National Collection does not

include two examples of the Sokol KV-2 suit. The first was worn by NASA astronaut Norman Thagard on Soyuz TM-21 to the Mir Space Station in 1995. The second was worn by businessman Dennis Tito as the first space tourist in 2001.

Since the death of the Soyuz 11/Salyut 1 cosmonauts, all passengers on board the Soyuz spacecraft are strapped into an individually shaped and fitted small couch, while wearing the Sokol suit. The pieces are integral to each other, and together provide a relatively safe and comfortable launch and re-entry position.

Entry is through a large "V" shaped zipper opening in the torso cover-layer, and the pressure bladder is sealed by twisting the opening flap and tying it in place with an elastic band-type closure. The KV-2 is made of white nylon canvas with blue trim, and the attached helmet has a rigid, hinged visor. Blue break lines are sewn into the shoulders and forearms and pleated, elasticized knees form part of the restraint system. Anodized aluminum hose connectors are attached to the chest.

The KV-2 is a much less complicated spacesuit than the ones worn during the Apollo era, but is a most efficient piece of equipment. The X-ray of the Sokol suit (Fig. E.3) highlights the differences between the Russian and U.S. spacesuits.

Fig. E.6
STS-88 Mission Specialist Performing EV Activities
1998
NASA Image # STS-088-343-025
Courtesy of NASA

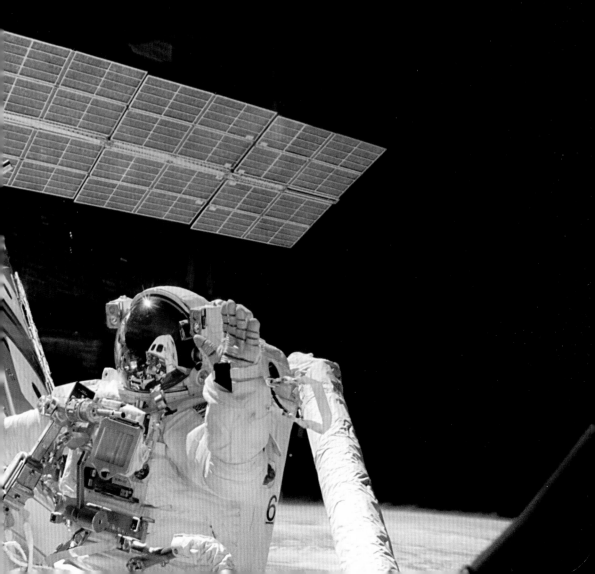

The Early Years:
Around the World in Eight Days: The Flight of the Winnie Mae
Wiley Post and Harold Gatty
Orion Books, New York
ca. 1931, reprinted 1989

"Wiley Post: His Winnie Mae, and the World's First Pressure Suit"
Stanley R. Mohler and Bobby H. Johnson
Smithsonian Annals of Flight, no. 8
Smithsonian Institution Press, Washington D.C.
1971

Suiting up for Space: The Evolution of the Space Suit
Lloyd Mallan
The John Day Company, New York
1971

Historical Note:
"Wiley Post: First Test of High Altitude Pressure Suits in the United
 States"
Major Charles L. Wilson, USAF (MC)
Archive of Environmental Health 10
May, 1965

Conversations with Joseph Kosmo
March, 2001

Mercury:
"U.S. Human Spaceflight: A Record of Achievement, 1961 – 1998"
Compiled by Judy A. Rumerman, NASA History Division
Monographs in Aerospace History, no. 9
July, 1998

"This New Ocean: A History of Project Mercury"
Loyd S. Swenson, Jr., James M. Grimwood, and Charles C. Alexander
The NASA History Series, NASA SP-4201
ca. 1968, reprinted 1989

Jane's Manned Spaceflight Log
Tim Furniss
Jane's Publishing Company, New York
1983

We Seven: by The Astronauts Themselves
M. Scott Carpenter, L. Gordon Cooper, Jr., John H. Glenn, Jr., Walter
 M. Schirra, Jr., Alan B. Shepard, Jr., and Donald K. Slayton
Simon and Schuster, New York
1962

Conversations with Dennis Gilliam
2006

Gemini:
"U.S. Human Spaceflight: A Record of Achievement, 1961 – 1998"
Compiled by Judy A. Rumerman, NASA History Division
Monographs in Aerospace History, no. 9
July, 1998

Field Maintenance Instructions for Gemini Spacesuit Type G3-C
Manual no. DCM-G3C-4
David Clark Company, Worcester
October, 1964

"NASA Project Gemini Technology and Operations: A Chronology"
James M. Grimwood, Barton C. Hacker, and Peter J. Vorzimmer
The NASA History Series, NASA SP 4002
Excerpts relating to pressure suit development and use
 extracted online from
 http://history.nasa.gov/SP-4002/contents.htm
March 13, 2004

Space Suit Development Status
Richard S. Johnston, James V. Correale, and Matthew I. Radnofsky
NASA Technical Note, TN D-3291
NASA, Washington D.C.
February, 1966

Jane's Manned Spaceflight Log
Tim Furniss
Jane's Publishing Company, New York
1983

Manned Orbiting Laboratory (MOL):
US Spacesuits
Kenneth S. Thomas and Harold J. McMann
Springer/Praxis Publishing, Chichester, UK
2006

"The Best Laid Plans: A History of the Manned Orbiting Laboratory"
Steven R. Strom
Crosslink 5, no 2
The Aerospace Corporation, Los Angeles
2004

"Space Suit Technical Information"
Manned Orbiting Laboratory (MOL)
HS/SSI Space Hardware Heritage Team Corporate Publication
Undated

*Evaluation of Manned Orbiting Laboratory Design Definition
 Pressure Garments*
J. Donald Bowen
Document no. AMRL-TR-66-235
Aerospace Medical Research Laboratories
Wright Patterson Air Force Base, Ohio
July, 1968

Conversations with Ken Thomas
2001

Apollo/Skylab/ASTP:
"Apollo Block I Pressure Garment Assembly"
Field Maintenance Manual w/ Parts Catalog
Manual no. DCM-A1C-04-00
David Clark Company, Worcester
November, 1975

"A7-L Apollo Block II"
ILC Familiarization & Operations Manual
Manual no. 8 812 700 149 B
ILC Industries, Bohemia
June, 1969

A7-LB Parts and Materials List
Manual no. 8 822 400 876
ILC Industries, Bohemia
July, 1971

ILC Spacesuits & Related Products
William Ayrey
Manual no. 0000-712731
ILC Industries, Bohemia
2007

US Spacesuits
Kenneth S. Thomas and Harold J. McMann
Springer/Praxis Publishing, Chichester, UK
2006

Jane's Manned Spaceflight Log
Tim Furniss
Jane's Publishing Company, New York
1983

Conversations with Bill Ayrey
1993-2008

Conversations with Ken Thomas
2001

Conversations with Tom Stafford
1993-2008

Advanced Extra-Vehicular Suits:
"The Origins and Technology of the Advanced Extra-Vehicular
 Space Suit"
Gary L. Harris
AAS History Series 24
Univelt, San Diego
2001

The Extra-Vehicular and Lunar Surface Suit
Litton Industries, Space Science Laboratories
Publication no. 6826

Litton Industries
December 1967

US Spacesuits
Kenneth S. Thomas and Harold J. McMann
Springer/Praxis Publishing, Chichester, UK
2006

NASA General Working Paper, no. 10 058
Space Suit Technological Developments (U)
Manned Spacecraft Center, Houston
January, 1966

Conversations with Bill Elkins
1993-2008

Conversations with Gary Harris
1993-2008

Conversations with Vic Vykukal
1993-2008

Conversations with Bruce Webbon
1993-2008

Conservation:
"The Preservation, Storage, and Display of Spacesuits"
Lisa A. Young and Amanda J. Young
Collections Care Report, no 5
Smithsonian National Air and Space Museum, Washington D.C.
2001

Conversations with Lisa Young
1993-2008

Epilogue:
US Spacesuits
Kenneth S. Thomas and Harold J. McMann
Springer/Praxis Publishing, Chichester, UK
2006

ILC Spacesuits & Related Products
William Ayrey
Manual no. 0000-712731
ILC Industries, Bohemia
2007

"The Partnership: A History of the Apollo-Soyuz Test Project"
Edward C. Ezell and Linda N. Ezell
The NASA History Series, NASA SP-4209
1978

Conversations with Cathy Lewis
1993-2008

Conversations with Valerie Neal
2008

Conversations with Bill Ayrey
1993-2008

Conversations with Ken Thomas
2001

Beta Cloth: Tightly woven, Teflon-coated, small-diameter glass fiber yarn—used as a flame-resistant outer layer of Apollo spacesuits. Developed by Owens Corning Fiberglass Corp., Ashton, Rhode Island, under contract to NASA.

Chromel-R: Single draw (non-braided) high chromium/steel material. The fine threads were bundled together and woven into fabric used as a protective layer in lunar gloves, overshoes, and selected areas of spacesuits. Developed by Fabrics Research, Dedham, Massachusetts, under contract to NASA.

Cycolac: Thermo-plastic acrylonitrile-butadiene-styrene (ABS) resin, used for high-impact and flame-retardant properties, combined with high gloss grades, for aesthetic appeal. Developed by General Electric Plastics Division.

Mylar: Highly reflective polymer material, used as lightweight insulation in spacesuits when perforated and alternated with layers of Dacron. Developed by the National Research Corporation, Cambridge, Massachusetts.

Nomex: High-performance heat and flame-resistant textile, used in protective garments for firefighters, race car drivers, and for the outer layer of spacesuits. In sheet form it is used in high-temperature applications, on generators, hoses, etc. In honeycomb form it is used in aircraft. Developed by the DuPont Company, Wilmington, Delaware.

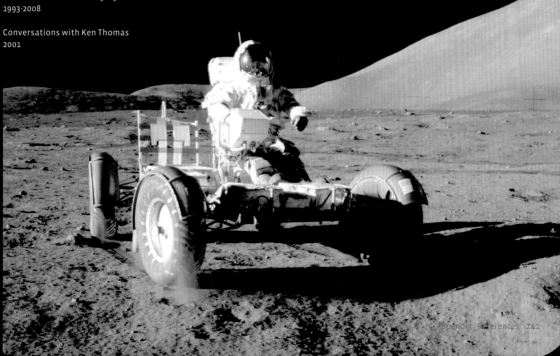

Astronaut Eugene Cernan Driving the Lunar Rover During Apollo 17 Mission
1972
NASA Image # AS17-147-22526
Courtesy of NASA

NASM Cat #	Manuf	Program	Series	Serial #	Date	Other Info	Disposition
1982-0454-000	AiR	AAP	EX-1-A	29-R-1	1968	Earliest confirmed AiResearch (AiR) pressure-suit prototype. Single wall laminate construction with toroidal joints, angled segments, pressure-sealed bearings. Part # 958000-1-1 Contract # NAS 9-7555	NASM
2004-0263-000	Ames	AES	AX-1		1964	NASA – Ames Advanced Extra-Vehicular Suit program Arms missing Rotary joints – 5 psi operation	NASM
2004-0264-000	Ames	AES	AX-2		1968	NASA – Ames Advanced Extra-Vehicular Suit program Rotary joints – 5 psi operation	NASM
2004-0265-000	Ames	AES	AX-3		1974	NASA – Ames Advanced Extra-Vehicular Suit program Hybrid – SWL construction, 8 psi operation	NASM
	Ames	AES	AX-4		1981	Drawings only – suit never constructed	
2004-0266-000	Ames	AES	AX-5		1986	NASA – Ames Advanced Extra-Vehicular Suit program Ortman Coupler connections, all aluminum construction	NASM
2004-0267-000	Ames	AES	AX-5	AX-5-1	1986	NASA – Ames Advanced Extra-Vehicular Suit program Ortman Coupler connections, all aluminum construction, slightly modified hips Shoulders at NASA-JSC Part # ARC AX5 UT	NASM
1975-0672-000	Arrow	DOD	Mk-IV	110		USN—Model 2-B Stock # RH 8475-791-2431-LF50 Contract # 383 (17) 65 183 A (?)	NASM
1980-0038-000	Arrow	DOD	Mk-IV	292		Arrowhead—Model 2-B	NASM
1960-0198-000	BFG	DOD	Mk-II	R-2	1956?	USN—Air Crew Equipment Laboratory/ B.F. Goodrich/Bureau of Aeronautics Contract # 53-384F	NASM
1982-0457-000	BFG	DOD	Mk-II	263		USN Stock # RL 37GD-G-199-20 Contract # N 156-338-28	NASM
1971-0038-000	BFG	DOD	Mark II Mk-IV	475 1308		USN—Model 'O' – Torso only USN—Model 3 Contract # N 383-71224A	NASM
1971-0028-000	BFG	DOD	Mk-IV	731		USN Serial # 1065 (?)	NASM
1971-0781-000	BFG	DOD	Mk-IV	927		USN—Model 2, Type 1-A	NASM
1971-0038-000	BFG	DOD	Mk-IV	1308		USN—Model 3, Type 1-A	NASM
1973-0864-000	BFG	DOD	Mk-IV	267		USN—Model 3 Serial # 1601 (?)	NASM
1971-0782-000	BFG	DOD	Mk-IV	W-85		USN	NASM
1974-0740-000	BFG	DOD	Mk-IV			USN	NASM
2002-0093-000	BFG	DOD	Mk-IV	396		RH 8475-791-2420	NASM
1980-0040-000	BFG	DOD	Mk-V	007		ID # NAS 1-7634	NASM
1980-0041-000	BFG	DOD	Mk-V	151400	1968	One arm with modified shoulder joint – possibly by HS or by BFG for HS Right glove integrated to arm Contract # NAS 1-7634	NASM
1969-0037-000	BFG	Mercury	Mercury	M-2	1959	Phase I, Training—Glenn	NASM
1973-0684-000	BFG	Mercury	Mercury	M-6	1959	Phase I, Anthropomorphic—Carpenter Contract # AS 60-8011C	NASM
1969-0033-000	BFG	Mercury	Mercury	M-8	1959	Phase I, Training—Shepard	NASM
1984-0432-000	BFG	Mercury	Mercury	M-14	1960	Phase II, Training—Meyers	NASM
1972-1158-000	BFG	Mercury	Mercury	M-15	1960	Phase II, Flight – Sigma-7—Schirra	NASM
1969-0035-000	BFG	Mercury	Mercury	M-16	1960	Phase II, Training—Augerson/ Slayton	NASM
1975-0751-000	BFG	Mercury	Mercury	M-19	1960	Phase II, Training—Schirra	NASM
1985-0234-000	BFG	Mercury	Mercury	M-20	1960	Phase II, Flight – Faith-7—Cooper Modified shoulders	NASM
2003-0178-000	BFG	Mercury	Mercury	M-21	1960	Phase II, Flight – Liberty Bell-7—Grissom	NASM
1977-0563-000	BFG	Mercury	Mercury	M-22		Phase II, Flight – Freedom-7—Shepard	NASM
1967-0178-000	BFG	Mercury	Mercury	M-23		Phase II, Flight – Friendship-7—Glenn	NASM
1972-1161-000	BFG	Mercury	Mercury	M-24		Phase II, Training—Carpenter	NASM
	BFG	Mercury	Mercury	M-25		Phase II, Anthropomorphic – Slayton Contract # AS 60-8011C	NASM 1973-0685-000 Deaccessioned – 1981 Transferred to NASM – Education Div.
1971-0022-000	BFG	Mercury	Mercury	M-26		Phase II, Flight – Aurora-7—Carpenter	NASM
1972-0541-000	BFG	Mercury	Mercury	M-27		Phase II, Training—Cooper	NASM
1976-1555-000	BFG	Mercury	Mercury	M-28		Phase II, Training—Glenn	NASM
1973-0686-000	BFG	Mercury	Mercury	M-29		Phase II, Anthropomorphic—Grissom Contract # AS 60-8011C	NASM
1973-0682-000	BFG	Mercury	Mercury	M-30		Phase II—Schirra Contract # AS 60-8011C	NASM
	BFG	Mercury	Mercury	M-31		Phase II—Shepard Modified shoulders Contract # AS 60-8011C	NASM 1973-0683-000 Deaccessioned – 1982 Trans to NASA-JSC Trans to Omniplex
1982-0422-000	BFG	Mercury	Mercury	M-32		Phase II, Training—Slayton	NASM
1962-0022-000	BFG	Mercury	Mercury	Unk		Shepard	NASM
1972-0542-000	BFG	Gemini	G2-G	001	1962	Size: Medium-Regular Contract # NAS 9-252	NASM
1971-0023-000	BFG	Gemini	G2-G	002	1962	Prototype GX2-G	NASM

NASM Cat #	Manuf	Program	Series	Serial #	Date	Other Info	Disposition
1969-0036-000	BFG	Gemini	G2-G	004	1962	Shepard	NASM
	BFG	Gemini	G2-G	005	1962		NASM 1972-1162-000 Deaccessioned – 1981 NASM Conservation Lab
1971-0036-000	BFG	Gemini	G2-G	008	1962	Grissom	NASM
	BFG	Gemini	G2-G	009	1962	Size: Large-Long	NASM 1969-0029-000 Deaccessioned Disposed—1979
	BFG	Gemini	G2-G	010	1962		
	BFG	Gemini	G2-G	011	1962		NASM Reacquired by NASA – 1985
1971-0027-000	BFG	Gemini	G2-G	012		Grissom	NASM
1969-0031-000	BFG	Gemini	G2-G	014	1963	Size: Large-Regular Contract # NAS 9-252	NASM
1969-0034-000	BFG	Gemini	G2-G	015	1963	Size: Large-Regular	NASM
1979-1335-000	BFG	Apollo		XN-20	1964	Prototype made for HS using HS and BFG mobility concepts. 11/64 Order # LL 145802	NASM
						High-Altitude	NASM 1973-0836-000 Destroyed 1977
	DCC	Gemini	G1-C	001	1962	Grissom	NASM 1971-0787-000 Deaccessioned Disposed – 1980
	DCC	Gemini	G1-C	002			
	DCC	Gemini	G1-C?	003		Prototype Size: Medium-Regular	NASM 1973-0857-000 Deaccessioned Disposed – 1977
	DCC	Gemini	G1-C	005			Transferred to NASM No NASM Cat # Destroyed
1971-0029-000	DCC	Gemini	G1-C	006	1963	High-Altitude, full-pressure-suit, G1-C-6 Grissom, 04/63	NASM
1981-0590-000	DCC	Gemini	G1-C	008			NASM
	DCC	Gemini	G1-C	009	1963	G1-C-9 Grissom	NASM 1971-0037-000 Deaccessioned Disposed
1982-0417-000	DCC	Gemini	G1-C	012			NASM
1971-0786-000	DCC	Gemini	G2-C	103	1963	High-Altitude, G2-C-3 Marcum, 08/63	NASM
	DCC	Gemini	G2-C	104			Transferred to NASM No NASM Cat # Disposed – 1977
	DCC	Gemini		105		Kanowski	Transferred to NASM No NASM Cat # Transferred to KCSC
1971-0029-000	DCC	Gemini	G1-C? G2-C?	106		Grissom	NASM
1975-0666-000	DCC	Gemini	G1-C	107	1963	High-Altitude Shepard, 05/63	NASM
1971-0037-000	DCC	Gemini	G1-C? G2-C?	109		Grissom	** Record Discrepancy
1982-0456-000	DCC	Gemini	G2-C	111	1963	Young Part # 5961 11/63	NASM
1973-0822-000	DCC	Gemini	G2-C	116	1964	Conrad	NASM
1973-0837-000	DCC	Gemini	G2-C	122	1964	White/Carpenter? Part # S-961	NASM
	DCC	Gemini	G2-C	123	1964	Borman	NASM 1973-0817-000 Deaccessioned—1973 Trans to Naval Coastal Systems Lab
1973-0827-000	DCC	Gemini	G2-C	126	1964	Grissom Part # S-961 Model # G2C-26	NASM
	DCC	Gemini	G2-C	129	1964	Shepard Part # S-961 Model # G2C-29	NASM 1971-0788-000 Deaccessioned Transferred to KCSC
1973-0854-000	DCC	Gemini	G2-C	131	1964	Slayton Part # S-961 Model # G2-C-31	NASM
1968-0456-000	DCC	Gemini	G3-C	101	1964	Flight – Gemini 3—Grissom	NASM
	DCC	Gemini	G3-C	102	1964	Stafford?	No NASM Cat # Disposed – 1977
1968-0442-000	DCC	Gemini	G3-C	103	1964	Flight – Gemini 6—Schirra	NASM
1973-0226-000	DCC	Gemini	G3-C	104	1964	Flight – Gemini 3—Young	NASM
1973-0832-000	DCC	Gemini	G3-C	105	1964	Grissom	NASM
1975-0660-000	DCC	Gemini	G3-C	107		Training—Schirra	NASM
	DCC	Gemini	G3-C	108		Training?—Young/Castor Part # S-964-A	NASM 1973-0820-000 Deaccessioned Disposed – 1977
1983-0079-000	DCC	Gemini	G3-C	213		Training—McDivitt	NASM
1973-0838-000	DCC	Gemini	G3-C	214		White	NASM
1967-0167-000	DCC	Gemini	G4-C	403		Flight suit – Gemini 4—McDivitt	NASM
	DCC	Gemini	G4-C	404		Cernan	NASM 1973-0821-000 Deaccessioned Disposed – 1977
	DCC	Gemini	G4-C	405			

NASM Cat #	Manuf	Program	Series	Serial #	Date	Other Info	Disposition
1985-0223-000	DCC	Gemini	G4-C	406		Training—Overmeyer Part # 983-A Model # AFG-4C-6	NASM
	DCC	Gemini	G4-C	406		Lovell	NASM 1973-0829-000 Deaccessioned Disposed—1980
	DCC	Gemini	G4-C	406-B		Lovell/Borman Part # S-983-A	NASM 1973-0830-000 Deaccessioned Disposed – 1980
	DCC	Gemini	G4-C	407			
1967-0210-000	DCC	Gemini	G4-C	408		Flight – Gemini 4—White Modified G3-C suit used thermal over-gloves and slipover jacket Helmet GH4-C-4 S#404, Gloves S#GG3C-10L – 14R	NASM
1968-0447-000	DCC	Gemini	G4-C	410		Flight – Gemini 5—Cooper	NASM
1973-0815-000	DCC	Gemini	G4-C	411	1963	Training—Anders	NASM
	DCC	Gemini	G4-C	412		Armstrong	NASM 1971-0799-000 Cover-layer destroyed – 1977
	DCC	Gemini	G4-C	413			
	DCC	Gemini	G4-C	414		Training suit?—Cooper Pressure garment and coverlayer accessioned separately	1973-0823-000 – PG 1973-0801-000 – CL Deaccessioned – 1977 Disposed
1968-0452-000	DCC	Gemini	G4-C	415		Flight – Gemini 5—Conrad	NASM
	DCC	Gemini	G4-C	416			
1968-0444-000	DCC	Gemini	G4-C	417	1965	Flight – Gemini 9 – Stafford Used same helmet as on GT-6	NASM
	DCC	Gemini	G4-C	418		Grissom	NASM 1973-0828-000 Deaccessioned
1968-0300-000	DCC	Gemini	G4-C	419		Flight – Gemini 10—Young	NASM
	DCC	Gemini	G4-C	421		Flight – Gemini 6—Stafford Missing coverlayer Used same helmet as on GTA-9	NASM 1968-0445-000 Deaccessioned Transferred to KCSC – 1982
1973-0818-000	DCC	Gemini	G4-C	422		Training—Borman	NASM
1968-0455-000	DCC	Gemini	G4-C	424		Flight – Gemini 8—Armstrong Part # S-983-A EV Configuration	NASM
1968-0452-000	DCC	Gemini	G4-C	425	1965	Flight – Gemini 5—Conrad	NASM
	DCC	Gemini	G4-C	427	1965	Flight – Gemini 8—Scott Part # S-983	NASM 1973-0835-000 Deaccessioned Transferred to NASA – JSC – 1980
	DCC	Gemini	G4-C	429		Training—See Part # S-983	NASM 1973-0833-000 Deaccessioned—1973 Transferred to NCSL
1973-0824-000	DCC	Gemini	G4-C	431		Training—Cooper	NASM
1968-0439-000	DCC	Gemini	G4-C	432	1965	Flight – Gemini 9—Cernan Coverlayer used for post-flight research Part # A-1725	NASM
	DCC	Gemini	G4-C	433		Back-up—Bean/Collins Part # S-983	NASM 1973-0816-000 Deaccessioned—1973 Transferred to NCSL
1985-0224-000	DCC	Gemini	G4-C	434		USAF Part # S-983	NASM
1968-0437-000	DCC	Gemini	G4-C	436	1966	Flight – Gemini 10—Collins Part # S-983	NASM
	DCC	Gemini	G4-C	439		Flight – Gemini 11—Conrad	NASM 1968-0454-000 Deaccessioned Transferred to KCSC – 1982
1972-0544-000	DCC	Gemini	G4-C	440		Flight – Gemini 11—Gordon	NASM
1968-0449-000	DCC	Gemini	G4-C	441		Flight – Gemini 12—Lovell	NASM
	DCC	Gemini	G5-C	0	1965	Developmental—Lovell	NASM 1973-0831-000 De-accessioned Disposition unknown
	DCC	Gemini	G5-C	502	1965	Lovell Part # S-1006	No NASM Cat # Transferred to KCSC – 1984
1972-1159-000	DCC	Gemini	G5-C	503	1965	Back-up—Borman Part # S-1006	NASM
1977-1017-000	DCC	Gemini	G5-C	504	1965	Training—Lovell Part # S-1006	NASM
1968-0022-000	DCC	Gemini	G5-C	505	1965	Flight – Gemini 7—Borman Part # S-1006	NASM
1968-0450-000	DCC	Gemini	G5-C	506	1965	Flight – Gemini 7—Lovell Part # S-1006	NASM
1985-0220-000	DCC	Gemini	G5-C	507	1965	Prime – Back-up crew – Gemini-7—Collins Part # S-1006	NASM
	DCC	Gemini	G5-C	509	1965	Training—Borman Part # S-1006	NASM 1973-0819-000 Deaccessioned Transferred to NASM Educational – 1980
1973-0839-000	DCC	Gemini	G5-C	511	1965	Prime – Back-up crew – Gemini 7 Part # S-1006	NASM
1975-0659-000	DCC	Apollo	A1-C	101	1966	Block I, Early Apollo Training—Collins Contract # NAS 9-1369	NASM
1973-0846-000	DCC	Apollo	A1-C	102	1966	Block I, Early Apollo Training Size: Large-Long Part # S-987 Contract # NAS 9-1369	NASM
1985-0216-000	DCC	Apollo	A1-C	104	1966	Early Apollo Training Size: Large-Regular Part # S-987 Contract # NAS 9-1369	NASM

NASM Cat #	Manuf	Program	Series	Serial #	Date	Other Info	Disposition
1973-0849-000	DCC	Apollo	A1-C	108	1966	Early Apollo Training Size: Large-Regular Contract # NAS 9-1369	NASM
1973-0848-000	DCC	Apollo	A1-C	112	1966	Early Apollo Training Size: Large-Long Contract # NAS 9-1369	NASM
	DCC	Apollo	A1-C	113	1966	Block I, Early Apollo Training Contract # NAS 9-1369	NASM 1971-0805-000 Deaccessioned—1973 Trans to Univ/ CA – 1987
1973-0850-000	DCC	Apollo	A1-C	114	1966	Block I, Early Apollo Training Contract # NAS 9-1369	NASM
1973-0851-000	DCC	Apollo	A1-C	115	1966	Block I, Early Apollo Training Contract # NAS 9-1369	NASM
1973-0834-000	DCC	Apollo	A1-C	120	1966	Block I, Early Apollo Training Contract # NAS 9-1369	NASM
1983-0076-000	DCC	Apollo	A1-C	125	1966	Block I, Early Apollo Training—Schirra Part # A-1936-000, 08/66	NASM
1973-0825-000	DCC	Apollo	A1-C	127	1966	Block I, Early Apollo Training—Cunningham Contract # NAS 9-1369	NASM
1973-0852-000	DCC	Apollo	A1-C	128	1966	Block I, Early Apollo Training—Stafford Contract # NAS 9-1369	NASM
1983-0075-000	DCC	Apollo	A1-C	129	1966	Block I, Early Apollo Training—Borman Contract # NAS 9-1369	NASM
1985-0644-000	DCC	Apollo	A1-C	131	1966	Block I, Early Apollo Training—Schirra EV Configuration Liner Serial # 125	NASM
1979-0872-000	DCC	Apollo	A1-C	132	1966	Block I, Early Apollo Training—Eisele Contract # NAS 9-1369	NASM
1973-0826-000	DCC	Apollo	A1-C	133	1966	Block I, Early Apollo Training—Cunningham Contract # NAS 9-1369	NASM
1973-0851-000	DCC	Apollo	A1-C	155	1966	Block I, Early Apollo Training—Schirra Contract # NAS 9-1369	NASM
1973-0845-000	DCC	Apollo	S1-C	101	1965	HEPA – used by technicians supporting astronauts in vacuum chamber tests	NASM
	DCC	Apollo	S1-C	103	1965	HEPA – used by technicians supporting astronauts in vacuum chamber tests	Transferred to NASM No Cat # Transferred to USSRC (ASRC) – 1984
1985-0222-000	DCC	Apollo	S1-C	104	1965	HEPA – used by technicians supporting astronauts in vacuum chamber tests Part # S-993	NASM
1973-0847-000	DCC	Apollo	S1-C	105	1965	HEPA – used by technicians supporting astronauts in vacuum chamber tests Size: Large-Long Part # S-987	NASM
1985-0221-000	DCC	Apollo	S1-C	106	1965	HEPA – used by technicians supporting astronauts in vacuum chamber tests Model # S-1C-6 Part # S-993	NASM
1973-0223-000	DCC	DOD	S-848-C				NASM Aeronautics Division
1985-0219-000	DCC	MOL	MD-1 S-1020-A	101	1966	USAF Evaluation Prototype Part # 10004G-01 Contract # AF04 (695)-944	NASM
1985-0218-000	DCC	MOL	MD-2 S-1020-A	102	1966	USAF Evaluation Prototype Part # 10049G-02, 03/66 Contract # AF04 (695)-944	NASM
1979-1333-000	DCC	MOL	MD-3 S-1020-A	103	1966	USAF Evaluation Prototype Size: Medium-Regular, 07/66 Part # 10184G-01 Contract # AF04 (695)-944	NASM
1982-0463-000	DCC	Adv. Apollo	S-1021	101	1967	Prototype – Advanced component Horseshoe-shaped zipper closure	NASM
	DCC	Adv. Apollo	S-1026	101		Advanced component	NASM 1973-0842-000 Deaccessioned?
1977-2788-000	DCC	Adv. Apollo	S-1026	102	1966	Anders—Prototype	NASM
1973-1213-000	DCC	DOD	S-1030			Size: Small-Short	NASM Aeronautics Division
1992-0082-000	DCC	DOD	S-1030		1983	Serial # 37 or 41?	NASM Aeronautics Division
1999-0074-000	DCC	DOD	S-1030				NASM Aeronautics Division
2001-0212-000	DCC	Shuttle	S-1032	024	1989	Launch Entry Suit (LES) – Flight, orange Size: Small-Long, 02/89	NASM
1980-0039-000	HS	MOL	XT-3	104	1965	Experimental Tiger Suit #3, later retrofitted to XT4 restraint system, and later modified for R&D. Fitted w/ experimental shoulders & hips to enable torso to bend.	NASM
1977-1018-000	HS	MOL	MH-5	001	1967	First MOL training suit configuration, cover garment needs to be re-attached. Part # SV 721700-1-1	NASM
1978-1466-000	HS	MOL	MH-6	003		MOL—SV 731150181-3 Retrofitted to MH-7 w/MH-8 LSS connector configuration Original thermal coverlayer Doesn't match engineering control drawing at HS	NASM

NASM Cat #	Manuf	Program	Series	Serial #	Date	Other Info	Disposition
1973-0859-000	HS	MOL	Dev. # 1	001	1968	MOL, Developmental Suit # 1, verified cost saving production methods. Missing cover garments (was short sleeve TMG config.), 03/68 Size: Large-Regular Part # SV 721575-1-1	NASM
1974-0795-000	HS	MOL	MH-7	001?		MOL, First training suit made in final training suit configuration. Was originally equipped with the blue, single-ply, short sleeve MH-7 cover garment. Was retrofitted later with TMG and aluminum plate (to replicate pressure control conductivity) for thermal testing. Part# SV 731850-1-3	NASM
1980-0042-000	HS	MOL	MH-7	004		MOL – Training—Overmeyer Part # SV 731850 AC-1-1	NASM
1978-1453-000	HS	MOL	MH-7	005		MOL – Training Has thermal cover garments	NASM
1983-0102-000	HS	MOL	MH-7	008		MOL – Training	NASM
1973-0860-000	HS	MOL	MH-7	010		MOL – Training Part # SV 731850 AH-1-1	NASM
	HS	MOL	MH-7	011		MOL – Training	NASM 1976-1201-000 Stolen while on loan -1979 Deaccessioned—1983
1973-0861-000	HS	MOL	MH-7	013		MOL – Training, cover garment missing from torso section. Part # SV-731850AL1-2	NASM
1983-0100-000	HS	MOL	MH-7	015		MOL – Training	NASM
	HS	MOL	MH-7	016		Part # SV-731850 AP1-2	NASM 1973-0862-000 No other NASM Record Disposition unknown
	HS	MOL	MH-7	017		Part # SV 731850 AR1-5	NASM 1973-0863-000 No other NASM Record Disposition unknown
1983-0101-000	ILC	MOL	A7-L	007	1966	Probably MOL—modified Apollo A 7-L—given DOD type LSS connector and believed part of USAF purchase of ILC suits in 1966 for evaluation Has arm bearings and ILC lining.	NASM
	ILC	Apollo	AX1-L	001	1962	Mobility Suit Prototype, Model #1	NASM 1973-0865-000 Deaccessioned, Disposition unknown
	ILC	Apollo	SPD-143	001	1962	SPD-143-2A Coverall Assembly	No NASM Catalog# In NASM/DSHB-24
	ILC	Apollo	SPD-143	003	1962	AX1-L, SPD-143-3, 11/62 Size: Medium-Regular, NASA-9-1100-61 Contract # NAS 9-616	NASM 1971-0026-000 No other NASM record Disposition unknown
1979-1334-000	ILC	Apollo	SPD-143	004	1962	AX1-L, Training & evaluation Suit SPD-143-3	NASM
	ILC	Apollo	SPD-143	005	1962	AX1-L, Modified training & evaluation suit, 12/62 Model SPD-143-3, Size: Large Contract # NAS 9-616	NASM 1971-0024-000 No other NASM record Disposition unknown
	ILC	Apollo	SPD-143	006	1962	AX1-L, 12/62 Model SPD-143-3, Size: Large-Long Contract # NAS 9- 616	NASM 1971-0034-000 No other NASM record Disposition unknown
	ILC	Apollo	SPD-143	008	1963	AX1-L, Modified SPD-143-3, 05/63 Size: Medium-Long, NASA-9-1100-8 Contract # NAS 9-1267	NASM 1971-0025-000 No other NASM Record Disposition unknown
1973-0840-000	ILC	Apollo	SPD-143	011	1963	AX1-L, Training & evaluation suit Size: Medium-Regular Contract # NAS 9-1964	Transferred to NASM – Stolen Disposition currently unknown/missing
2001-0293-000	ILC	Apollo	SPD-143	012	1963	AX1-L, Modified	NASM
2001-0293-001	ILC	Apollo			1963	Thermal cover-layer for above suit	NASM
	ILC	Apollo	SPD-143	013	1963	AX1-L, Modified, ID# AX1-L-013 Size: Medium-Regular Contract # NAS 9-1964	NASM 1971-0032-000 No other NASM record Disposition unknown
1973-0841-000	ILC	Apollo	SPD-143	014	1963	AX1-L, Modified, ID# AX1-L-014, Model # SPD-143-3, 07/63 Size: Medium-Regular Contract # NAS 9-1964	NASM
	ILC	Apollo	SPD-143	015	1963	AX1-L, Modified	NASM 1971-0030-000 No other NASM Record Disposition unknown
	ILC	Apollo	SPD-143	016	1963	AX1-L, NASA 81-4-29, ID# AX1-L-016 Model# SPD-143-3, Size: Large-Regular Contract # NAS 9-1964	NASM 1971-0031-000 No other NASM record Disposition unknown
	ILC	Apollo	SPD-143	017	1963	AX1-L, Modified Contract # NAS-9-1100-12	NASM 1971-0033-000 No other NASM Record Disposition unknown
	ILC	Apollo	AX1-H	003	1963	ID# A1-H-023, Model# SPD-804-1, 07/63 International Latex Corp. for Hamilton Standard Contract # E-92003-SS	NASM 1969-0039-000 Deaccessioned Disposed 04/79
	ILC	Apollo	AX1-H	021	1963	ID# A1-H-021, Model# SPD-804-1, 07/63 Size: Medium-Regular. International Latex Corp for Hamilton Standard Contract # E-92003-SS	NASM 1971-0035-000 No other NASM Record Disposition unknown
	ILC	Apollo	SPD-766	018	1964	A2-L, Training & evaluation Suit, ID#A2-L-001 Model# SPD-766-1, 03/64 Made to support Command Module evaluation	NASM 1969-0030-000 Deaccessioned – 1979 Disposition unknown
1985-0217-000	ILC	Apollo	SPD-766	019	1964	A2-L, Training & evaluation suit, Derivation of AX3-H suit, Model# SPD-766-1, 03/64, A2-L Torso Assembly S/N 002 indicating 2nd in A-2L series. Made to support Command Module evaluation Contract # NAS 9-2098	NASM
	ILC	Apollo	SPD-766	020?	1964	A2-L, Training & evaluation Suit, 03/64 Made to support Command Module evaluation Contract # NAS 9-2098	No NASM Catalog # Disposed – 1977

NASM Cat #	Manuf	Program	Series	Serial #	Date	Other Info	Disposition
	ILC	Apollo	A4-H	Unk			NASM 1972-1163-000 Deaccessioned Currently in DSHB24
	ILC	Apollo	A4-H	Unk			NASM 1982-0432-000 Deaccessioned – 1985, Transferred to NASA-JSC
	ILC	Apollo	A4-H	022	1964	A4H-027— Peterson Model ILC 782-4	NASM 1973-0814-000 Deaccessioned – 1980 Disposition unknown
	ILC	Apollo		024	1964	A4H-029—Hadjegeorgion Model ILC 782-4 Helmet remains in NASM collection w/Cat #	NASM 1973-0811-000 Deaccessioned – 08/77 Destroyed
1975-0661-000	ILC	Apollo	A4-H	028	1964	ILC for HS—Training Suit (Torso Assy # 023) HS Model ILC-782-4, Early configuration—No longer considered developmental Contract # NAS 9-2820	NASM
1983-0078-000	ILC	Apollo	A4-H	030	1964	ILC for HS - (torso assy. 831)—Lovell Model# ILC-782-4, 10/64 No longer considered developmental, included NASA requested improvements, larger neckring, HS-C-3 helmet, sizing looptape reduced from 7 – 4 sets. Contract # NAS 9-2820	NASM
1983-0077-000	ILC	Apollo	A4-H	031	1964	ILC for HS - Torso S/N 825—J. O'Kane Model# ILC-782-4 Included NASA requested improvements, see S# 30 Contract # NAS 9-2820	NASM
1977-2789-000	ILC	Apollo	A4-H	032	1964	ILC for HS - (Torso Assy # 826)—E. Cytryn, late A-4H config., originally had 2 dual port LSS connectors, later converted to single Gemini units, alum. outer fabric. Included NASA requested improvements, see S# 30 Contract # NAS 9-2820	NASM
1982-0436-000	ILC	Apollo	A4-H	034	1964	Torso Assy # 838, ID# A4H-034 Included NASA requested improvements, inc modified feet, see S# 30 Contract # NAS9-2820	NASM
1973-0810-000	ILC	Apollo	A4-H	036	1964	ILC for HS - (Torso Assy # 830)—W. Clark, late A-4H config., last in series, originally had 2 dual port LSS connectors, later converted to single Gemini units, white outer fabric. Included NASA requested improvements, see S# 30 ID# A4H-036, Model # ILC 782-4 Contract # NAS 9-2820	NASM
1979-1326-000	ILC	Apollo	Composite Mock-up	833		ILC for HS, HS modified multiple times to support development. Used for CO2 testing and arm/shoulder mobility Model # ILC-810-5	NASM
2004-0268-000	ILC			834	1965	ILC for ARC – "Lobster Shell Suit" w/X-15 style helmet, RHPS PGA—Used by NASA-Ames Ejection prototype suit using suit to replace "seat." Model # ILC-811-A Contract # NAS 2-1712	NASM
1977-2796-000	ILC	Apollo	A5-L	001		Developmental – Apollo prototype	NASM
	ILC	Apollo	A5-L	002		Sized for Gordon Constructed late 1965 early 1966 Tested at US Army Natick Laboratories	Transferred to NASM on HOU 470 Lost in transit Whereabouts unknown
	ILC	Apollo	A5-L	003		With coverlayer A5-L-001 R&D design Corporation	NASM 1978-1414-000 Deaccessioned Reacquired by NASA–JSC – 1985
1973-0813-000	ILC	Apollo	A5-L	005		Developmental – modified A5L-100000—Peterson Gemini-style boots – no coverlayer Contract # NAS 9-5332	NASM
1973-0576-000	ILC	Apollo	A5-L	006		Prototype—Jackson	NASM
1977-0355-000	ILC	Apollo	A5-L	009		Prototype—Jerry Armstrong	NASM
	ILC	Apollo	A5-L	010		B. Welson coverlayer—Newell	NASM 1973-0812-000 Deaccessioned – 1973 DSH Demonstration
	ILC	Apollo	A5-L	012		Qualification test	NASM 1978-1410-000 Deaccessioned – 1985 Reacquired by NASA – 1985
1985-0645-000	ILC	Apollo	A5-L	012		R&D Design Corp – Coverlayer A5L-003 Size: Medium-Long Contract # NAS 9-10568	NASM
1978-1411-000	ILC	Apollo	A5-L	013			NASM
	ILC	Apollo	A5-L	014		Sylvester	Transferred to NASM Reacquired by NASA – 1985
1973-0578-000	ILC	Apollo	A6-L	002		Hermling/766? Model# 1001	NASM
	ILC	Apollo	A6-L	004			Transferred to NASM on HOU-470 Lost in transit Whereabouts unknown
	ILC	Apollo	A6-L	005		Bull Part # A6-L-100000	Transferred to NASM on HOU-701 Returned to NASA-JSC – 08/83
	ILC	Apollo	A6-L	009			Transferred to NASM Reacquired by NASA – 1985
1977-2790-000	ILC	Apollo	A6-L	011		Training—Scott	NASM
1977-0621-000	ILC	Apollo	A6-L	012		Schweickart?	NASM
1973-0577-000	ILC	Apollo	A6-L	016		Training—Kerwin	NASM
1982-0465-000	ILC	Apollo	A6-L	020			NASM—MISSING
1973-1473-000	ILC	Apollo	A6-L	023	1967	Training—Conrad Combined w/ A7-L-TMG S#046—Cooper NASM Cat #1973-1475-000 for display purposes	NASM
1973-0579-000	ILC	Apollo	A6-L	025		Training—Gordon	NASM

NASM Cat #	Manuf	Program	Series	Serial #	Date	Other Info	Disposition
	ILC	Apollo	A7-L	001	1967	EV Configuration, no thermal cover-layer Delivered to NASA 12/4/67	NASM 1978-1412-000 Deaccessioned Reacquired by NASA – 1985
	ILC	Apollo	A7-L	002	1967	Young Part # A7L-100000, EV Configuration, Delivered to NASA 1/23/68	Transferred to NASM Reacquired by NASA-JSC – 1983
1983-0262-000	ILC	Apollo	A7-L	003	1968	Training—Young EV Configuration, Delivered to NASA 4/16/68	NASM
1973-0228-000	ILC	Apollo	A7-L	004	1968	Apollo 7 – Flight—Schirra EV Configuration, Delivered to NASA 6/7/68 Model# 2001, TMG Serial # 010	NASM
1972-1013-000	ILC	Apollo	A7-L	005	1968	Apollo 7 – Flight— Eisele IV Configuration, Delivered to NASA 6/8/68	NASM
2002-0106-000	ILC	Apollo	A7-L	006	1968	Apollo 7 – Flight— Cunningham EV Configuration, Delivered to NASA 6/7/68	NASM
	ILC	Apollo	A7-L	008	1968	Apollo 7 – Prime – back-up crew—Young Part # A7L-100000 IV Configuration, Delivered to NASA 6/28/68	Transferred to NASM – HOU-701 Reacquired by NASA-JSC – 1983
	ILC	Apollo	A7-L	010	1968	Apollo 7 – Back-up—Schirra Part # A7L-100000 EV Configuration, Delivered to NASA 7/3/68	Transferred to NASM – HOU-701 Reacquired by NASA-JSC – 1983
1977-2791-000	ILC	Apollo	A7-L	011	1968	Apollo 10 – Prime – back-up crew—Eisele Apollo 7 – Back-up—Eisele TMG Serial # 014 IV Configuration, Delivered to NASA 7/3/68	NASM
	ILC	Apollo	A7-L	012	1968	Apollo 7 – Back-up—Cunningham EV Configuration, Delivered to NASA 6/26/68	Transferred to NASM – HOU 700 Acquired by KCSC – 1983
1976-1538-000	ILC	Apollo	A7-L	PP-014		Training—Irwin	NASM
1983-0341-000	ILC	Apollo	A7-L	014	1968	Apollo 9 – Back-up—McDivitt TMG serial # 021 EV Configuration, Delivered to NASA 10/21/68	NASM
1973-1283-000	ILC	Apollo	A7-L	015	1968	Apollo 9 – Flight—Schweickart TMG Serial # 048 EV Configuration, Delivered to NASA 7/30/68	NASM
	ILC	Apollo	A7-L	016	1968	Apollo 9 – Prime – back-up crew—Conrad EV Configuration, Delivered to NASA 7/26/68	Transferred to NASM – HOU 703 Reacquired by NASA – USSRC – 1983
1977-2793-000	ILC	Apollo	A7-L	017	1968	Apollo 9 – Prime – back-up crew—Gordon IV Configuration, Delivered to NASA 8/7/68 Part # A7L-101100-12 , Model# 2001-A	NASM
1973-1284-000	ILC	Apollo	A7-L	019	1968	Apollo 9 – Flight—Scott IV Configuration, Delivered to NASA 8/5/68	NASM
1973-1285-000	ILC	Apollo	A7-L	020	1968	Apollo 9 – Flight—McDivitt EV Configuration, Delivered to NASA 8/5/68 TMG serial # 047	NASM
1978-0200-000	ILC	Apollo	A7-L	021	1968	Apollo 9 – Back-up—Schweickart Training—Duke EV Configuration, Delivered to NASA 8/2/68	NASM
1973-1420-000	ILC	Apollo	A7-L	023	1968	Developmental—Swigert EV Configuration, Delivered to NASA 4/19/68 Model # 2001-A	NASM
1977-2792-000	ILC	Apollo	A7-L	024	1968	Training—Borman EV Configuration, Delivered to NASA 5/25/68	NASM
1973-0580-000	ILC	Apollo	A7-L	025	1968	Training—Anders IV Configuration, Delivered to NASA 5/27/68	NASM
1971-1841-000	ILC	Apollo	A7-L	026	1968	Training—Collins TMG serial # 025 IV Configuration, Delivered to NASA 7/15/68	NASM
1977-2794-000	ILC	Apollo	A7-L	028	1968	Training—Roosa, possibly Lovell TMG Serial # 046 IV Configuration, Delivered to NASA 7/15/68	NASM
1975-0836-000	ILC	Apollo	A7-L	029	1969	Apollo 8? – Training, back-up—Shepard, possibly Borman TMG Serial # 096 EV Configuration, Delivered to NASA 8/23/68	NASM
1969-0370-000	ILC	Apollo	A7-L	030	1968	Apollo 8 – Flight—Borman TMG Serial # 048? IV Configuration, Delivered to NASA 9/24/68	NASM
1970-0342-000	ILC	Apollo	A7-L	031	1968	Apollo 8 – Flight—Anders TMG Serial # 049 EV Configuration, Delivered to NASA 9/21/68	NASM
1973-0042-000	ILC	Apollo	A7-L	033	1969	Apollo 11 – Flight—Collins IV Configuration, Delivered to NASA 2/24/69	NASM
	ILC	Apollo	A7-L	035?		Borman Coverlayer only? Part # A7L-201100-16	No NASM Cat # Transferred to NASM Education – 1990
1970-0343-000	ILC	Apollo	A7-L	037	1968	Apollo 8 – Flight—Lovell TMG Serial # 055 IV Configuration, Delivered to NASA 9/5/68	NASM
1973-1287-000	ILC	Apollo	A7-L	043	1968	Apollo 10 – Flight—Young TMG Serial # 061 IV Configuration, Delivered to NASA 11/19/68	NASM
1973-1286-000	ILC	Apollo	A7-L	044	1968	Apollo 10 – Flight—Cernan TMG Serial # 068 EV Configuration, Delivered to NASA 11/10/68	NASM
1975-0597-000	ILC	Apollo	A7-L	047	1969	Apollo 10 – Flight—Stafford TMG Serial # 059 EV Configuration, Delivered to NASA 02/5/69	NASM
1983-0343-000	ILC	Apollo	A7-L	048	1968	Apollo 10 – Back-up—Young TMG Serial # 021 IV Configuration, Delivered to NASA 12/13/68	NASM
1977-1267-000	ILC	Apollo	A7-L	049	1968	Apollo 10 – Back-up— Cernan Cooper – Training TMG serial # 044 EV Configuration, Delivered to NASA 01/3/69	NASM
1977-2548-000	ILC	Apollo	A7-L	051	1968	Apollo 8 – Prime – back-up crew—Haise TMG Serial # 073 EV Configuration, Delivered to NASA 11/07/68	NASM
	ILC	Apollo	A7-L	055	1970	Apollo 16 – Prime – back-up crew—Brand, Cernan? IV Configuration, Delivered to NASA 03/17/70	Unknown NASM Cat # Deaccessioned – 1985 Transferred to Hansen Planetarium

NASM Cat #	Manuf	Program	Series	Serial #	Date	Other Info	Disposition
1973-0040-000	ILC	Apollo	A7-L	056	1969	Apollo 11 – Flight— Armstrong TMG Serial # 063 EV Configuration, Delivered to NASA 02/11/69	NASM
1972-1024-000	ILC	Apollo	A7-L	057	1969	Apollo 11 – Back-up—Armstrong TMG Serial # 064 EV Configuration, Delivered to NASA 03/11/69	NASM
1973-1289-000	ILC	Apollo	A7-L	061	1969	Apollo 13 – Flight—Haise TMG Serial # 066 EV Configuration, Delivered to NASA 03/18/69	NASM
	ILC	Apollo	A7-L	062?		Lovell Coverlayer/PG only? Serial # A7L-100000-3	NASM 1976-1239-000 Deaccessioned – 1983 Transferred to NASM Education – 1990
1971-1835-000	ILC	Apollo	A7-L	065	1969	Apollo 12 – Flight—Conrad TMG Serial # 065 EV Configuration, Delivered to NASA 04/01/69	NASM
1971-1836-000	ILC	Apollo	A7-L	066	1969	Apollo 12 – Flight—Gordon TMG Serial # 088 IV Configuration, Delivered to NASA 02/24/69	NASM
1971-1837-000	ILC	Apollo	A7-L	067	1969	Apollo 12 – Flight—Bean TMG Serial # 090 – replaced – flight TMG used for post mission destructive testing EV Configuration, Delivered to NASA 03/28/69	NASM
1972-0588-000	ILC	Apollo	A7-L	073	1069	Apollo 14 – Flight—Mitchell TMG serial # 085 EV Configuration, Delivered to NASA 06/25/69	NASM
1985-0646-000	ILC	Apollo	A7-L	074	1969	Apollo 11 – Prime – back-up crew— Lovell Apollo 13 – Back-up—Lovell EV Configuration, Delivered to NASA 03/09/69	NASM
1976-1982-000	ILC	Apollo	A7-L	076	1969	Apollo 11 – Back-up—Aldrin Training—Schmitt TMG serial # 105 EV Configuration, Delivered to NASA 03/09/69	NASM
1973-0041-000	ILC	Apollo	A7-L	077	1969	Apollo 11 – Flight—Aldrin TMG Serial # 071 EV Configuration, Delivered to NASA 04/25/69	NASM
1973-0013-000	ILC	Apollo	A7-L	078	1969	Apollo 13 – Flight—Lovell TMG Serial # 058 EV Configuration, Delivered to NASA 08/21/69	NASM
	ILC	Apollo	A7-L	079	1969	Anders Part # A7L-100000-88 EV Configuration, Delivered to NASA 12/10/69	Transferred to NASM Returned to NASA – JSC – 08/83
1974-0151-000	ILC	Apollo	A7-L	082	1969	Apollo 16 – Flight—Mattingly TMG Serial # 401 Retrofitted to A7-LB (see same serial # A7-LB) IV Configuration, Delivered to NASA 08/25/69	NASM
1975-0836-000	ILC	Apollo	A7-L	084	1969	Apollo 14 – Back-up—Shepard TMG Serial # 029 EV Configuration, Delivered to NASA 07/29/69	NASM
1974-0134-000	ILC	Apollo	A7-L	085	1969	Apollo 14 – Flight— Roosa TMG serial # 105 EV Configuration, Delivered to NASA 08/19/69	NASM
1973-1288-000	ILC	Apollo	A7-L	088	1969	Apollo 13 – Flight—Swigert IV Configuration, Delivered to NASA 08/18/69	NASM
	ILC	Apollo	A7-L	089	1970	EV Configuration, Delivered to NASA 03/06/70	NASM 1976-1235-000 Deaccessioned Transferred to NASA – KSC – 1983
1972-0587-000	ILC	Apollo	A7-L	090	1970	Apollo 14 – Flight—Shepard TMG Serial # 098 EV Configuration, Delivered to NASA 02/13/70	NASM
	ILC	Apollo	A7-L	091		Apollo 14 – Back-up—Roosa	Transferred to NASM Reacquired by NASA – JSC – 1983
1973-0059-000	ILC	Apollo	A7-L	094	1970	Apollo 15 – Flight—Worden TMG Serial # 402 IV Configuration, Delivered to NASA 06/19/7 A7-L retrofitted to A7-LB (see same serial # A7-LB)	NASM
1974-0151-000	ILC	Apollo	A7-LB	082	1971	Apollo 16 – Flight—Mattingly TMG Serial # 401 Retrofitted A7-L LM crew suit as A7-LB suit (see same serial # A7-L)	NASM
1973-0059-000	ILC	Apollo	A7-LB	094		Apollo 15 – Flight—Worden TMG Serial # 402, Part # A7LB-1012-004 IV Configuration, Delivered to NASA 06/19/70 Retrofitted A7-L LM crew suit as A7-LB suit (See same serial # A7-L)	NASM
			A8-L	200		No 200 Series suits found Believed to be proposed concept	
			A9-L	300		Believed to be A9-L series, subsequently chosen and renamed A7-LB – as below	
	ILC	Apollo	A7-LB	301		DVT Von Ehrenfried Part# A7LB-201154-02	NASM 1976-1238-000 Deaccessioned Transferred to NASA – KSC – 1983
1974-0189-000	ILC	Apollo	A7-LB	315		Apollo 15– Flight—Scott Apollo 17 – Training—Cernan TMG Serial # 315	NASM
1983-0126-000	ILC	Apollo	A7-LB	317		Apollo 15 – Prime – back-up crew—Gordon TMG Serial # 317	NASM
1974-0132-000	ILC	Apollo	A7-LB	320	1971	Apollo 15 – Flight—Irwin TMG Serial # 360	NASM
1974-0149-000	ILC	Apollo	A7-LB	322	1971	Apollo 16 – Flight—Young TMG serial # 322 – 04/71, Part # 201154-05 PG – 07/71	NASM
	ILC	Apollo	A7-LB	325	1971	Apollo 16 – Prime – back-up crew—Mitchell Training— Mitchell TMG Serial # 325	NASM DSH Demonstration purposes

NASM Cat #	Manuf	Program	Series	Serial #	Date	Other Info	Disposition
1974-0150-000	ILC	Apollo	A7-LB	327		Apollo 16 – Flight—Duke TMG serial # 327	NASM
1974-0133-000	ILC	Apollo	A7-LB	328	1972	Apollo 17 – Flight—Cernan TMG serial # 328	NASM
1974-0183-000	ILC	Apollo	A7-LB	329	1972	Apollo 17 – Flight—Schmitt TMG serial # 329	NASM
1974-0135-000	ILC	Apollo	A7-LB	404		Apollo 17 – Flight—Evans TMG Serial # 404 A7-LB-107033-01	NASM
				500		No 500 series suits found	
1976-1192-000	ILC	Skylab	A7-LB	614	1972	Skylab 2 – Flight—Conrad Skylab Configuration TMG serial # 615	NASM
1976-1195-000	ILC	Skylab	A7-LB	615	1972	Skylab 2 – Flight—Kerwin Skylab Configuration TMG serial # 616	NASM
1976-1196-000	ILC	Skylab	A7-LB	616	1972	Skylab 2 – Flight—Weitz Skylab Configuration TMG Serial # 617	NASM
1976-1197-000	ILC	Skylab	A7-LB	626	1972	Skylab 4 – Flight—Carr Skylab Configuration TMG serial # 627	NASM
1976-1198-000	ILC	Skylab	A7-LB	627	1972	Skylab 4 – Flight— Pogue Skylab Configuration TMG Serial # 628	NASM
1976-1199-000	ILC	Skylab	A7-LB	628	1972	Skylab 4 – Flight—Gibson Skylab Configuration TMG serial # 629	NASM
1976-1193-000	ILC	Skylab	A7-LB	632	1972	Skylab 3 – Flight—Bean Skylab Configuration TMG Serial # 633	NASM
1976-1194-000	ILC	Skylab	A7-LB	633	1972	Skylab 3 – Flight—Garriott Skylab Configuration TMG serial # 634	NASM
1976-1191-000	ILC	Skylab	A7-LB	634	1972	Skylab 3 – Flight—Lousma Skylab Configuration TMG serial # 635	NASM
	ILC	Skylab	A7-LB	701		DVT ITMG—Part # A7-L- 100000-04	NASM 1976-1236-000 Deaccessioned – 1983 Transferred to NASA-KSC
	ILC	Skylab	A7-LB	702		DVT-002 ITMG—Part # A7-L- 100000	NASM 1976-1237-000 Deaccessioned – 1983 Transferred to NASA-KSC / USSRC
	ILC	Skylab	A7-LB	703		DVT Part # A7L-100000-X	Transferred to NASM on HOU 470 Lost in transition Whereabouts unknown
1978-1494-000	ILC	Skylab	A7-LB	705		DVT—Anders Conrad PG, Combined with NASM Cat # 1978-1474-000 TMG Serial # 036 for display purposes Catalog # NAS 9-6100	NASM
1977-2795-000	ILC	Skylab	A7-LB	706		DVT	NASM
1977-2536-000	ILC	ASTP	A7-LB	801	1974	ASTP – Flight—Stafford ASTP Configuration	NASM
1977-2537-000	ILC	ASTP	A7-LB	803	1974	ASTP – Flight—Slayton ASTP Configuration	NASM
1977-2538-000	ILC	ASTP	A7-LB	806	1974	ASTP – Flight—Brand ASTP Configuration	NASM
	Litton	AAP	RX-1	-0-	1962	Feasibility demonstrator for constant volume suit. Had soft bellows-type hip joint which ballooned on pressurization. Was disassembled to construct the RX-2.	NASM
1972-0536-000	Litton	AAP	RX-2	-0-	1963	Modified from RX-1 to become RX-2 with rolling convolute hip mobility joint. Bandolier closure. Front crank to raise interior sear so head/eye position could be maintained.	NASM
1973-1015-000	Litton	AAP	RX-2	-0-	1964	Lower torso and legs only. RX2 legs combined with RX2-A lower torso. Dual-plane closure.	NASM
1982-0453-000	Litton	AAP	RX-2A	-0-	1964	Dual-plane closure system with a quick-detach hemispherical helmet, and rolling convolute waist joint. Contract # NAS 9-1278	NASM
1982-0435-000	Litton	AAP	RX-3	-0-	1965	Litton proposal for MOL ejection system. With MOL ejection seat attachment. Dual-Plane closure.	NASM
1976-0872-000	Litton	AAP	RX-3	-0-	1956	Feasibility demonstrator for follow-up development prequalification. Modular sizing enabled fit to within 10-90% of body sizes. Hemispherical helmet with visor assembly, Velcro-attached thermal covers to exposed joints.	NASM
1976-0873-000	Litton	AAP	RX-4	-0-	1966	Modified upper front torso for anticipated movement of life support connections. Modular sizing, first to have thermal garments.	NASM
	Litton	AAP	RX-5		1967	Diagonal, single-plane body closure with dual-axis, rolling convolute waist joint. 3-bearing hip joint. Life support systems relocated to upper torso.	Unknown
	Litton	AAP	RX-5A		1968	Modified from RX-5 to improve thermal and micro-meteoroid protection. Waist changed to single-axis joint.	Unknown
	Litton	AAP	CVS		1968	Litton "hard suit" prototype	Unknown
	Litton	AAP	AES		1969	Litton advanced soft prototype	Unknown

NASM Cat #	Manuf	Program	Series	Serial #	Date	Other Info	Disposition
1982-0455-000	Litton	AAP	AES		1969	Litton advanced soft prototype with Chromel-R coverlayer Modified B1-A Hemispherical helmet	NASM
	Litton	AAP	B-1-A	001	1968	Litton – AES – Pre-shuttle prototype No Thermal garments Part # 241300-001; #241400-001 Size: Medium-Long Contract # NAS 9-7533 Mod 5	NASM suit Awaiting final disposition currently at AHoF
1982-0464-000	Litton	AAP	B-1-A	002	1968	Litton – AES – Pre-shuttle prototype. In "All-Up" configuration w/thermal covers, no PLSS	NASM
1979-0690-000	Litton	AAP	AES	LT-101	1969	Litton advanced soft prototype Model # 500590	NASM
				082		TMG only? A7L-201100-43	NASM 1976-1234-000 Deaccessioned Transferred to NASA – KSC – 1983

Acronyms_

AAP = Apollo Applications Project, for development of Apollo 18 and later suits

Arrow = Arrowhead Rubber Company

AiR = AirResearch Division of Garret Corporation, now Honeywell Corporation.

A-L = Air-Lock Corporation, now the Air-Lock subsidiary of DCC

BFG = B. F. Goodrich Corporation, now Goodrich Corporation

DCC = David Clark Company

HS = Hamilton Standard Division of United Aircraft, now Hamilton Sundstrand Division of United Technologies

HS = Product of a HS/ILC/A-L team

ILC = Was International Latex Corporation, ILC Industries, now ILC Dover

USN = United States Navy

AES = Advanced Extra-vehicular Suit

DVT = Design Verification Testing

PGA = Pressure Garment Assembly

MOL = Manned Orbiting Laboratory

SPD = Specialty Products Division, of ILC

TMG = Thermal Meteoroid Garment

Astronaut Edwin "Buzz" Aldrin on the Moon, Apollo 11
1969
NASA Image # AS11-40-5903
Courtesy of NASA

Spacesuits
The Smithsonian National Air and Space Museum Collection

Published in the United States by

powerHouse Books, a division of powerHouse Cultural Entertainment, Inc.

37 Main Street, Brooklyn, NY 11201-1021

telephone 212 604 9074, fax 212 366 5247 e-mail: spacesuits@powerHouseBooks.com

website: www.powerHouseBooks.com

First edition, 2009

Library of Congress Cataloging-in-Publication Data

Young, Amanda (Amanda Joan)
 Spacesuits within the collections of the Smithsonian National Air and
Space Museum / by Amanda Young ; photographs by Mark Avino ; introduction by
Allan Needell ; foreword by Thomas P. Stafford.
 p. cm.
 ISBN 978-1-57687-498-1 (hc.)
 1. Spacesuits--History--Catalogs. 2. Spacesuits--Pictorial
works--Catalogs. 3. Spacesuits--Collection and preservation--Catalogs. 4.
National Air and Space Museum--Catalogs. I. National Air and Space Museum.
II. Title. III. Title: Spacesuits within the collections of the Smithsonian
National Air and Space Museum. IV. Title: Spacesuits.
 TL1550.Y66 2009
 629.47'72074753--dc22
 2009075080

Hardcover ISBN 978-1-57687-498-1

Printed and bound by Midas Printing, Inc., China

Book design by Mine Suda

A complete catalog of powerHouse Books and Limited Editions is available upon request; please call, write, or visit our website.

10 9 8 7 6 5 4 3 2 1

Printed and bound in China

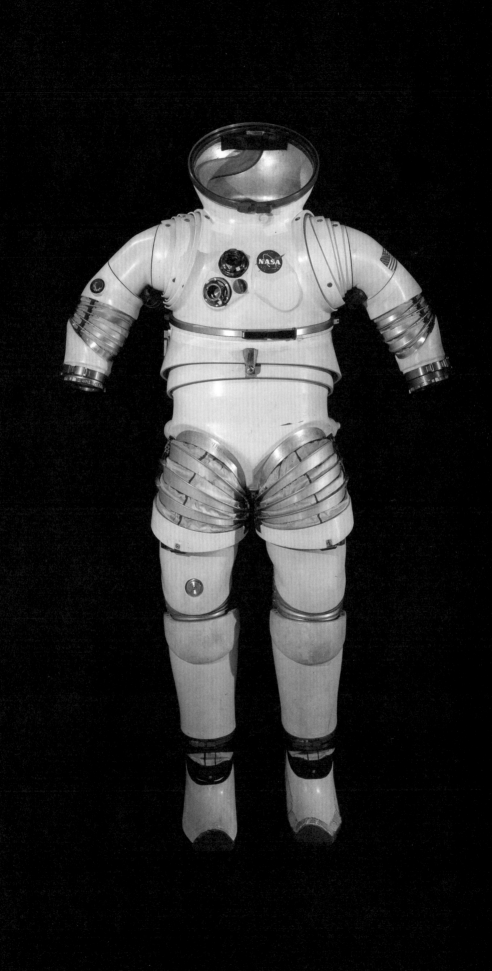

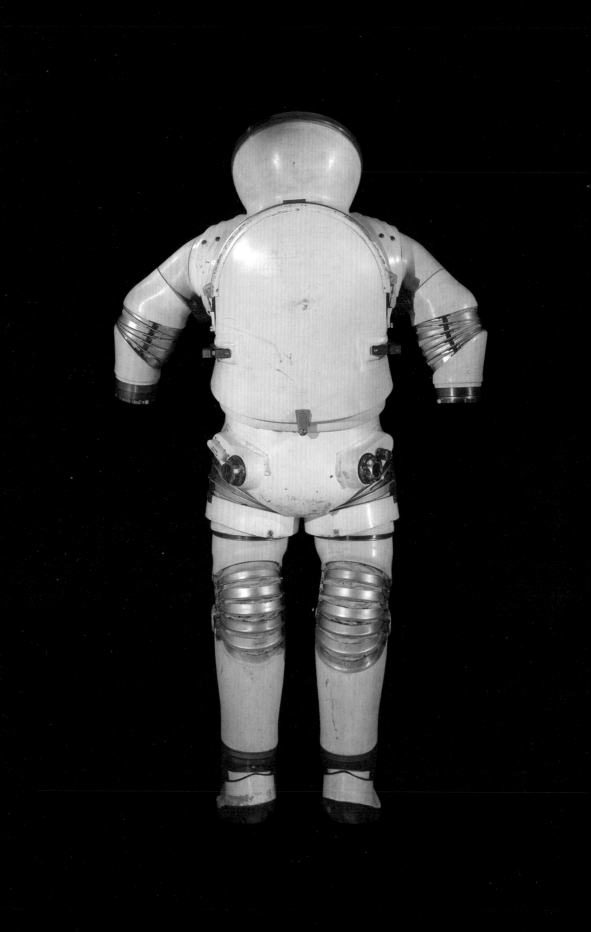